Dedalus Origin

A BIT OF

Karina Mellinger was born i... ...ung
French and Italian at Oxfor... ...i marketing in
England and Italy. In 1995 she ... up work to bring her two
sons up. She now writes full time.

Dear Pat
and John

with love

Karina

X

To Sally

Karina Mellinger

A Bit Of A Marriage

Dedalus

Published in the UK by Dedalus Ltd
Langford Lodge, St Judith's Lane, Sawtry, Cambs, PE28 5XE
email: info@dedalusbooks.com
www.dedalusbooks.com

ISBN 1 903517 46 X

Dedalus is distributed in the United States by SCB Distributors
15608 South New Century Drive, Gardena, California 90248
email: info@scbdistributors.com web site: www.scbdistributors.com

Dedalus is distributed in Australia & New Zealand by Peribo Pty Ltd
58 Beaumont Road, Mount Kuring-gai N.S.W. 2080
email: peribo@bigpond.com

Dedalus is distributed in Canada by Disticor Direct-Book Division
695 Westney Road South, Suite 14 Ajax, Ontario, LI6 6M9
web site: www.disticordirect.com

First published in 2006

Printed in Finland by WS Bookwell
Typeset by RefineCatch Limited, Bungay, Suffolk

CHAPTER 1

Today is Saturday. Laura, David's wife, has just woken up.

Laura likes to read when she wakes up. She reads all those magazines dedicated to wealthy women of impending middle-age like herself, and the novels from the 'just published' table in her local bookshop. People at dinner parties only ever talk about the just published novels. If anyone starts talking to Laura about any book which came out any earlier than last week, Laura offers them a scowl of indignant compassion and turns the other way.

When David, her husband, starts to stir, Laura quickly puts down her magazine or just published book and feigns sleep. She enjoys the privacy of waking up alone in the bedroom. She can't stand the kind of ritualistic nonsense married people feel obliged to engage upon when waking. The plati-tudes. 'Good Morning, Darling!' 'Did You Sleep Well?' 'Did You Have Any Dreams?'

Who bloody cares.

Sleeping with David is a chore in many other ways too. He snores terribly all through the night. Laura is a reasonable woman: she understands that he does, after all, have to breathe while he's asleep, nevertheless she is not sure for how much longer she can stand it. She has tried remedies: applying nasal strips, ionic air machines, rolling him over onto his side, even kicking him in the shins, but nothing seems to work. So this is something Laura has just had to learn to put up with, along with so much else. Just as long as he remembers to ask and apologise in the morning in case his snoring has kept her awake at night. If he forgets, Laura will sulk all day.

Another thing: David always wakes up with a hard-on. This isn't pleasant. They both act like they haven't seen it (as Laura's pretending she's asleep anyway this isn't difficult).

Laura always wonders what David must have been thinking of, dreaming of, in his sleep to wake up like that. Whatever – she wants nothing to do with it. Fortunately he always goes straight to the cosy privacy of his en suite where he has somehow learnt to deal with it. Laura is not sure how he does this. Neither does she want to know. Masturbation both confuses and repulses her. She's never tried it – why would she need to exercise that kind of power over herself? As far as Laura is concerned, the end justifies the means. If David reappears calm and not expecting sex, that's just fine. Laura does not care for just-woken-up sex. It disorientates her. It is too spontaneous, too physical. She is not averse to sex per se, but there is a time and a place for everything and 8.30 a.m. on a Saturday is not it. Usually, at the weekend, after having eaten his breakfast, David will come back to the bedroom and make congenial conversation with her. This is the sign that he wants sex and Laura must decide, on a case by case basis, whether 9.05 a.m. might be the time or the place after all or whether it still isn't and he's just going to have to wait until bedtime.

(Laura doesn't do day-time sex either – it doesn't agree with her hair and make-up.)

Having emerged from his en suite suitably composed, David goes into the kitchen to make toast and read the morning papers. Laura lies in bed, assailed by the familiar acridity of burning bread in the kitchen. (Even as she lies there, she knows David will have used the butter knife in the jam. When she next reaches for the jam jar, the small clots of fat will wink maliciously up at her from their raspberry depths and once again, the shudders of frustration, revulsion even, will course through her body and it will take only the greatest willpower to stop her from throwing the whole lot in the bin.) Anyway, this is Laura's slot. While he's in the kitchen, making toast, burning toast, working out how to turn off the toaster to extract the cremated remains and eat them, Laura gets up, goes into her own en-suite and inspects her face and body in the

8

arrangement of angled mirrors for any seismic changes which may have come about overnight. Then she goes back to bed and pulls the covers over her and considers whether when David re-appears half an hour later to cry the inevitable 'Good Morning, Darling!' she will consent to sex with him or not.

<div align="center">★</div>

Laura and David have been happily married for 15 years.

<div align="center">★</div>

'Good Morning, Darling!' David says.

David is smiling at Laura. David has come into the bedroom with his plate of scorched toast to talk to her, even though he knows how Laura feels about food in the bedroom.

Silly David.

David wants this to be a nice, happy, problem-free Saturday. For a start, this is one of his precious days of rest. (At least he gets two, even though God only got the one, but then making planet Earth can hardly be compared to running one of the most prestigious legal firms in the country.) More importantly, David is now in the throes of selling the practice he founded some twenty-three years before to a larger outfit which will make him more cash than even Laura can spend and give him a senior partnership in an international legal firm. This evening the managing partner of the other company is coming with his wife to their house for drinks (if the deal looks shaky) or drinks and then dinner (if it looks like it's going ahead). He knows the guy, Gerard, has made the decision to buy in his head. But Gerard is the morally upright sort who thinks success in the workplace starts with stability in the home. David just needs to nudge him the last inch by showing him what a calm, solid, happily married type he can authentically claim to be.

David needs this deal to happen. His business has the kudos; now it requires the funding and the infrastructure to get a hold globally. If the thing doesn't come off at this late stage

and word gets out, the future of David's firm would not look good.

Sometimes you've just got to take risks.

David is depending on Laura's support today. He has to have her in a good mood and talking to him. These two ecosystems don't often coincide but he's ready to do whatever it takes.

It's not that Laura doesn't want it to be a happy Saturday either. God knows she could do with some calm after the trials she's had this week with the interior designer doing up their drawing room. But she just can't get the jamjar out of her head and how it will be riddled with clusters of unsaturated animal fat next time she opens it. Then, as always, there's the issue of David's teeth. As he sits on the edge of her side of the bed smiling at her, all Laura can see is David's teeth. Most especially she can see the one front tooth which protrudes, perhaps only a millimetre or two, but nevertheless indisputably, from the rest. This protruding tooth has noticeably deeper ridges and is a more aggressive shade of yellow than the others. They had already been married a good few months before Laura first noticed that one of his front teeth lay ahead of the rest. Once she had, she wondered how on earth she ever could not have seen it. Now, after 15 years, she can see nothing but that one tooth every time he opens his mouth. How typical of David to have the most unsightly tooth as the protruding one and not even to notice or, most probably, care. She has discussed it with him on several occasions, sometimes in a kindly tone of voice, sometimes not, always reminding him that a good dentist would be able to sort it out in no time. David isn't interested. He says he's quite happy with himself as he is. Yes, replies Laura, curtly, but he is not the one who has to look at himself every day, is he? She is the one who has to do that. At this, David loses interest, or starts checking his emails, or grabs the paper, or all three. And Laura feels isolated, rejected, rebuffed, and needs to go and have a hot bath with aromatherapeutic oils to revive herself.

KARINA MELLINGER

She has to keep reminding herself that she must be grateful for small mercies. In the days when they still kissed with their mouths open, she used to imagine that tooth, rubbing up against her gum. She could feel the yellowness of it. She could taste it. At least now, with the restraint of passion that comes with a long marriage, she no longer had to suck it, just look at it.

She knows what he's thinking as he's sitting there on the edge of the bed smiling at her. He's thinking: it's Saturday morning, I've worked hard all week and I've got every right to have sex with my own wife. She knows exactly how his mind works. As yet, however, Laura is not sure whether she'll be consenting or not, so for the time being she has decided on a mid-course option. She will not continue simulating sleep but she will not look as if she is actually quite awake either. She asks him to make her a cup of tea. This permission to perform a task lets David know that, while sex that morning is not altogether out of the question, he'd be pushing his luck to take it for granted.

David looks and understands.

'Fine. And I'm still a bit peckish. While I'm in there I think I'll make myself some bacon and eggs,' he says. Laura looks at him. How is she supposed to respond to this tedious piece of information? With exclamations of delight? With applause? She nods. He goes.

This would be a good moment for Laura to try on the new trousers she bought herself yesterday, to see if they fit her any better this morning after she skipped dinner last night. Laura is a size 8 on a good day and a 10 on a bad so life is always lived on a bit of a knife-edge. Like David, however, she is prepared to take risks and paid the £350 for these fabulous trousers just in case they did sit smoothly across her crotch in the absence of a sufficient number of meal occasions.

But of course Laura cannot do any such thing, cannot try

11

on her new trousers, cannot enjoy herself, cannot even have five minutes of relaxation, because as she hears him crashing about in the handmade teak pan drawer to find the frying pan he wants, she's worrying about David and the bacon. David just doesn't get the concept of raw meat, the whole universe that is food hygiene. Even as clearly as if she were there in the kitchen watching him, probably even more clearly than that, Laura can see him pulling the open pack of bacon across the glass shelf of the fridge with his bare fingers – extracting the rashers, one, two, three, what the hell, let's go for four – and slopping them into the pan. She can see him wiping his fingers on the tea towel. (That tea towel will have to go straight in the wash.) She can feel, smell, hear the germs calling out to her. She can picture him, in technicolour, breaking the eggs straight into the pan (what if one of them had gone off, for heaven's sake?) and chucking, from a distance, the empty shells into the bin, the side of which they will hit before they fall in, or not, leaving a thin, snail-like slime trail of egg white no doubt at that very moment working its way slowly, methodically, down the side of their designer stainless steel bin and congealing at its base.

David obviously thinks that because he earns in excess of £1m plus bonus and share options a year he is entitled to chuck leaking eggshells onto the bin with impunity.

David is wrong.

David will eat his bacon and eggs and leave the kitchen, full and mindlessly happy. He will have no knowledge of the torment which he has obliged his wife to endure – no knowledge because she has learnt to suppress her anguish, wordlessly to replace the tea towel and leave instructions for the cleaner to clean the bin inside and out. Because that's the sort of woman she is. (Laura, not the cleaner.) Selfless. Silent. Suffering.

As she dozes off again under the cosy covers, Laura's mental picture moves from David masticating his bacon and eggs to

the scene where she tells Anouschka, her cleaner, to give the insides of the bin an extra good clean. 'But, Meesees David, I only do it yesterdaah,' Anouschka will moan, squinting her porridge-features into a scowl of discontent. 'Yesterday I paid you for yesterday. Today I am paying you for today,' Laura will assert politely. Meanwhile, Anouschka takes the remaining eggs from their box (which David is somehow physically, emotionally and culturally never quite able to put back in the fridge where he found it) and starts treading them into Laura's new limestone kitchen floor.

Fortunately Laura really has fallen asleep now and that last bit is just a bad dream.

<p style="text-align:center">★</p>

David is something of a legend in the esoteric world of commercial litigation. Winning a multimillion pound case for him is a piece of cake. Making breakfast, however, presents more of a challenge. Although he enjoys cooking, he has no instinct for it and nothing ever quite goes to plan. This morning he pours too much extra-virgin Tuscan olive oil in the pan, then drops the eggs in straight on top of the raw rashers so that the whole thing coagulates into one pink and orange thing swimming in a sea of molten gold. Bugger. He always forgets to remember to give the bacon a chance first. Bacon, certainly crispy bacon the way he likes it, cooks more slowly than egg. Why does he never remember that? He wants to start again. He hates burnt egg and undercooked bacon. He hates wasting food. He tries not to look, but, like passing cars slowing down to see a fatal accident, his eyes are drawn inexorably to the curdling mess. It might be all right when it's cooked, he reassures himself. When it's cooked, it's not really, but David eats it anyway, has several cups of coffee, goes out on the terrace to belch (best to be out of Laura's sound range for that, even if she has gone back to sleep) and returns to the bedroom to see if she's up or up for it or either or both.

When he first tiptoes into the room it appears she is asleep,

but when he trips over a pair of shoes (his) (of course) in the doorway and crashes into her dressing-table, she wakes up. She doesn't look very happy.

'You don't look very happy,' David says. (David's brain works in very straight lines. It's what makes him so good at his job but so hard to sit next to at a dinner party.)

'Is the kitchen in a state?' Laura asks rhetorically.

'No. Why should it be?'

'You've been in there.'

'So?'

Laura sighs. She keeps forgetting that David wouldn't know subtlety if it sat on his lap. She wants to say, 'So – you always make a bloody mess when you're in the kitchen', but it's all so wearisome she just can't force the muscles around her mouth to shape the words.

David sits down on the side of the bed. They can both see his erection waving at them under his boxer shorts, but both decide politely to ignore it, as one does with a tramp talking to himself on the underground train.

David has forgotten to make Laura the cup of tea he promised her. He can make himself a full cooked breakfast and yet forget a simple cup of tea for her. She's going to count till ten and if he doesn't remember in that timeframe she's going back under the covers to sulk again for a really seriously long period of time.

When she gets to eight the phone rings. David's mobile phone. Although she has talked to herself about this, Laura cannot quite rid herself of the feeling that every time David's phone rings when he's with her it's somehow his way of showing her that he's in charge. That his whole career, his whole money-spinning existence, is only there just to show her how little she's worth. 'Don't forget,' trills the phone, 'he's the breadwinner, not you! Since when do you get vital phone calls demanding vital decisions at each and every moment of the day?' Immediately David is engrossed in some

complex discussion of verbal legal hieroglyphics with a client about another life or death case.

'Blah blah blah,' says David. 'Blah blah judicial review. Blah blah Queen's Bench writ. Blah blah interrogatories.'

Laura reminds herself that there's more to life than making money.

Being a discerning, interesting human being is just as important.

And being an artist. With a show coming up in Cork Street.

'Blah, blah, blah, crucial,' says David into his little phone.

Not only is creating beautiful life-enhancing paintings more important for the human psyche than doing legal blah-blah all day but if this show comes off it will also, as a completely arbitrary by-product, earn her tons of money too. Then we'll see how things change in this relationship, Laura thinks with a silent snort. Then perhaps David won't talk down to her quite as much as he always bloody does.

'Blah, blah, bye.'

David snaps his phone shut. She knows he thinks he's pretty stylish the way he does this but frankly she doesn't give a damn.

He's grinning again. The tooth. Ugh. He says, 'Have we got anything planned for next weekend? Why don't we go away for a couple of nights, just the two of us? How about that hotel in the Cotswolds, the one we used to go to all the time. We haven't been there for ages.'

'Are you doing this deliberately?' Laura cries. David frowns. 'You know we've got that drinks party at Isabelle's next Friday. You know how important that is to me!'

(Isabelle is sort of Laura's agent. Sort of, because Laura has never actually sold a painting through her – or anyone else actually – although there has been masses of interest in Laura's studies of hard surfaces and, Isabelle has assured her, it's all a question of timing and Laura's time will come when the time is right.)

'Yes,' says David softly, 'but that's early, at 6. We could stay

there a couple of hours, miss the traffic and then set off, have a late supper en route.'

'Unbelievable,' Laura says, shaking her head vehemently without a thought for what it's doing to her hairstyle. 'This is a critical stage in my career. My agent invites us to a drinks party where everyone who's anyone will be, and you're allocating me a couple of hours. I'm not bloody Cinderella, you know. Can you imagine if I were to say that to this man we're supposed to be having dinner with tonight, if I were to suddenly look at my watch in the restaurant and say – "Ooh, look, the two hours are up. Sorry, must dash!" Can you imagine that? Can you?!'

Laura is at her wit's end. She wonders how much more she can take of this kind of extreme provocation. She disappears under the covers to show David she is angry, really angry, and waits for him to apologise. Instead his mobile starts chiming again and he's off discussing another imminent megacase. That's it. Now she's going to sulk for hours. Until after lunch at least.

She watches David walking towards the kitchen, yakking away. From her hidey-hole under the silk covers Laura can also see the antique green Lalique clock he got her for her birthday and computes that Anouschka, the cleaner, is already twenty minutes late. No, not the cleaner, Laura reminds herself. She must remember to stop referring to her as the cleaner. Last week she promoted her to housekeeper with an extra 60p an hour on her wages which was hardly merited but life is too short to get upset by these things. Laura had recently become aware that all her friends employed housekeepers, not cleaners, and Anouschka, when she answered the phone in Laura's absence, was prone to saying, 'Hello – is cleaner here'. (Laura knows because sometimes when she's out she rings her own home number anonymously to check that Anouschka hasn't gone home early.) 'Hello – is housekeeper here', clearly has much more of a ring to it. 'Hello, this is the housekeeper

for the Denver-Barrettes,' would, of course, be even better but with Anouschka's finite command of English one must be happy for what one can get.

Normally Anouschka doesn't come in at the weekends but as David, in a gesture of typical thoughtlessness with no consideration at all as to the extra work and worry this is going to cause Laura, has asked this couple to come for drinks at the house this evening prior to going out to a restaurant for dinner, Laura wants Anouschka to do a few extra hours to get the place really looking its best before they arrive. Then Anouschka will also be on hand to help Laura with the final touches to her hair, open the bags of pistachios, and put the drinks glasses in the dishwasher afterwards. Of course, with Anouschka there on a Saturday, this also means that Laura will feel like her house is not her own. Every room she goes in Anouschka will appear and say in her appalling English, 'I clean in here, Meesees David?' like some over-dependent puppy which cannot stay anywhere on its own. Laura has explained, she does not know how often in the time that Anouschka has been working for them, that she is Mrs Denver-Barrette, not Mrs David. 'David is my husband's first name,' Laura explains firmly. 'I am Mrs Denver-Barrette, Barrette with an e.' Anouschka nods sweetly, her curtains of greasy pale brown hair flapping asymmetrically at the sides of her dumpy face. 'Yes, yes,' Anouschka repeats dutifully. 'Meesees DenverBarrettewithany.' Then, five minutes later, it's, 'I clean this, Meesees David?' Perhaps, Laura rationalises generously, whichever Eastern European country it is that Anouschka comes from (Laura never can quite get to grips with the geographies of her cleaners) they still retain some sort of feudal code of conduct whereby married women are addressed by their husband's first name.

Meanwhile, David has ended his call and reappears back in the bedroom with the cup of tea for Laura, and coffee and an orange for him. He knows there's no point in arguing with his

wife. It spoils his day, she always wins, and he's desperate for sex this morning. He needs to relax. Who cares if he has to grovel a bit to get his way. 'Laura darling, please don't be angry. I'm sorry.' At this point neither of them can quite remember what he's apologising for but that doesn't seem to matter. The fact is, he has apologised. Laura peels back the covers to sit up and accept her cup of tea. He feels his penis buck again at the very sight of her. She's wearing that pale blue nightdress he bought her last year. The silk straps are barely clinging to her slender shoulders. Her skin is pale and polished. The front dips very low and just skims her pretty nipples. She's got better tits than an eighteen-year-old. God, he wants her and he wants her now but with Laura you've got to be careful, be patient, bide your time, count to ten and then a hundred. He takes a deep breath.

'I've brought you your tea, darling,' he coos, as she takes the cup. David is never afraid to state the obvious.

'Ah,' says Laura. 'And there was me thinking it was a baby elephant.'

David's eyebrows knot in confusion. Perhaps she's premenstrual. He tries to remember when his advances were last rejected with the time of the month pretext. He smiles nervously and sits on the edge of the bed, placing the FT judiciously over his swollen part.

Laura sips her tea. It's lemongrass. Laura has been very partial to this since their last winter holiday in Phuket. When they got back, she taught David how to cut up the bits of lemongrass to make it for her and he has almost got it right now. 'Mm,' says Laura approvingly as she takes her first sip. Bombs away, thinks David and lets the FT slip to the floor. But just then, sod it, the house phone trills. Laura grabs the receiver, flashing David a triumphant look. Ha! So he's not the only one to receive calls first thing on a Saturday! David, oblivious to all looks and their inferences, gets up miserably to find another orange in the kitchen.

Laura is in a state. This may, just may, be her agent about the show at the gallery. Pleasegodpleasegodpleasegod.

'Hello!' Laura announces loudly, triumphantly.

'Hell low, Meesees David,' comes the breathless reply. 'Is Anouschka.'

Laura feels her heart slip. 'Anouschka,' she sighs.

'Yes?'

'Yes. You are Anouschka. What do you want?'

'I no come today. I' − and this is punctuated by a fit of chesty coughing so violent that Laura can almost see the colour of the phlegm − 'no well.'

'But you were fine yesterday! And the day before!'

'Yes. But I no fine today, Meesees David.' More mucus splatters the phone. Obviously fake. Obviously the lazy cow just wants the day off.

'I leave everything so nice yesterday, Meesees David. I sure is OK for you today.'

Laura sighs. For all that she has been working there for well over three months (something of a record for one of Laura's cleaners), this girl has no idea about the sort of life they lead, of the sort of people they are.

'Look, Anouschka, we cannot live in the past tense. Since yesterday, Mr Denver-Barrette and I have had supper, slept in the bed, used the bathrooms − you know. The place is a mess! We have people coming this evening. Important people − to do with Mr Denver-Barrette's work. Look, Anouschka, the fact is you made a commitment to be here. Do you know what "commitment" means? Do you understand? A commitment is something serious, something you can't just wish away. Why don't you have an extra hour in bed and then come in. Yes? OK? OK. Goodbye, Anouschka.' Best not to give her time to reply, Laura thinks, hanging up brusquely.

It is, of course, unthinkable that Anouschka does not turn up. God knows what state the kitchen is in after David's

attempts to cook breakfast. The whole house reeks of bacon. And the brass door furniture definitely needs further work. Not to mention the silverware. The list is endless.

David in the meantime has returned with his orange. Peeling it takes his mind off his erection. Laura watches him stripping back the pieces with his tongue drooping out at the corner of his mouth, as is his wont when he is concentrating. Maybe his mother told him once this was an endearing habit of his. Laura does not concur. She decides that, if he asks her who it was on the phone, Laura will tell him it was the gallery owner asking for more information on her latest collection of paintings. Laura's agent Isabelle says that the gallery owner is fascinated by her intimate studies of limestone and slate. Pictures within pictures he calls them. He is fascinated and very excited. Laura's agent Isabelle is very excited. Laura is very excited.

It's all very exciting.

David does not ask her who was on the phone.

This is typical of him. He is not curious. He simply does not have an enquiring mind. He assumes that if he should know who it was on the phone, she will tell him. Laura cannot understand what it must be like to have a mind like that, but at least she has come to learn that David does have a mind like that. Since then, life has been considerably easier for both of them. Lower expectations are so much more easily met.

But what I want, Laura reflects sadly, is a man with an enquiring mind. Laura picks up the magazine and pretends to read it.

David, meanwhile, starts eating his orange. Laura never fails to be amazed by the amount David can eat. He is a slim man, naturally, but he eats endlessly. Laura finds this unattractive. Now he is stuffing absurdly large pieces of the moist fruit into his mouth, yellow tooth sinking into orange orange. He begins to chew. Laura watches his jaw working, a curious combination of side to up to down to side. Any minute he's

going to swallow. She knows he is, of course he is. He's eating so he's going to have to swallow.

Munch, munch, munch.

Munch, munch, munch.

He's going to swallow. She knows he is.

It makes Laura feel sick to see him swallow. Hear him swallow. She forces her eyes away from his throat, forces them to study the pattern in the curtains, to inspect the cornicing, the shape of the dressing table, to look anywhere but there, but of course they will not, cannot move from it and she knows, it is only a question of time before she's going to have to watch it, to see the mechanism in action, sound and vision, vision and sound, to endure David swallowing.

Here we go, she thinks. She digs her nails into her palms. One final side to down to up to side and – eugh. It happens. The adam's apple, the swivelling ball in his neck, the unnatural bulge, bloated and hirsute like an unpeeled lychee, swings into action, swells grotesquely and subsides. And – as if that wasn't enough – then there's the noise – the glunk-thud of the masticated pulp as it drops into his oesophagus. And no sooner have the panelled walls and parquet flooring of the bedroom stopped reverberating with the sound of David's hideous swallowing than David lifts another segment of the orange to his lips and the process begins all over again.

Laura is not sure she can stand it.

'Is something wrong?' David asks. A thin line of juice trails down his chin to his cleft, the cleft she had once adored him for.

'You've got a small sticky spot on your chin,' Laura remarks as casually as she can.

He wipes it, cheerfully, with the back of his hand. So now he no longer has a small sticky spot on his chin but a completely sticky chin and a sticky hand. Laura holds her breath and tells herself to calm down. She busies herself choosing another magazine from the selection by her side of the bed

but she knows she's not going to be able to get David's chin out of her mind. That orange juice will only get stickier and start to smell. It'll wipe off on his clothes or, worse, on her when he tries to kiss her. Can't he tell that he's got juice all over his chin? Can't he smell it, feel it on himself, for God's sake? Don't men have feeling in their chins? Laura asks herself in quiet wonder. She was sure that if she had a pool of orange juice congealing around her lower lip she would know about it. Perhaps men just don't. Or perhaps it was just David. Perhaps he was hit on the chin as a child by a cricket ball and had been left with a permanent numbness which merited only pity and compassion and not the repugnance which Laura is experiencing now as she watches the goo solidify, a vibrant dayglo on his face.

She's not going to say anything to him though. She's not. She's going to control herself.

David has a last swig of coffee and makes a half-hearted attempt to suppress a belch behind the back of his hand. This is as ridiculous as people who use toothpicks at the end of their meal behind a cupped hand. It's a disgusting act and if you know it to be so disgusting that you have to proffer up an apologetic hand to cover it, why do it in the first place? The hypocrisy. Laura knows for a fact that if David had just been having a breakfast meeting with one of his business associates he would not have belched at the end of it. She wonders, not for the first time, why he feels the price for fifteen years of marriage is listening to him belch at the end of every meal.

He wants sex. He smiles at her. There's the tooth again.

She turns the page of the magazine which she isn't really reading to convey the sort of insouciance she wants to convey.

This is the moment, David decides. He'll have her now. He veers towards her.

'You might want to give your chin a wipe. That juice has got everywhere.'

'Fuck my chin,' says David, because he's not a total wimp.
He starts attempting to put his face in hers.

'Eurgh. David. Use this.' She gives him a tissue. He doesn't
understand. He looks down between his legs.

'For your chin, you idiot.'

He gives his chin a cursory wipe and then he's back on the
attack.

Laura racks her brain.

'But you always go to the gym on a Saturday morning!' she
cries with what part of her mouth is still available.

Instinctively, Laura clutches onto the bed-head, as if it's
going to be any help. Her mind fumbles for any reason why
David should not penetrate her at this time. If only Anouschka
were coming when she was supposed to be. Laura feels her
insides vibrate with loathing for the stupid girl who by the way
has B.O. and doesn't seem to know or care. (Laura specialises in
random thoughts, especially in moments of stress.)

'Come on, we haven't done it for ages.'

'You mean since Tuesday!'

'Exactly. Ages,' he mumbles through a mouthful of her
neck.

'This is absurd,' she counters, tossing back her hair so it
catches the light.

'Absurd? Why? Because it's Saturday morning and I want
to make love to my wife?'

She looks at him. There is no excuse. No exhaustion (it's
9.30 in the morning), no bleeding (she did that last week), no
appointments, arrangements, engagements. No reason not to,
apart from the disinclination to concede spontaneously to
David's desires.

Laura feels something twang between her thighs. Actually,
if the truth be told, which, in Laura's world, it rarely is, Laura
would love to have sex with her husband. Big sex. She would
like to be jumped on, have her expensive nightdress torn from
her and be heartily shagged by him. But she resents the way he

23

assumes he can get back into bed on a Saturday morning and just expect sex with her. And that resentment means more to Laura, much more, than the twanging longing vibrating in her clitoris.

'It's not like you to miss the gym,' she persists.

'I can go later,' he reasons simply.

He's looking at her. He doesn't seem to mind her reluctance. He doesn't seem to notice it. How can he not, notice it? Like any normal man would. Why doesn't he say 'Well, of course, if you don't feel like it . . .' and she could say, 'Well, actually, since you mention it, I'm not that keen this morning . . .' and it would be resolved. Laura would be able to go, get dressed, get on with her day, physically frustrated but certainly in control.

David, however, is not noticing, and Laura's twanging is getting so bad she can feel a thin line of desire starting to run slowly down one thigh.

'I just need the loo,' she murmurs, edging her way over to her en suite, shutting the door, making space, buying time. She remembers, as she dries herself down, how when she had first met David she would get so damp at the prospect of sex with him she would worry he'd think she was incontinent. Now, fifteen years later, she still fancies him. But she cannot let him know that. Sex is not about wet legs. Sex is about defining territories.

She pees, just so he can hear she has. She does some deep breathing. She goes to sit next to him on the bed.

'How's work?' she says.

'Work?'

'Yes.'

'Same. Fine. Why?'

Why? Oh, because even though I do actually want sex with you, in fact I want sex with you quite a lot, I don't know how that affects the balance of power between us. If you see that I'm enjoying it, what happens to my control?

I'm scared of feeling vulnerable. That's why I always play so hard to get.

This is what Laura doesn't say.

'Why? Hell. I can't win, can I?' she says. 'If I don't ask about work, you complain I never ask. If I do, you bite my head off.'

The stupidity of this argument takes them both by surprise. Asking 'why' cannot constitute the biting off of a head, even by Laura's complex processing of interpreting semantics. And David has never complained to Laura that she never asks about his job. (Which she never does, but she has her reasons. David is a solicitor. Laura is, allegedly, an artist. Laura doesn't do money, David doesn't do colour as an expression of emotion. So there's really no point in her asking, unless one of the partners is having a nervous breakdown or an affair with a PA which sometimes holds her interest for a few minutes.)

She's blown it. David wins. They both know it.

'Take your nightie off,' he grins wickedly. He gets up to close the curtains and she sees his massive erection in all its glory. She feels like the vegetarian who is about to be forced to eat wurstel. With Laura there is always this trauma before she can allow herself to enjoy sex. She feels nausea. She feels hot and cold. But still no excuses come.

She takes off her nightdress and lies back. She catches David's habitual look of wonder. It never surprises her. At 35, Laura knows herself to be still indisputably beautiful. And she knows that this is mainly down to her own good sense in avoiding the whole dreary children thing. Every time they have sex, she can feel David wishing, willing the sperm onwards and upwards. He does not know that his little fish are on a pointless journey. Laura had her fertile regions quietly put out of action a good few years back; she could only spread her hands with sad acceptance of her sad fate whenever friends mustered up the courage to comment on their sad lack of offspring. When this became tedious, Laura happened to mention to her best friend Louella that it was David's sperm which was not

playing ball and after that people stopped commenting. (Louella's chronic sense of indiscretion was not without its uses.)

This means that there have been no children to stretch her perfect pelvis or cause her sleepless nights. But her ongoing loveliness is also, partly, thanks to David. His prowess at earning has provided her with a lifestyle where stress for Laura consists of wondering whether to have the dining room done in a pinky shade of red or a reddy shade of pink. His obvious and absolute devotion has left her free from any emotional anxiety. (Worrying about a mistress can impact horribly on the complexion.)

For all this and more, Laura is grateful to David. But only up to a point. And that point is simply not one where she feels she has to have sex with him any Saturday morning he feels like it. Yes, he's given her everything but the fact remains that Laura is beautiful just because she is, always has been and probably always will be. She is evolutionarily superior. (Which can, of course, be stressful in itself. But Laura has learnt to cope.) He doesn't own her, she doesn't belong to him, and if they have sex when he wants it and he sees how much she enjoys it, where does that leave her?

She looks at him. She wants to sigh, wants to argue, wants to do anything except have it off with her husband. An imperceptible flicker of weary impatience bounces off his green eyes. She knows he's tense about the drinks thing this evening. What had he said to her – something about make or break on a big deal? Except that everything's a big deal for David. His face is looming over her, full of desire. David's features don't look at their best seen from this angle, she reflects.

'All right,' she says. She forces a genuine smile. She lies down and open her legs.

This is surely not so hard for me she keeps telling herself as she prises her thighs apart.

She is doing the deep breathing she learnt with her yoga

instructor. She is wet, wet, wet. David is delighted when he feels it. Yes, she wants to say. But that is not really me. That's not the important part of me – that wet is not who I really am. The important part of me does not want you imposing your will on me first thing on a Saturday morning just because you wake up with a hard-on. The important part of me will let you know when I want sex and not the other way round. The important part of me will have my own show at a gallery in Cork Street!

David is on top of her dribbling into her ear. 'Oh Laura,' he moans. 'Talk to me. Talk to me. Tell me you want me.'

I want you to get on with it, Laura thinks. She's refusing to let herself enjoy it. She wants to, wants to, but she's not going to let herself go, not going to let him see her letting go. He can do what he wants – he does do what he wants – but she's in control if she's not enjoying it. Anyway, David always comes so quickly that if she can just focus for long enough on something vaguely pleasant, it should all be over soon and her body won't have had to get involved at all.

David is grinning at her again. Before, when she first woke up, it was a soppy sort of 'you-look-low-is-there-anything-I-can-do-to-help-but-please-God-don't-say-yes' kind of a smile. Now it's evolved into a smirk of complicity, as if instead of being about to copulate, they're going to stick a kipper in the exhaust of the headmaster's car. Little does David know that whenever he opens his mouth and she sees that bloody tooth Laura feels queasy.

David moves down for his token minute of foreplay. He starts slobbering on her throat and breasts. He is a very wet kisser and she's worried his saliva is going to get into her hair which she had done only yesterday evening so it would look as good as possible for the drinks thing tonight. Yesterday because Rupert, the only man she lets near her hair with a pair of scissors, was going for a romantic weekend to Amsterdam with his boyfriend Edmund. During which time

he hoped to receive a proposal of marriage (after a seven year courtship during which time both of them have remained ardently loyal one to the other apart from Rupert's slip-up three years ago at his sister's wedding about which the whole salon knows everything but Edmund knows nothing, thank God). Even Laura, his favourite client, could not persuade Rupert to postpone his trip so her hair could be done on the Saturday morning itself, rather than the night before. Laura had cajoled, bribed, threatened, even wept but Rupert had said it was now or never with Edmund. After seven years he simply didn't have the energy to start all over again with someone else. He simply couldn't not go. The result of Rupert's selfishness is that Laura's had to sleep the whole of Friday night in a semi-upright position so that her hair, a sophisticated concoction of colour highlight, lift volume and controlled curl, was not overly disturbed. And the result of this – for yes, the butterfly beating its wings in Venezuela can cause an earthquake on the other side of the world – is that Laura has had next to no sleep and is hardly in the mood now to accommodate her husband's over-enthusiastic salivary glands.

The minute concludes and David is now back up, ready for entry. His sweaty face hangs over her. She can smell the bacon and egg on his breath. She can imagine the combination of dead pig and chick making its way down to his gut, where it will coagulate and decompose until nature takes its course.

'What are you thinking about?' David asks tenderly as he positions himself.

Laura hesitates. 'Marriage,' she replies simply.

'Ah,' he says nervously, not knowing if this is quite good or bad. 'Ah,' he repeats, playing for time. Laura can hardly suppress a short gasp of satisfaction. She can feel his penis, rock hard against her thigh. David can hold back no longer. She is the gatekeeper. She has all the power. David must play his cards right. If he asks her another question ('What, exactly,

about marriage, darling?') she might lose patience. If he says 'ah' again he will annoy her (Laura loathes repetition of any kind – two 'ahs' was already pushing it). If he cracks a joke (Laura does not like David's silly jokes) she may just get up and leave. David says nothing. He decides that actions are louder and safer than words.

He reaches down and starts rolling one of her nipples between his thumb and forefinger. Laura, lying there mutely, is not sure why he insists on doing this. She suspects that he has read in a magazine somewhere that this is what women like, or perhaps a friend has told him (although, as Laura can't quite picture David reading that sort of a magazine or indeed having any friends for whom this sort of conversation would be viable, these suspicions are never very satisfying).

Meanwhile David renews his rubbing of his mouth over her neck while fiddling with her mamilla. Laura is quietly impressed. This, she reflects, as he jerks his head up and down, must be what being able to play the piano is like: one brain, two actions. On the other hand, so to speak, as David never shaves on a Saturday until he gets back from the gym this is not as pleasant an experience for her as he might imagine it to be. And Laura's nipple is actually starting to get quite sore. She wants to remind him that she does in fact have another one which would give her first one some respite, but fears that he may interpret it as encouragement on her part. It's a delicate situation. If, however, she doesn't demonstrate some kind of positive response soon this could go on forever. And any more rubbing, Laura fears, will cause her nipples to ignite and self-immolate.

Worst of all: this is doing her hair no good. She gives up.

'Uh-uuuh-uh,' Laura murmurs with as little enthusiasm as she can muster. 'Uh-uuuh-uh,' and twitches imperceptibly to show she is ready for him.

Usually, at Laura's first sign of participation, not to say continued consciousness, David immediately gives up whatever

altruistic act of arousal he is diligently engaged in and flings himself on top of her and in her. Today, instead, he slides the nipple fingers down her body to between her legs where he starts ferreting about like he's looking for a lost widget in a toolbox.

'Uh–uuh–uh,' insists Laura, in case he didn't quite get it the first time. 'Uh–uuuh–uuh.'

But David is on a mission, a mission of exploration which can only end in failure as far as Laura is concerned. 'Uh–uuh–uh,' he responds ardently. 'Uh–uuh–uuuuuh–uh!!'

Finally, when she can stand it no longer, with a minimum of affection and a not total absence of brutality, Laura grabs his penis and guides it firmly and rather too quickly towards the top of her thighs.

'Ooh,' says David. Laura is not sure if this is pleasure or pain or whether she quite cares either way. Once inside her, feeling his duty done, David starts to enjoy himself. She sees his nose, looking enormous from where she is, going up/down, up/down rhythmically above her face.

He's happy at last. He smiles at her.

'Don't smile,' she says quickly.

'Don't smile?'

'No.'

David gets the message and starts pumping hard. Boy oh boy does he need this release after all the stress of sorting out the deal over the past few days.

He starts panting. David always pants when he's about to come. Laura is not sure why because it's not an attractive sound. If he broke into a bark she would not be at all surprised. She decides to lie there, just lie there, and make no sound or movement and just wait for it all to be over. This is her last vestige of control and she's going to use it well. She closes her eyes and lets her mind wander to a beautiful non-specific place where she is being admired by all around her.

Meanwhile, somewhere way up in another galaxy above her, David is pushing, pushing for all he's worth. He's almost there. This won't last long but Laura never seems to mind so why should he. She's not reacting at all; in fact she's showing so little sign of life that David is worried that she might have had a heart attack or something else sufficiently serious that she has simply died underneath him while he's been pumping away and been too polite to mention it. That would not be Laura's style, but you never know. He tries to put the worry out of his mind but he can't. It's putting him off his stride. He needs to stop and check she is still alive but if he stops, that's it, he'll lose his erection. David knows himself – he cannot stop at this stage. Jesus, what's he going to do? He makes some more noises in the hope that she will reciprocate and reassure him of her continued existence. Nothing. Her eyes are shut but not in a shut-in-ecstasy kind of a way, more a I-may-be-dead kind of a way. He's starting to panic and if he panics he'll droop. He must stop the panic, stop it now.

So he does something stupid.

He asks Laura to tell him she loves him.

'Uh-uh-uuh. Tell me you love me, Laura. Tell me you love me. I need to hear you say you love me.'

What? What! No. No, no, no. This is all too much for Laura. So now he wants sex and emotional support? Hello? What is she – a helpline as well now?

She pulls him straight out. David whimpers in agony.

'David – tell me: what do you want – sex or analysis?'

'But I only asked you . . .'

'I know what you asked me. So now as well as your wife, housekeeper, social secretary, cook, florist, interior decorator and purveyor of sexual favours, you also want me to be your counsellor? I'm sorry, but even I have limits.' She gets out of bed and retreats to the bathroom for the sulk of all sulks.

She looks at herself in the highly-illuminated bathroom

mirror. She looks lovely. She is in control. She can sanction sex, she can veto it. She is in control.

'I'm sorry,' he calls after her.

Yes, she's not surprised he's sorry. But it's too late. This time it really is too late. She looks harder at her face. And, to her horror, she sees that the beauty is not as beautiful as it might be. It is wan, pale, as bleached as the magnificent marble surround. My God, Laura thinks, that's me. This is me. This pale, dissatisfied, unhappy face is me.

And all at once, as if by reflex, the knowledge enters her head that she is going to leave David, leave him today. She just can't stand it any more. This perfect marriage of theirs, admired by friends, envied by enemies, it's no longer what she wants. She is simply not content with her life and therefore with him. Nothing is quite the way Laura exactly wants it to be. Nothing has been right ever since she woke up this morning. The tooth, the saliva, the toast, the mobile phone calls, the need to be loved. None of it is the way it would be if it were perfect.

Their marriage is over.

She can only take so much.

CHAPTER 2

Now that Laura has made the decision, it all seems so obvious. Everything that's wrong in her life is David's fault and everything will be so much better without him. She'll be like a new woman. Free, uninhibited, outgoing, alert, popular, successful. Happy.

Why didn't she think of this before?

The trouble with David is that he just doesn't appreciate her. And he's holding her back. There's no point in stressing herself out, wasting hours of her time trying to understand what the problem is. He is the problem. People think life is so complicated, so full of ambivalence. Actually, if enough honesty and discipline are applied, life is fairly straightforward: you just need to identify the problem and the solution to it.

David is the problem. She needs to leave him. Simple.

All she has to do now is to find the words to tell him. She practises her farewell speech in the mirror.

'Look, David, I feel you don't appreciate me and you're holding me back. Last month I went on a diet to lose the extra two pounds I put on over the holiday. I ate only egg white and organic rice cakes and lost the weight in three days. You didn't notice. Not at all. Every week I arrange for new floral displays around the house, carefully chosen to reflect the season, or to accent colours in our interior decor, and you never make any comment. At best you say 'that's nice'. Last week, I arranged for our dining room chairs to be completely reupholstered in a fresher shade of duck-egg blue, which involved spending many hours with the interior designer, first in the house then in I don't know how many fabric showrooms and you said nothing. I'm beginning to wonder: what is the point of it all? Why do I bother? You come home from work so exhausted that you hardly speak

to me. I, who have (or should that be who has? Laura is not sure) been waiting for you all day, making sure everything looks lovely for you, making sure the bloody cleaner hoovers everywhere, not just the bits you can see, and remembers to wipe under the bathroom basins as well as round them, and you just don't care!'

It is at this point Laura makes a new decision, supplementary to her last. If, when she's gone back into the bedroom and said all this, David says, 'Oh my darling, I'm so sorry, I promise I'll change and I'll do it now', (or any combination of words to that effect), she'll stay with him. If he says, 'What are you on about, Laura, you know I love you, I do my best, I know that's not always good enough for you but it's all I can offer, I do appreciate you, maybe I don't always show it etc etc etc', (she's heard it all before), then she'll go.

She's not unreasonable. She's prepared to give him one last chance.

Having come to this suitable agreement with her reflection, Laura adds a last coat of mascara – major life-altering scenes are best played out in full make-up – and walks back into the bedroom.

She begins. 'Look, David, I feel you don't appreciate me. Last month I went on a diet . . .'

But there is no point.

David, exhausted, sore and cut off in his prime, with the grimace of the unfulfilled hovering on his lips, has fallen fast asleep.

*

That's it. If David can't be bothered to stay awake for her, she's definitely going to go – get out of the house before he wakes up and before Anouschka arrives. She'll just grab some clothes, and go. Imagine his horror when he wakes up and she isn't there! Yes. This is absolutely the best idea. To shock him into realising how much harm he's done her. On the other hand, however, perhaps she should stay and for the good of

her own soul – and his! – confront him and tell him that it's all over and exactly why it's all over before she goes.

That would also give her time to try on those trousers again.

She can't decide what to do. Then she remembers the drinks planned for that evening, with the business partner and his wife. She remembers what David told her: that if all goes well this evening, it could be worth millions. For him. For her. Perhaps best to wait then. Break the news after the drinks. Yes. That's what she'll do. She'll take her time, over the course of the day, to plan her departure. That patience will pay off handsomely. What's more, if she goes now, their guests won't get to see her hairdo. It would be a shame to waste such a lovely hairdo.

<div align="center">*</div>

Laura hears a key in the door.

This must be Anouschka who is no longer the cleaner but now the housekeeper.

Thank God. Anouschka may have the mouth odour of a cheeseboard but for one horrible moment Laura was worried she may have to do her own cleaning.

Anouschka presents herself in the doorframe, pale and thin. Laura is also thin, but she is rich-thin. It costs Laura (David) thousands each year in specialist victuals, customised exercise regimes and lymph-draining treatments to keep Laura the shape she is. Anouschka is merely thin because she often does not eat. Anouschka's bones shine through her grey skin. Her eyes look too big for her head. It occurs to Laura that Anouschka really does nothing to add to the aesthetic appeal of the house where every fabric, every ornament has been relentlessly considered and coordinated. But then she does clean well and life is all about compromise as Laura, who lives with David, knows only too well.

'I so sorry I so late, Meesees David.' Anouschka is trembling so violently at the prospect of her employer's wrath that

she can hardly control her lips sufficiently to stammer her apology.

'Don't they have verbs in the Urals?' Laura asks herself silently, not for the first time. She takes one step back to be out of the line of fire of Anouschka's breath.

'Oh! Don't worry! Really! Don't worry at all. These things happen! Good heavens! I quite understand!' she cries.

This show of bonhomie scares Anouschka so much she feels her knees buckle. Meesees David has never understood anything before, not a broken ashtray, a missed fleck of dust on a carpet, nothing.

Anouschka is wearing a brittle, cheap scent which makes Laura's stomach heave each time there is a movement of air. She has spoken to Anouschka, in the past, about Anouschka's problem with perspiration, even going to the effort of buying her an anti-perspirant and demonstrating to her how to use it, explaining that, with all the exertion of vigorous cleaning, it is inevitable that there should be body odour and how, with the robust application of a good deodorant, much of it was easily preventable. But instead of using the deodorant, Anouschka took it into her head to douse herself with this vile perfume. Laura sighs. She hasn't the energy now to explain that the smell of this cheap perfume is worse than the B.O. She needs the cleaning done.

'How nice your hair looks today, Anouschka. Have you done anything special to it?'

They both survey Anouschka's locks of rich mouse brown.

'Yes. I wash them.'

'Them?'

'My hairs.'

'No, it's hair. Hair, in English, is in the singular unless it's . . . Never mind.'

Suddenly Laura feels she really just can't cope any more. Is this what her life has become? A loveless marriage and an illiterate cleaner?

Jesus.

Then Laura does what she hasn't done for a long, long time. She starts to cry. Soft, gentle, attractive sobs.

Anouschka is terrified. It's clearly something she's done wrong. But what? What?

'I so sorry, Meesees David,' Anouschka whines.

'Oh, it doesn't matter,' says Laura. 'It's just that my life is, well, very hard. Do you understand? Very hard.'

Anouschka isn't sure what to say. There is an uneasy silence. 'I do kitchen floor now?' she offers sympathetically.

Laura nods heroically. 'No hoovering just yet, though, Mr Denver-Barrette is still asleep.' The words falter on her lips. More tears fall. It's unbelievable. Even at her most distressed, her most vulnerable, all Laura can think about is others.

★

Out in the hall where Laura is checking the effect of her upset on her mascara, the phone demands her.

It's Louella, Laura's best friend. Louella is a woman as attractive as her, almost as blonde and nearly as slim. Anything less wouldn't be fair. As soon as Laura hears Louella's voice, actually not her voice but rather her raucous smoker's cough – Louella always has a coughing fit when she makes or takes a call, it's a sort of nervous condition which comes with the territory that is Louella – Laura knows she will, she must tell her friend.

'I have something to tell you, Louella,' Laura announces. 'I'm ending my marriage.'

Louella, who has only just recovered from her 'it's me' coughing fit, surrenders to an even more violent attack of choking. Laura understands. It must come as a surprise. The choking abates to a series of gasps. 'I know, I know,' Laura murmurs wearily. Louella is not taking this well. Louella gasps again – and there is something in the tone of this last exhalation that indicates to Laura this is not a gasp of astonishment but rather a huff of irritation.

'This is rather inconsiderate of you, darling. I rang you. I rang you to tell you about a problem I'm having. I rather think you might hear my problem out before you burden me with yours.'

'Oh,' Laura says. 'I'm sorry. Of course.'

'You are not going to believe this,' Louella wails. This is probably right: Louella is prone to hyperbole. 'I mean, really Laura, you are not,' Louella insists to quell all silent protestations to the contrary. Louella proceeds to tell Laura about an unpleasant incident which has taken place in her antique shop earlier that day. A customer had placed a large order for a walnut cabinet worth a good few thousand pounds. Then, on her way out of the shop, the woman had knocked over a small Sevres dish worth a good few hundred and broken it. Louella had told the woman she would have to pay for it. The woman said it had been an accident and that it was Louella's fault for placing the plate so near the door. Louella told her it was her shop and she would put her pieces where she bloody well chose to and if the woman was incapable of conducting herself properly in a high-class antiques emporium perhaps she'd better stick to the Portobello Road. At this the woman said that if Louella persisted with her demand not only would she cancel her order for the furniture, but she would also, with the help of her barrister husband, sue Louella for all she was worth.

'What would she sue you for though?'

'I just told you! All that I am worth!'

'Yes, but why would she sue you? What for? She was the one who broke the plate.'

There is a pause.

'I don't know,' Louella replies eventually. 'I was upset. I didn't ask. Would you ask David what he thinks?'

Laura ignores this.

'So what happened next?' Laura moves the story on politely.

'Well that's just it, darling. Nothing. She left the shop. So

now I don't know what to do. Shall I carry on with the order? Shall I send her a bill for the broken plate? Or shall I just do nothing and see what happens? What do you think?'

I don't give a toss, Laura thinks.

'Send her a letter asking her if she wants to continue with the order and charge her only the cost price on the plate. It's a compromise which hopefully won't incur her legal wrath and save you the order.'

'Mmm,' Louella reflects. 'I don't know if that will work. She kept harping on about her moral rights. I wanted to tell her she was too short to merit moral rights but I held my tongue. You know how I feel about women who are five foot five and under. Anyway, thanks for the advice, but it's really David's brain I wanted to pick. Have a chat with him about it, would you, darling, and give me a quick call back. Would appreciate it. Bye, darling.'

'Wait! Wait! I want to tell you more about my decision to leave David.'

'Oh. Of course,' Louella mutters reluctantly.

Laura pauses. What else, actually, is there to say? There is a silence. Louella hates silences. She hates short women, fat women, navy and cerise together in one outfit, handbags with writing on the sides and silences. Spend enough time with Louella and a clear personality profile soon builds up.

'Have you told anyone else you're leaving him?' Louella asks to break the silence.

'No.'

'Can I tell anyone else?'

'No!'

'Oh.'

'Look, angel, I can hear you're upset. But when you say it's over, it's not really is it? Every marriage has it peaks and troughs. This is merely one of the troughs. You just need to sit tight and wait for a peak to come along. Buy yourself a new dress or something, take your mind off it.'

'You're not taking me seriously,' Laura whispers angrily.

'No, of course I'm not,' Louella barks back. 'You're married to one of the nicest men I know. He adores you. He earns a fortune. He keeps you in a style to which you have enthusiastically become accustomed. Why on earth would you want to leave him? He's not cheating on you, beating you or expecting you to dress up like Cat Woman at bedtime,' Louella concludes with some bitterness (her first husband could only reach full orgasm if he entered her as a traffic warden). 'Why, exactly, do you want to end it?'

This question seems fair enough. Laura wants to end fifteen years of marriage to David just because she's had enough of him. Is that a good enough reason? Laura takes a moment to think. She's aware that this moment will be setting Louella's teeth on edge. Not only does she hate silences and this is already the second in a very short space of time but it's a Saturday and, according to legend, Louella's shop is always at its busiest on a Saturday. Well damn it all, Laura reckons. Her marriage is worth a few moments silence and the patience of a few customers. So she thinks – one second, two seconds, three seconds. And she decides.

'Simply because I've had enough of him. That's got to be as good a reason as any, hasn't it? It's certainly good enough for me and as I'm the wife, i.e. the only interested party (apart from David), it'll have to do. I've had enough of him. Does there have to be a better reason?'

Louella groans.

'No, I mean it,' Laura insists. 'What if I just don't want to be married to him any more?'

'For no reason? To cause him – and yourself – all that hurt, for no reason? Are you on Prozac? You're not menopausal yet, are you?'

What can Laura do? How can she explain, even to Louella, that she just can't cope with one more day of life With David? That she can hardly put into words, even to herself,

how she has become allergic to David, the sound of him, the smell of him, the very sight of him?

'Last time I saw you,' Louella continued, 'you spent half an hour telling me how he was driving you insane because he didn't rinse the bits of cereal out of the waste disposal unit when he tipped his half-empty bowl of cereal down it. Half an hour, Laura. And I didn't say anything at the time but all the while you were talking I was thinking – all we're talking about here is a half-empty bowl of breakfast cereal, about three, maybe four bits of cornflake attached to the side of the waste disposal, bits of cornflake which your cleaner is going to wash off for you anyway, –'

'– but it's the principle –'

'– be quiet, and you're telling me how that's indicative of his complete disregard for your feelings, how you've told him maybe a hundred times to rinse it out straight away with the cold tap so it doesn't stick to the side and how he says he will but he never does and how if he doesn't listen to you about that it means he's never listening to you about anything!'

Louella pauses here for breath and a heavy sigh which she hopes will convey definitively to Laura the utter ridiculousness of it all.

'I mean,' she continues, 'if you were to leave him, what exactly would you say to him?'

'I'd say – David, it's over.'

'OK. And then what?'

'Then what?'

'He'd say – "Oh my God Laura. Oh my God. Why?" ' Louella conveys this with rather more drama than Laura thinks is strictly necessary but she's prepared to play along. She can see that Louella, her best friend, is only trying to help.

'Why?'

'Yes. Why? You can't say – oh because I've had it, I mean I've really had it this time with the way you leave bits of cornflake in the waste disposal. Can you? Can you imagine

going to your divorce lawyer, standing up in court and saying that?'

'What about you? You told me once that you had to get rid of Peter, one of the boyfriends you had between your second husband and your third, because he made a funny clicking sound with his tongue once every thirteen seconds and you ended up locking yourself in the bathroom so you wouldn't hear it.'

'Yes – but that's hardly comparable.'

'Why not?

'Because he was only a boyfriend. And he was unemployed. He wasn't rich like David, for God's sake.' Laura waits for Louella to laugh, to show this is meant as a joke. Louella doesn't laugh. Louella says, 'I think you'll regret this the moment you've done it. You're going to lose everything. Your security, your house, your friends . . .'

'I wouldn't go that far. I think most of our friends like me for myself, not just because I'm David's wife, don't you?'

Louella says nothing.

'Sorry!' Laura cries. 'Is the fact you're not answering me meant to be your way of telling me that in fact you think people do only like me because I'm David's wife?'

'No – it's because I'm watching some bloody woman who has just let her dog crap on the pavement right outside my shop. Right outside! People'll be treading it into my parquet flooring. I've a good mind to call the police. In fact I think I will. Must go.' She tells Laura to call her if there is anything, anything she can do for her and plonks down the phone.

Almost immediately the phone rings again. Louella. 'Just a quick thought. If you do decide to leave David, can you remember to ask him about my customer problem thing first? Thanks. Love. Bye.'

Laura reflects on the call. She knows that Louella thinks she is mad, and that her reasons for wanting to leave David are petty. Only now is Laura beginning to realise how brave and

utterly courageous she is to be leaving a man like David simply because of her principles. Louella just doesn't have Laura's ethics. All at once Laura starts to feel giddy with her own vertiginous values, with the altitude of her own integrity.

In fact Laura wants to cry again. The moment feels right for her to cry, but just in time she remembers her make-up and desists. Cornflakes in the waste disposal. Crazy perhaps. Petty? Yes, even petty. But that's where love is. In the little things. If David can't understand, even now, even after all the times she's asked him to, that it's important for her that he shows enough consideration to wash down the waste disposal unit after he's tipped the contents of his cereal bowl into it, then what hope is there?

All Laura knows is that she's had enough. Why can't she put her finger on quite what it is about him, cornflakes aside, that she's had enough of? Maybe it's just boredom. Fifteen years is a long time. A long time to see the same man, have the same conversations, look at the same face (and tooth), live with the same habits day in, day out. If someone made you eat the same food every day for fifteen years that would be considered cruelty, but for some reason you're expected to have to put up with the same man.

Nevertheless, in one way Louella is right. Even if it's valid enough for her, Laura cannot confront David, her family and his, all their friends, her agent, her hairdresser and tell them the reason she's leaving him is because she's had enough of him generally and specifically the way he never rinses the cornflakes out.

If she is going to leave David, she needs a good reason to do so.

Leaving him would be easy. Saying why was going to be hard.

There must be a reason why.

Now she just has to find out what it is.

*

'I'm ending my marriage.'
'I've had enough of him.'

Was that 'ending' or 'mending'? To have had enough of someone – does that mean being fed up with them or some state of sexual satisfaction? Anouschka is not sure. She was trying to focus on cleaning the already immaculate kitchen floor, trying so hard not to listen to Meesees David's conversation on the telephone in the hall but she couldn't help it. She heard every word. Understood almost half of them. And now her poor heart is beating so fast that she can hardly stand up straight and needs to get herself a glass of water (from the tap, not the mineral water from the fridge – Meesees David has explained the difference) before she keels over.

The more she thinks about it, the more Anouschka knows she cannot lie to herself. She has understood perfectly well. Meesees David is leaving Meester David. Her grandmother always told her, 'Dzbry vynzy bisch mzbet vyznay.' This means – 'Be careful of your dreams in case they come true'.

After so many weeks of hoping and praying, Meester David is to be hers. From the very first moment she saw him, that Saturday eleven weeks before, she knew he was her 'vzyshnzy-shka' (literally: 'life destiny man'). That's the only reason she'd stuck with this awful job, with the horrible Meesees David accusing her of using too much bleach in the bathroom and emptying the hoover bags before they were really full. She could put up with anything if it meant seeing Meester David. She saw him maybe only once or twice a week, on days when Meesees David had asked her to stay late to turn out a shoe cupboard or polish up the entire canteen of silver cutlery. Even then, these were fleeting moments as he walked past on his way in from work. Usually he said nothing to her, as if she were not there. Once, when he almost tripped over her while she was cleaning the underneath of a chest of drawers in the bedroom, he said sorry and gave her a half-smile. Such

a beautiful smile. She didn't reply. She didn't need words. Electricity is a silent force.

Recently, the passion had been getting stronger and stronger. All Anouschka had to do was see the back of his head as he walked out of a room or see his cuff links on a table and she felt faint. Last week she had actually stolen one of his socks from the washing pile and taken it back to her little bedsit in Queensway and cuddled it all night. She was so worried about her obsession that when Meesees David insisted she come in today, on a Saturday, when she knew he would be there all the time, Anouschka had told her she was ill. She was no longer sure of her own strength to resist him.

Now, it seems, that strength is not necessary. There had been a reason God had wanted Anouschka to be here today – to hear the words from Meesees David's own mouth. She no longer wants her husband. Meester David is a free man. Anouschka is trembling from head to toe and all the bits in-between.

At that moment the doorbell rings. It takes Anouschka a few moments to remember that she, now, in her new and improved capacity of housekeeper is expected to open the door when she is there. She tries desperately to recall the script that she and Meesees David have practised together.

'Welcome to DenverBarrette's house.' Or was it, 'Welcome to DenverBarrette's home?' Her palms sweat so feverishly as she struggles to remember which version Meesees David decided in the end had a better ring to it that Anouschka can hardly grip the door handle to open it.

'Welcome to DenverBarrettehousehome!' she announces energetically. (Even as the words come out Anouschka remembers it was DenverBarrettehouse that Laura wanted her to say, not home. She's happy. She knows for next time.)

'Oh do shut up,' says the woman, shoving Anouschka to one side.

Laura, who has been hovering in the drawing room to let Anouschka greet guests in the manner they have rehearsed,

recoils in horror as her mother charges in. She was just about to settle down for a quiet half-hour with her interior design magazines – God knows she never seems to have the time during the week.

'Guests are supposed to wait for me in the hall,' Laura mutters irritably.

'Don't be a fool. I am your mother!' Lydia proclaims, not for the first time.

The two women stand and inspect each other. Laura sees a 73 year old woman with cropped hair, dyed an acidic shade of red, in a red leather miniskirt which barely covers her underwear, pink silk shirt and black thigh-high boots. She is overwhelmed by an instinctive and familiar longing for a mum called Jane in specs and pleated paisley. She sees herself being scrutinised, evaluated, partially accepted, primarily rejected. Laura reminds herself that, at 35, she has no longer any need to feel agitated in her mother's presence. She reminds herself of this several times before she can stand it no longer and returns wordlessly to the drawing room to the safety of the sofa.

Lydia forces herself to cope with her daughter's hostile manner. Thank God for that gin she had for breakfast otherwise she really would not be able to. Why Laura is quite as impossibly frosty as she is, Lydia cannot imagine. When she thinks of all that she has sacrificed to be a mother, of all the postcards she would send to Laura's boarding school during term-time and how carefully she would vet the nannies in whose care she left Laura during the holidays . . . Lydia wonders now why she bothered. Anyway, over time she has learnt to be impervious to her daughter's uncongenial ways. And she is here today on a mission: last time she saw her daughter Laura was wearing a rather nice ivory chiffon blouse which Lydia fancies wearing to a dinner she is attending tonight. She will go to Laura's wardrobes and find the blouse. If her daughter is incapable of affection, the least she can do is provide her with a nice top for the evening.

Yes. Because Lydia must now enjoy every day as if it is her last. She only went to see her GP to complain of a weak bladder. First, he told her this was to be expected at her age, which was a pity because she was just on the point of inviting him round for a dinner à deux and this remark rather spoilt the moment. Then – the bombshell: that if she did not cut down on her drinking it would kill her. Delivered just like that, with the stark and callous brevity typical of a thirtysomething who has no concept of the anguish of mortality. Knowing she is imminently to die is, of course, very painful for Lydia. She had hoped to share some of this pain with her daughter today, but looking now at Laura's set features Lydia realises that there is no hope of that. She is going to have to carry the cross of this death sentence on her own.

(But when Lydia is dead, how Laura will suffer! Her guilt will consume her! Her remorse will torment her!)

Lydia follows Laura and Anouschka follows Lydia into the drawing room. Anouschka is all primed to offer them coffee (coffee before 12, tea before 5, and wine thereafter) but before she has a chance to form the words, 'is now good coffee please?' she hears Meesees David's mother announcing, 'There is something, something wrong, is there not, my darling?' and the double doors of the drawing room are shut firmly in her face.

Anouschka's heart leaps. This is her destiny unfolding. She tiptoes up the stairs, along the corridor, into the heavily curtained bedroom. Meester David is asleep, his head thrown back, his mouth open, snoring. It is the sound of angels. Anouschka takes off her clothes, gently lifts the edge of the bedclothes and creeps in beside him. If she were to die now, she would not mind. She wishes she could die now. Perhaps she would die – die of happiness. The bed is warm, soft and cosy. She snuggles deeper down under the heavy covers. It's now or never, she decides. Meesees David doesn't want him. He belongs to her, only her, his Anouschkina.

Slowly, gently, deftly she moves her hand down towards Meester David's thighs.

'Dzbry vynzy bisch mzbet vyznay.'

<center>*</center>

'There is something, something wrong, is there not, my darling?'

Lydia likes repeating herself. And why not. What she has to say is so good it's a waste to say it only the once. Laura, meanwhile, remains silent. Like all of her mother's questions, this is one which requires not even a response, much less an answer. Laura hangs her head. Her mother is a scary woman. Not so much because she is so relentlessly critical, so heartlessly insensitive and so ruthlessly intransigent – but because she is all of those things and she is always right.

Lydia flings herself expansively onto the sofa, cerise silk layers flapping. 'Of course, my darling, you know your moon is in Saturn. I have warned you about this before. We have to expect the worst.'

Since her earliest years her mother has been warning Laura about her astrological chart which had her cast as impetuous and capricious at birth, with a catastrophic trine, not to mention her fifth house in Taurus.

'Where is David, by the way?'

'David? Oh, yes, still asleep, he was very –' Laura begins enthusiastically, hoping against hope that the inevitable zodiacal analysis might yet be circumvented.

'So?' Lydia continues stoically, 'how bad is it? I am sitting at home, I am busy, of course, working to a deadline, always deadlines governing my life, tormenting me, but the dream I have had last night is pounding, pounding in my head.' Lydia bangs her forehead, presumably to show Laura what pounding means, or indeed where her head resides. 'And you know what I have dreamt? Of you; and you are in the desert, buried to your knees, only your knees, in the sand. We can talk about why to the knees later. And you are sick, dehydrated, the sand

<center>50</center>

is on your tongue, and in your eyes. And a man – I can only assume this man is David – rides past on a stallion – chestnut, proud, magnificent. The man alights from his horse and offers you his water bottle. "Take it!" he demands. But you turn away. The winds blow over you and when you turn your face back to him again, you have no mouth, no nose. Only your eyes, now no longer seeing but encrusted completely in the searing sand. The man returns slowly to his horse. He knows there is nothing to be done. He rides away.'

Lydia's dream-visions usually have as the basis of their plot and location whatever film was on TV the night before but few are those who would be brave enough to mention this. Anyway, there is no point. Lydia is a certified sex psychotherapist so any criticism you care to make of her she can immediately re-assign to some defect in your own psychosexual infrastructure.

'So! What do you think? What would you think if you were a mother and were to dream that about your daughter?' (The chance for a little dig at Laura's childlessness is never passed by. Even though Lydia, unmarried, got pregnant with Laura by accident and spent the first twenty years of Laura's life complaining to her about it, she has spent the next fifteen intimating to Laura the state of superiority which motherhood confers.)

'Lydia, this is a bad time.'

'I know, darling! That is why I am here!'

'No, I mean, just now, right now is a bad time. Generally it's not, I mean everything's fine.'

Lydia looks at Laura with that look to show her she is not afraid to let Laura see how puzzled she is by this remark. She pats the seat next to her. 'You are in denial, sweetheart. How many times do I have to tell you – don't be afraid of your shadow side! Befriend it! Embrace it! Incorporate it!' she cries, the veins bulging in the taut, restyled skin on her forehead.

'Would you like coffee, Lydia? I can ask Anouschka to . . .' Laura murmurs miserably.

Lydia shakes her head. 'This is no good, Laura. I understand what you are doing.'

'I'm offering you a cup of coffee.'

'No, you are pushing me away, you are denying your shadow side! Why the knees, Laura? Why to the knees only are you buried in the sand?' Lydia seems to think that a con-voluted syntax makes her sound more interesting, more mys-tical. Her clients love it. The weirder her grammar, the more she can charge for a consultation.

'You're right. The knees,' Laura concurs wearily. 'I just need a moment to think about it. Just give me a moment to ask the cl–housekeeper to put the coffee on and I'm going to focus on my knees.'

'And I'll make a wee-wee!' Lydia trills in triumph. Laura disappears in the direction of the kitchen. Lydia pours herself a nip of a drink from the fine selection in the cabinet then heads for Laura's dressing-room. As she creeps through the bedroom she realises that this is going to be more of a chal-lenge than she thought. The curtains are all still drawn and David, she remembers, is still in bed. She tiptoes past. David is snoring loudly. Actually it is more grunting than snoring. Not very pleasant grunting to tell the truth. Once inside the dressing-room it requires some careful fumbling to locate the blouse. And all through her tactile inspection of Laura's extensive range of designer couture Lydia is thinking to her-self: these noises David is making, they are really not very nice. Perhaps he is unwell? Screwing up 146 years collective worth of eyeball she strains to see through the half-open dressing-room door, though the half-light, to the bed. She identifies the brown curls of her son-in-law. Then she sees another head. And she realises that the first head appears to be making enthusiastic love to the second head in the bed.

'Oh dear,' thinks Lydia. Discretion itself, she manages to

hold on to her priorities. She slips the blouse off its padded hanger in Laura's wardrobe and stuffs it into her bag. She waits until David's head is lost between the other head's legs – her experience in this area tells Lydia it is unlikely a man will notice much at that angle – and then slinks back past them and away.

★

Laura has been obliged to arrange the coffee cups on the tray herself, bloody Anouschka having disappeared to some unknown corner of the house as was her wont. Maybe it was an Eastern European thing, this need to scuttle away to secret places all the time. She was just about to set off to find her, and her wretched mother come to that, who was no doubt in the process of rifling through the contents of Laura's dressing-room yet again, when the phone demands her.

'Crisis over,' Louella gasps exultantly. 'Not only did the woman have a poop scoop with her but she came in and bought that painting of a dead rabbit that's been clogging up the second window in the shop for months for three thousand pounds. Just goes to show you, doesn't it?'

'Shows you what?'

'It's an expression, Laura, a turn of phrase. Really, my darling, you can be quite pedantic at times.'

'So you didn't call the police?'

'Call the police? I'd have scooped the stuff up in my bare hands to get rid of that painting. One of those purchases you make and you regret even before the chap's brought down his hammer. And, you're not going to believe this,' Louella insists, 'but I've just had that other woman in the shop again. The one who smashed the plate.'

'Look, Louella, I can't talk now. I've got my mother here.'

'How nice. And how lucky for you, still to have your mother. I often wonder how different my life would've been if my own mother was still around. Very different, I suspect. Anyway, mustn't dwell. Mustn't mope. Moping brings on the frown lines! How is Lydia, by the way? Last time I saw her she

was sucking the air out of some young lawyer at one of your drinks things. Remarkable that a women of her age should still have the desire for it. Did they go all the way, do you know? Does she confide in you with that sort of thing?'

'No, thank God.'

'Mind you, I had an aunt who ran 3 lovers and a husband well into her eighties. Marvellous. Of course, at that age one must be very dry but my aunt would always say that selecting the lubricant was always half the fun. How is sex currently with David anyway?'

'How is sex with David? What sort of a question is that? I've told you, I'm leaving him!'

'So when did you last do it?'

'God I don't know . . .'

'When?'

'Um – this morning actually.'

'This morning! So –'

'Yes, yes, but we didn't do it properly. I mean, I cut him short.'

'Why?'

'He wanted me to tell him that I loved him and I thought, Jesus, I'm having sex with you aren't I? How much more do you want?'

'Oh, I know, I know. I don't care for the ones who want chitchat while you're doing it either. And who want to drag it out endlessly with all that touchy-feely stuff. A nice short sharp shag is always the best. Get it over and done with and on with the day, that's what I always say. Talking of which, that's exactly what I must do now. It is Saturday, Laura darling, you do understand. Saturday's my busy day. You have that wonderful husband of yours to earn oodles of money for you but as for the rest of us, well, life is lived a bit nearer the coalface! I must be going now.'

'Of course,' Laura agrees irritably, 'go. And might I just remind you that it was you who rang me so –'

'Wait! I almost forgot! That woman! We've been so busy

talking about you that I'd forgotten I was in the middle of something important about me. I must finish telling you the story about her. So she walks in, bold as brass, and says she wants to apologise – apologise! Can you believe it! – About the incident earlier. It turns out she'd just found out her husband was having an affair and was shopping her way through her pain. She said her plan was going to get him back where it hurt him most – through his bank account. And suddenly I warmed to her, you know. She said she'd booked a flight to Paris to leave this evening – she was going to stay at The Georges V and spend herself silly. Oh, you don't want to bother with Paris, I say. Milan is the only real place to shop. Is it, is it really, she says? Why yes, I say, I was there only two weeks ago and there was the most fabulous grey dress in the very first shop I walked into. I bought it there and then and wore it to that charity bash I went to last week. Grey, she says. Your colouring can handle grey but it makes me look so washed out. Well, she had a point actually, but I said nothing, customer always right and all that. Did you wear your hair up or down? she asked. What for? I say. Oh, for the charity thing, she says. Oh, up, definitely up, I say. That kind of thing, got to pull out all the stops, you know. She understood entirely. Shoes? she asked. You see, I do like a woman who understands the importance of shoes. Oh, I say, there's this marvellous little man off the Fulham Road who dyes my shoes for me and got a little silk pair the perfect grey to match. All a bit of a rush and I had to pay through the nose but the end justifies the means. Anyway, finally I managed to persuade her about Milan and so we ended up sort of agreeing we'd go together. I hope you don't mind, darling. I know we always said we'd go to Milan together, but this is a good time for me, the shop's quiet and you've got David.'

'Why do you keep banging on about David? I've told you, Louella. I'm leaving him.'

'Yes, you did, darling, of course you did. But that's going to

take ages, isn't it? What with the lawyers and everything to sort out and in the meantime the shops in Milan will have sold out of all the best stuff for the new season! Anyway, I'll send you a postcard, and we'll talk before I go. And don't worry, you don't need to ask him about this woman suing me. I mean, if she and I are going to be best chums now – I mean, obviously not best chums in the way that you and I are, of course, Laura darling, but you know what I mean. Anyway, you needn't bother David about it. OK? Love you lots. Byee.'

By the time Louella has decided the call is definitively over, Laura's mother is back, looking pale. Pale with the guilt of swiping whatever item of Laura's it is she has bulging in her leather handbag, Laura presumes. Although it is true that Laura always gets the stuff back, perhaps a little stained and generally worse for wear but almost as good as new after Anouschka has taken it to the dry-cleaners, she somehow never fancies wearing it again. She's never quite sure where it's been, who it's rubbed up against. Which kind of takes the pleasure out of wearing it. And dropping off such big carrier bags at the local Oxfam once a month gives one such a nice, warm feeling.

Anyway, the point is that Laura cannot face any more of her mother one-on-one this morning. She's had a stressful week and now with all the hassle of the marriage break-up she's got enough on her plate without Lydia's antics to put up with. She's going to get David up and out and he can deal with her. He actually likes her, for Christ's sake.

'Sorry, I've been on the phone. I'll just go and wake David up. He'll be furious if he knows you're here and I didn't get him. Unless of course he already knows you're here,' she adds with a sudden rush of courage.

Lydia looks alarmed, then disgusted, a combination of expressions she often favours when listening to her daughter. 'Laura, my dear, if he is, as you say, asleep in the bedroom, he would only know that I am here if I had been into the

bedroom and why, can you tell me, would I have done that?'
she challenges her offspring.

Because you're always creeping through there to snoop
through the stuff in my dressing-room, is what Laura wants to
say. But in the firing line of her mother's leering stare the
words stay tamely and safely tucked in Laura's prefrontal cor-
tex. 'I must find the housekeeper and tell her to get the coffee
on,' she mumbles instead.

'The housekeeper?'

'Yes. The housekeeper, you know, Anouschka.'

'Anouschka? She's the bloody cleaner, darling, not a
housekeeper.'

Laura feels the familiar surge of frustration well deep
within her. Only her mother can infuriate her with quite
such precision and alacrity.

'Lydia, there's no degree course in housekeeping. If I
decide she's my housekeeper, that's what she is, do you see?
There are no special skills required, it's just a title, that's all.'

No, no special skills, thinks Lydia, finally identifying the
other head in the bed. Only the ability to open your legs and
come quietly. Unexpectedly, momentarily, she feels a pang of
compassion for her pompous, ignorant daughter, but like all
pangs involving feelings other than her own, Lydia suppresses
it quickly and returns to first base.

So – her son-in-law is banging the hired help. How
predictable; how vulgar. And not what she would have
expected from David, to be honest, but if she has learnt one
thing from her encyclopaedic experience of men it's never to
expect anything of them. Anyway this is not the point. What
is the point, is that David is the one who earns the money and
pays not only for Laura and her lavish lifestyle but also for
Laura's mother. And Laura's mother, knowing which side her
bread is buttered, is buggered if some cleaner is going to come
between her and her shopping trips to Harrods. She may be
about to die but as she had fled the surgery sobbing before the

doctor had had a chance to elaborate on his prognosis, she wasn't sure whether she had merely days to live or possibly weeks or even months. And if the latter, was she going to live them out in vile impecunity simply because that thing which had answered the door had not yet learnt the English for 'no'?

'Lydia, are you listening to me? I'm going to wake David. I'll be back in a minute.'

'No! Wait!' She grabs her daughter by the elbow. 'Laura, darling, I must talk to you. I have something I must tell you. Something . . . seminal.'

Laura groans. Lydia's somethings are always seminal. Lydia spreads her fingers, and shuts her eyes as if invoking divine guidance to help her find the right words. She inhales deeply, opens her eyes and begins. The article from The National Geographic open on the table in front of her provides a natural autocue.

'My darling, listen. I've spent all morning in the British Museum. When you spend time there –'

'– I thought you said you were at home working to a deadline?'

'– please listen. When you spend time there, with the Egyptians, the Greeks and the Romans, with the Aztecs and the Assyrians, you realise how insignificant we are. With our filthy burger bars and seedy interpretations of the arts – we are a civilisation in decline! I stood, for what must have been the best part of an hour – and of course this is not the first time I have worshipped it – before the stone panel of The Dying Lion, taken from the palace of King Ashurbanipal. Enrapt, I mean totally engrossed, I neither saw nor heard the crowds who were standing staring at me whispering: 'She looks transfixed' – 'She's been there for ages' – 'I wish I could see it through her eyes' – etcetera – etcetera. Could we produce something so exquisite now? No, we could not. Do our lives mean anything in the light of – and the gargantuan shadow cast by – these civilisations which have come before, never to be seen again?'

'Have you been taking too much Royal Jelly again, mother?'

'Oh,' sighs Lydia, drawing Laura's elbow which she clutches ever closer to her, because the monthly allowance which David pays his mother-in-law is a very generous one and there's no way she's going to risk it by letting her daughter disappear too soon, 'don't worry. I know. This is probably all above your head. What I'm trying to say is that your problems with David, such as they are, probably hold some importance for you, but believe me, my darling, in the greater context, in the historical context, they mean nothing. Focus on that. Focus on the historical perspective and see your life in its sharpest relief!'

This is why her mother drives her mad. How does she know that there are problems with David? Laura didn't know herself until she woke up this morning.

'Lydia, why are you shouting? You'll wake David!' Which is what both of them want to happen, of course, albeit in different ways and for different reasons. And right on cue David duly appears.

He is, it has to be said, in rather a strange mood. He's still in his dressing-gown. His co-ordination isn't quite right. All the colour has gone from his face. This pantomime, Laura knows, is designed to pay her back for what happened in the bed-room earlier. She is not impressed. But she is happy to have him there because that means she can cut short her analysis with her mother. And Lydia is happy to have him there because that means Laura won't catch him shafting the cleaner and she can still buy that pair of white leather boots she's got on order at Harrods, not to mention keep a roof over her head and eat for whatever time it is she has left to her. And David, when he catches sight of her, is happy to have Lydia there because then he won't have to look his wife in the eye after what he's just done.

So everyone's happy, which is nice.

David likes his mother-in-law. He was worried at first that

being a sex psychotherapist she would constantly want to be analysing his performance in that arena. On his wedding day, however, Lydia confidently assured him that if he ever wanted any advice she only provided consultations for a fee. She was joking of course – he was her son-in-law after all – but David was nevertheless careful to steer clear of the subject during the course of his marriage. (This was not hard for David as he never talked about sex with anyone. What was there to say, after all? When you wanted to do it you did it and when you didn't you didn't. He wasn't sure what all the fuss was about, honestly he wasn't.) Lydia, furthermore, had always displayed a very positive interest in David's job (which is more than can be said about her daughter) and seemed to be fascinated by all the detail of his legal cases. David liked this. He also liked the way she kept reminding him that his astrological birth chart reveals he has his tenth house in Leo and therefore would always be successful, popular and a leader amongst men. 'Lydia!' he cries. 'I thought that was your voice I could hear. What a lovely surprise!' He kisses her. She recoils slightly at the smell of cheap scent on him. 'Wow! You're looking great, better than ever, really good. The hair is amazing!' Laura's face curdles. Lydia loves it. She smugly pats her freshly dyed, inch-long, scarlet hair. 'Ah! I was wondering if someone would notice my hair,' she comments dryly. Laura knows this is her prompt to say something complimentary about her mother's hair but personally she thinks that kind of army crop looks ridiculous on a woman in her seventies.

'So, David, last night I was looking again at your astrological charts. Have you got something big coming up at work?' she demands while elegantly selecting one of Laura's expensive coffee-table chocolates. (Laura tries to remind herself when she told her mother about David's business deal – was it Wednesday or Thursday?) 'I don't know, it wasn't clear,' Lydia continues, as David opens his mouth to answer. She holds her temples, struggling to re-connect with her inner

dream-world. 'I saw you in some sort of arena – possibly the coliseum. You are surrounded by wild beasts. I see teeth, I see horns. And I see blood. I see the bodies of all those who have been slaughtered by others before you. When you appear, the beasts howl. They bare their fangs. Then they slink back and lie prostrate at your feet.'

'This gladiator, he didn't have an Australian accent by any chance?' Laura asks casually, because people might not think she has a sense of humour but they would be wrong.

'You have a sword,' Lydia continues triumphantly, unabated by the sad cynicism of her daughter, 'but you do not kill them. No. You walk valiantly from the ring. The crowd goes wild. You walk with the savage beasts meekly at your side. So tell me, David, what does this mean?'

This means David flushes crimson with pleasure. This means David gives his mother-in-law a big hug and wishes, not for the first time, that his wife could have inherited some of her mother's positive spirit. He understands what it is that Lydia has foreseen: the success of his business venture this evening.

'Well, we'll see,' David murmurs languorously. 'But enough about me. Let's talk about something more interesting. Let's talk about you,' he croons to his mother-in-law. Lydia's face, which given the volume of surgical readjustments it has enjoyed should know better, zings into a manifestation of delight. She wonders, not for the first time, whether an affair with her son-in-law would be totally out of the question, especially as she has now discovered he has no scruples about fidelity. Lydia herself, of course, has never enjoyed the warmest relationship with morals. And now she knows she is about to die, a debate on the ethics of sleeping with her daughter's husband seems irrelevant to the point of absurdity. 'Well, if we must,' she giggles, crossing her legs beneath the red micro-mini and popping the chocolate seductively into her mouth. 'Shall I tell you about my experience at the British Museum this morning?'

At this crucial point, however, Anouschka appears.

David feels his bowels contort in a way they haven't since he was six and his mother found him with an entire bag of liquorice in his mouth.

'I would love to hear about the Museum,' he mumbles, 'but I really must go to the gym now.'

'The gym?' Lydia demands.

'Yes,' David replies desperately. 'I've hired a new personal trainer and my lesson starts soon.'

'Of course this is typical,' Laura adds, spreading her fingers, the better to see how the colour of her new nail polish responds to being held at different angles. 'Have I been told any of this? About a personal trainer? Have I? And what if I had planned something for us to do this morning, what about that?'

But no one is taking any notice of Laura. They are staring at Anouschka, poised in the doorway with a dustpan and brush in the air on either side of her, like a monarch brandishing her sceptre and orb. Anouschka, no beauty even on a good day, looks positively deranged. Her hair is sticking out in all directions and her cheeks are a vibrant purple.

'I must say you all something,' she announces.

Yes. She is going to tell them. Her mind is made up. The blood is leaping through her veins, her heart is pulsating with excitement. She hasn't had sex for two and a half years since she last saw her fiancé back home and even then, they were neither of them quite sure which way round you were supposed to do it, having both had reticent parents. David certainly knew which way to do it. Anouschka had read about what an orgasm was in one of her employer's magazines and seen the pictures to match (it was amazing some of the stuff you could find under people's beds). Even so, she was sure it was meant to have stopped by now whereas she was still rippling and bubbling with pleasure.

Even at its best with Boris, it had never been like this.

At this moment, however, it's not Meester David she's feeling most passionately about. No. It's Meesees David. Anouschka is looking at Meesees David in a whole new light. Recently, to be honest, she'd been thinking about handing in her notice. Some of the things Meesees David had asked her to do, like retrieve an earring from the bottom of the toilet bowl with her bare hands or squeeze the blackheads on the bits of Meesees David's back which Meesees David couldn't reach herself, were surely more than a respectable cleaner on £4.60p an hour should be expected to endure. Meesees David also often forgot to pay her at all at the end of the week and then forgot at the beginning of the following week that she'd forgotten she'd forgotten and would argue with Anouschka as to whether she'd really forgotten or not.

Now everything was forgotten. Everything was different now. Meesees David had relinquished Meester David, her own husband, to Anouschka. Nothing else mattered. She will always be grateful to Meesees David for this act of sacrifice. All bad thoughts are gone. Meester David is hers. Anouschka loves Meester David. And Meester David loves her back! Because you cannot make love to someone as passionately as this and not have feelings for them! She could hardly believe it! A fine, important, handsome man like Meester David! Inside her! Anouschka felt the tingle run up her stomach once again. He'd been so tender and so – so firm and had whispered such nice things in her ear, not all of which she'd fully comprehended but she'd got the gist. Now Anouschka knew she would never leave the Davids. She felt loved, like one of the family.

Anouschka looks fondly at them both. She is going to tell them that. She is going to say what she really feels. Everyone is staring at her. Meester David. Meesees David. Meesees David's mother. Why does she see such terror in their eyes? She wants to speak. How they stare at her! She tries so hard to find the words. But the words she wants to say don't come.

'I do kitchen floor now,' she whispers.

What she wants to say is: 'I love you, Meester and Meesees David, I love you both.' But she has not the courage, so, 'I do kitchen floor now,' is what comes out.

<div align="center">*</div>

David goes to get ready for the gym.

Laura is once again, stuck with her mother. Extreme situations demand extreme measures, she decides. She says: 'Mother, I'm going to tell you something but I have to be sure, I mean completely sure, that it will go no further. Will you promise me?'

Lydia is just sitting thinking how boring she finds her daughter. She wonders how a woman like herself could have produced a creature like Laura. She was sure it wasn't right, to think your own daughter so tedious. Surely a mother should always instinctively, spontaneously love her own child but, speaking frankly, Lydia didn't love Laura. She'd been a dull baby, a drab child and now she was an immensely dreary adult and it was just as well she was so good looking or she'd never have pulled a catch like David and they'd both, Laura and Lydia, be up the swannee.

Watching her daughter's painted lips move, seeing her impeccable features contort to a position of discomfort, Lydia reflects that Laura is about to announce that she is afraid her husband may be having an affair. Lydia is going to have to bite her lip to stop herself from saying – 'Yes, he is, sweetheart, and, speaking frankly (Lydia likes to speak frankly, if only inside her own head), who can blame him?' But of course she could not say that, could not tell Laura that she had caught her husband shagging the cleaner in her bed in her house that very morning (which had a certain panache to it, if nothing else), because Lydia is the kind of high-maintenance mother-in-law who would not take well to having to cancel her account at Fortnum & Mason's and moving out of her cosy flat in Knightsbridge to somewhere like Battersea or

Wandsworth or any other of those ghastly south-of-the-river type suburbs where all the inadequates go. Even if she is about to die, she cannot contemplate that. Lydia had once earned her own very healthy income from her psychoanalytical consultations but with age, the energy required to diagnose the shortcomings of needy people had abandoned her. There had been a time when she was able to spin out a single insecurity into two years of lucrative sessions; now she was bored with it after five minutes. Having affairs with so many of her patients – male and female, Lydia was discerning but not discriminating – did not help matters much either. A couple of times things had got messy. When Laura had married David and David had suggested that he provide for his mother-in-law, it was only then that Lydia understood why she'd bothered to have a daughter in the first place.

Meanwhile Laura is looking at her mother and asking herself this: 'Why am I about to tell her that I am leaving David? Why, at the age of 35, am I still not able to take any significant action in my life without my wretched mother's approval and approbation?'

If only one could divorce mothers as well as husbands.

'Do you promise me?' Laura insists.

I promise I'll go mad if I have to listen to much more of you, Lydia thinks. 'Yes, my darling, I promise,' she replies gravely.

'The thing is, mother, what you were saying earlier – well, you were right. There is a problem between David and me.'

Lydia gasps in mock shock horror. 'Moon is in Saturn! What did I tell you!'

'Yes, well, I don't want to go through all that right now. The thing is, Lydia, that I'm going to leave David.'

Now Lydia gasps for real. 'Laura? Are you mad?'

'I know, I know. David is going to die when he finds out. Die! He so adores me. But I can't stand it any more. He limits me! He oppresses me! He suffocates me!'

'I see,' says Lydia slowly, because it's the first thing that comes to mind.

She has to stop this. She clutches the edge of her seat. She wants to cry but she's not sure there are any tear ducts left since the last facelift. 'Ah me! I never imagined things would come to this. Divorce! My own daughter. The issue of my womb!'

Laura reels in silent supplication that this will not, yet again, be the cue for Lydia to launch into the story of the hysterectomy she was forced to have after giving birth to her. Laura reels to no purpose.

'Still I bear the scars of when you tore me as you came into this world. Still echoing in my ears the renting of my flesh as you forced your way into existence. Now must I bear the humiliation of divorce from my own child, my only child, the child who closed the gate of my fertility behind her?'

Laura wonders in admiration at the dearth of shame in her mother, this being the woman who had slept with so many men that the identity of Laura's father would have required the services of an entire forensic science team.

'There's no point to all this, mother. I have made up my mind. I'm leaving him and that's it.'

'Aieeeee!' Lydia wails, like one impaled. 'Aieeeeeee!'

'Oh do be quiet. You're the one who's always telling me to get in touch with my shadow side. Well this is it.'

'But David is not your shadow side, you foolish girl. He is a wonderful, caring, considerate, wealthy husband! You should be kissing the ground he walks on, not preparing to eject him!'

At this point, Lydia composes herself sufficiently to run to a mirror and check her demeanour, rearranging the folds of skin at the sides of her face just the way the surgeon showed her to. Meanwhile, Laura, who has been trying to comprehend the vehemence of her mother's negative reaction, (her mother has always thrived, personally and professionally, on

emotional crises and normally welcomes them with open arms), hears the word 'wealthy' and all becomes clear.

'You're worried about your allowance, aren't you? The little arrangement you have with David. Do you think I don't know about that? Do you think he wouldn't tell me, his own wife, about that?'

'His own wife? What sort of an expression is this?' Lydia counters in disgust. 'Do you think maybe you might be somebody else's?'

'Shut up! Shut up! Don't change the subject! Tell me – isn't that what you're worried about?'

'So do I shut up or do I tell you? I am confused.'

'I'm right, aren't I?' Laura is yelling now. She rarely yells. 'You honestly thought I knew nothing about that, didn't you? And how long has it been going on now, seven, maybe eight, nine years? A couple of thousand popping up in your account, as if by magic, every month. Do you think David wouldn't tell me?' (Actually David hadn't told Laura about this. He was worried she might find it humiliating to know that her mother could no longer support herself and had quietly gone ahead and set up the standing order without discussing it. Laura had only found out when she had gone through some of David's personal papers while he was away on a business trip in Brazil a few years back.)

Before Lydia can answer, David comes running back into the room. 'What's wrong?' he cries. 'What's all the shouting about?' Mother and daughter stare at each other. Who's going to win this one? Laura has an idea but Lydia is too fast for her daughter. She stands up and faints, conveniently in the direction of the well-upholstered sofa.

'Oh my God,' David cries. 'What have you done to her? What have you said? Quickly – call Dr Aben!'

Lydia, who has a passion for surgeons but a violent dislike of doctors, starts groaning and attempting to prise open her eyelids under the weight of her false lashes.

'She's coming round! Thank God. Laura, go and prepare her some hot tea, with plenty of sugar, nice and sweet.'

'And a drop of whisky, darling, just to help it go down,' Lydia croaks almost inaudibly.

David picks up his mother-in-law in his arms and carries her up to one of the many spare bedrooms. She seems to be in rather a state. She's emitting low semi-sensual groans and unless it is David's imagination going wild, her right hand which got trapped somewhere down near his groin when he picked her up from the sofa seems to be twitching and clutching at that part of him. It must be an involuntary reaction of the muscles to the stroke. Tenderly he lays her out on the bed. 'Ah David, my love,' she whispers but then she is probably delirious by this stage. She clasps a scrawny hand round the back of his neck and appears to be pulling his mouth down towards her. He understands: she wants to tell him something, make a confession, a last wish. David holds his ear to her mouth. 'Kiss me, David,' she croaks. So he does: a gentle, almost paternal kiss on his mother-in-law's strangely clammy forehead. Once again, she cries out in something akin to pain. Sensing she needs rest and peace, David turns off the light and leaves the room.

'Wait!' Lydia cries, moments before he can make good his escape.

With sudden coherence she forces out the words: 'I must tell you something, David, please, let me, before you go. Something you must know.'

<p style="text-align:center">*</p>

Just when Laura thinks she has hated her mother with every ounce of energy available to her, something happens and she finds new reservoirs, entire new power stations of megawatts of animosity. Laura is angry as in ready-to-exterminate anger. She careers into the kitchen, and almost kills herself as she falls over the bucket of water into which Anouschka is nervously dipping her mop.

'Bloody hell! What a bloody stupid place to leave a bucket!' Laura cries.

Anouschka starts crying. 'But I do kitchen floor here. Where else I put it?'

'I don't bloody know!' Laura yells, sidestepping the dribble of dirty water now making its way slowly but surely over the surface of the polished limestone floor. 'You're the bloody cleaner, you sort it out.' Laura slams on the bloody kettle for her bloody mother's tea. She recognises that what she has just said is a bit much, even for her, but she knows enough from the scores of cleaners she has worked her way through over the years that one of the first rules of employing them is never to apologise. If you do, they get the upper hand, and then you're done for.

Laura starts scrabbling in a drawer, looking for her old address book with the name of the local florists who can do displays and have them delivered within the hour – she's unhappy with the flowers in the hall and wants a couple of new arrangements there for the pre-dinner drinks this evening. The drawer is full of rubbish; she wishes she'd transferred the number to her new address book, she wishes she'd stayed in touch with the woman who'd given her the number, she wishes she could at least remember what her name was, and failing all of that, she wishes she could find her old bloody address book in this drawer full of crap.

'I really do think you could attend to this drawer, Anouschka. It's a total mess!'

'But, Meesees David, you tell me always that this drawer is private and I no go sticking my nose in it,' Anouschka whines from somewhere in the pan cupboard.

Laura groans – she is just not in the mood for an argument right now.

Anouschka puts down the mop. 'I think I go home now,' she says quietly.

'Home? Don't be stupid. You've only just got here.'

'Yes. I go home,' Anouschka repeats slowly as if she's trying to convince herself and Laura simultaneously. She puts on her little green cardigan, the same one she always wears and has always worn, and pads off towards the front door.

'I've got Mr Denver-Barrette's business partners coming here tonight – you can't leave the place like this!'

'I go home.'

'If you go now, you needn't bother coming back! Or expect to ever see the £20 in your pay I keep in arrears! You can forget about that!'

Still Anouschka turns to go. She is girlfriend of Meester David now – she will not be spoken to like this. Just as she does, Meester David appears.

'I think she's OK now. I've put her in bed and she's resting. Laura, go and keep an eye on her. Poor darling. She needs you with her now. I'll make her the tea, I know the way she likes it,' he instructs manfully. David loves a crisis. 'Oh, what's all this water?'

'It's Anouschka's fault.'

'Is no me. Is Meesees David kick bucket.'

'Laura is upset,' David explains patiently to Anouschka, all commander-in-chief style. 'Her mother is unwell. Really unwell. Would you be so kind as to mop it up?' He turns to Laura. 'Go on, Laura. Go be with your mother.' (David likes talking like an American, it makes him feel empowered.)

Laura doesn't want to be told what to do by David. She doesn't want to see her mother. On the other hand, she wouldn't know how to clear up a spill of dirty kitchen floor water if her life depended on it, so she turns to go.

'By the way,' says David gently, putting his hand on her shoulder, 'I think you should know. Your mother has told me. She's told me everything.'

There and then Laura feels her insides turn to ice. The bitch. The dirty, money-grabbing, surgically reconstructed bitch. Even for Lydia this was lower than the lowest low.

'Oh God, David. I – I – I didn't mean for you to find out like that. I'm sorry.' They are both somewhat taken aback. Laura has never said she's sorry to David before.

'Yes well, it's best these things come out. And anyway, this isn't about me for heaven's sake. It's about you, darling. How do you feel about it?'

Laura turns and considers her husband with contempt. What a drip. He's just found out his wife is going to leave him and he's got no anger, no passion. How does she feel about it? Jesus. Isn't he going to fight for her? Beg her to stay? Any real man would be tearing his heart out in fury, demanding to know if someone else was involved, threatening her, cajoling her, basically responding in a normal, human, virile way. Any doubts she might have had about whether she was doing the right thing are gone. She is married to an amoeba. It's pitiful.

'I feel . . . Oh, it doesn't matter how I feel. I'll go to Lydia.'

Yes, Laura thinks. I'll go to Lydia. Because David might not know passion if it were to come up and bite him on the balls but she, Laura, she was feeling plenty of passion right now, a passionate desire to clamp her hands round her mother's scraggy neck and squeeze hard until the old bird went as duck-egg blue as the new upholstery fabric in the dining room. But that, of course, is what Lydia would want, what she would expect. She would die happy, knowing that Laura's eternal incapacity to deal with her shadow side had finally won the day. Laura would not give her that satisfaction. No. Laura would stay calm. That would cause her mother more pain than anything.

When Laura walks, serenity personified, into the second-best guest bedroom, Lydia is propped up on about sixteen cushions, wrapped in a large peony pink cashmere blanket intended for decorative purposes only, a bottle of sherry having appeared as if by magic on the bedside table beside her. She is watching one of those programmes on the TV where

people announce the end of their marriage to their partner in front of an appreciative audience of complete strangers.

'So,' Laura says pleasantly, 'we're feeling a bit better are we?'

'We? I am fine,' Lydia mutters through a mouthful of one of the strawberry liqueur chocolates in finest 70% cocoa from a box she has found on the bedside table. 'You, I am not so sure about.'

Calm, calm, calm, Laura reminds herself, sitting on her hands as she moves to the edge of the bed, lest in some incontrollable reflex action they should involuntarily carry out Plan A and wrap themselves round Lydia's neck. 'I hear you've had a little chat with David.'

'Yes,' Lydia nods gravely.

'And don't you think,' Laura continues, pressing down all seven and three-quarters stone of her weight as hard as she possibly can on her twitching fingers, 'that the fact that I, his wife, had decided to leave him was perhaps something I would have wanted to tell him myself?'

'Yes.'

'Yes? So?'

'So what?'

'So why did you tell him, you – you –' Laura bites her tongue hard on the words that would like to come out.

'I did not tell him this.'

'No?'

'No.'

'You didn't tell him I'm going to leave him?'

'No.'

'He said you had told him!'

'No. I didn't tell him that. I didn't tell him you're going to leave him.'

Lydia has another sip of sherry and pops in another chocolate. Throughout this little exchange her eyes have been glued to the television. She loves these programmes. She loves the bits where everyone starts to cry. This programme with

72

this particular presenter is her favourite. But even though she's watching as if she cares about her programme, she doesn't really, not today. What she cares about today is telling Laura what she has just told David. That she is going to die. That Laura is adopted. And how scared she is that if she finally confesses to Laura she is adopted she will reject her now, just when Lydia needs her most. Be brave, be brave, Lydia urges herself. Be brave.

'I told him you are adopted.'

Laura looks at her mother. Her fingers have stopped twitching. Oh dear. Oh dear, Laura thinks. Lydia has gone crazy. This is very sad, and Laura is probably to blame for it. It happens so often with the elderly – one piece of upsetting news and their minds go. Their grizzled brain cells just can't cope. It happened to the mother of a woman she'd sat next to recently at a birthday lunch. The only good thing about it was that this woman had given Laura the name of a superb old people's home, somewhere the right side of East Grinstead, far enough away to justify no more than a once-monthly visit and yet close enough to a lovely restaurant in one of those adorable country house hotels so smart you could still believe yourself in London which would at least give Laura something to look forward to afterwards. As Laura makes the mental journey from her handbag to the drawing room to the bureau where she had carefully deposited the piece of paper with the telephone number of the home, Lydia says: 'You don't believe me, do you?'

'Have another chocolate. David will be here soon with the tea.'

'You don't believe me.'

'If you're asking me whether I believe that you're telling me, now, when I'm thirty-five, that I was adopted, when I carry every detail of my childhood with you, mother dear, etched only too clearly in my memory, when I have seen countless baby photos, of you pregnant in the hospital about

to give birth, you in the hospital having just given birth clutching onto what very fiercely resembles a baby, then yes, the answer is no.'

Lydia sighs.

'I was pregnant, and I did give birth, and the baby was born, but she only lived for a few hours. I never did quite understand what went wrong. In those days things happened and even if they did always happen for a reason, the reason was not always forthcoming. Anyway my father, who adored me, as you know, could not bear to see me so upset. He discovered that the woman in the room next to mine had given birth only twenty minutes after me, also to a girl, also with dark hair and dark eyes. So he wrote her a cheque – the sum was never revealed to me but for my father money was no object, my happiness had no price limit, and that was that. We carried on as before. I did my best to bond with you, but hard as I tried, and believe me, darling, I did try, you just never felt right. You weren't as pretty as the first one for a start – she had much finer features. And you've always had this strange, pointy little chin whereas I come from a long line of square-faced women. Still, we've managed, haven't we? And if nothing else I've saved you from a life of rural monotony. I gather that the other woman's husband later lost everything on a risky business venture in The City so they had to sell their house in Pimlico and go and live in the country surrounded by cattle and sheep. Think of that, my darling! Think of the mess! Think of the boredom!'

Laura sighs. 'This is all fantasy, mother. And anyway, even if it were true why are you telling me? Why did you tell David? Why now?'

Lydia looks at her.

'Well?' Laura demands.

'Now – because . . . Oh darling, I want so much to tell you but I'm afraid it's too awful, you're going to be too upset . . .'

'I'll tell you why, you bat. You want David to think I believe all this adoption stuff so when I tell him I'm going to

leave him he'll think I'm just having, I don't know, some kind of emotional crisis and he won't take me seriously. That way you get to hang on to your bloody allowance. Pathetic. Don't think I can't see straight through your little games – don't forget, I've had a lifetime of them.'

Laura turns triumphantly on her heel and leaves the room.

'All right! I'll tell you why I've told you now about your adoption!' Lydia calls after her. 'I've told you now because . . . I'm going to die!'

'Only in my dreams, mother dear,' Laura whispers to herself.

As she walks back downstairs she sighs a weary sigh. Of course the adoption story is all nonsense. And yet, and yet – she remembers how, as a child, she would often ask herself why her mother had fine, arched eyebrows while she herself had bushy flat brows which met in the middle.

For some reason this had always bothered her terribly.

It bothers her still.

*

David and Anouschka are alone in the kitchen. This is the first time Anouschka has seen him since they had sex in the bedroom that morning and David had taken his leave of her, muttering something along the lines of, 'I'd better go and clean up now'. It had occurred to Anouschka at the time that she was the one who needed cleaning up, given what Meester David had deposited all over and up her, but as he did not invite her to join him in the bathroom she mopped herself down as well as she could with a duster, got dressed and went back to her duties.

David is fussing with the tea for his mother-in-law, preparing the tray and the china cup and saucer and the tea leaves in the little silver ball. He is ignoring Anouschka. Totally. Acting simply as if she was not there.

Anouschka yearns for him.

Anouschka is desperate for him.

Anouschka really loves him.

What can she do to make him see this? He is as remote from her as he has always been. He behaves now, as he did before, as if she is not even there. He doesn't talk to her. He ignores her. But now they are lovers, they are as one. What can she say or do? Her English is not good enough to convey what she feels. She is only on page 38 of her book: already if she had got to page 64 she would have covered the future tense more thoroughly and she might have been able to get her message across but for the time being there is no hope.

Then she remembers the song, the song she learnt as a girl, only a young girl, but even then she knew that one day, when she found her true love, the love of her life, she would sing it to him. One of her friends had an ancient cassette player and an uncle who bought him pirate tapes to keep him quiet when he came once a month to sleep with his mother. Anouschka and her friends would sit round this cassette player in Pyoter's unheated bedroom listening to the crackled love songs while Pyoter's uncle tested the bed springs next door. The first time she heard this song, she knew it was to be her anthem. Her English was only very basic then but so were the words, they said little, but they said enough.

The song comes floating back into her head. The tune. She mops the soggy floor while she looks at Meester David's back. She remembers his fingers hard up inside her, his mouth on her breasts. She remembers the song. Hm, mm, hm, hm, mm. Yes, she will sing it. She will. Then Meester David, he will understand what she feels. He will understand he is the one who must be hers. He will know that his place in this world is in her arms, between her legs.

She sings. She cannot remember all the words but she remembers the important ones: 'Love, baby, hm, mm, love, love, hm, mm, baby, hm, mm, love, love . . .' Quietly at first but then rising to a full crescendo of ardour: 'Love, baby, baby, hm, mmmmmm, l-o-v-e, l-o-v-e, baby . . .'.

David finishes the tea and takes it upstairs.

CHAPTER 3

David is standing naked in the bathroom inspecting his bits, his mouth contorted to a wide grin. There's nothing like a spot of extramarital sex with the cleaner to put a smile on a man's face.

What has he done? Is he mad? What's got into him? He's got into the cleaner. The cleaner! A woman who isn't Laura! After a lifetime of marital fidelity, he's just shagged the cleaner! Has he really just done that? Yes, he has. So how does he feel? Well, he feels appalled, ashamed. Of course he does. Embarrassed. Confused. But most of all he feels deliriously happy. After 15 years of misery with Laura, 15 years of yes/no/maybe/actually no, in bed, he's just had the best lay of his life. The irony. He's married to one of the most beautiful women in London, admired and envied by all their friends. Then the cleaner, the spotty, lard-haired, can't understand what she's saying at the best of times cleaner comes in, gets naked into his bed and starts tossing him off. Absurd! He should've shouted at her, told her she was mad, disgraceful, kicked her out! Instead, he wakes up, with a hard-on like a broom handle, turns around and gives her one. In fact he gives her two. And the second time was even better than the first!

Excuses? Well, if he wants, yes, there are excuses. He could have said he thought it was Laura – in the dark. He could have said he was desperate after being left high and dry. But the fact is – he doesn't want excuses. He liked doing it with the cleaner! Yes, he did!

He has to lie down on the marble floor. He's feeling dizzy. This is not the David that David knows. This is a different David. A better David. This is David the lad. The stud. The love-god, for Christ's sake.

David is euphoric, elated with his own virility. He's finding

out so many new things about himself, he can hardly keep up with his speed of thought.

David is capable of being unfaithful.

And then of doing it again.

David can screw the cleaner and then just get up and carry on with life. Cope with Laura, cope even with domestic drama between Laura and her mother, carry his mother-in-law upstairs, make tea, dole out sympathy, listen to his mother-in-law telling him that she has terminal something or other and is about to die, that his wife has never known all these years she's adopted anyway, then announce he's off to the gym as usual – do all of this and no one bats an eyelid! He's come into the bathroom to get dressed but when he takes off his robe, he stops, doesn't automatically reach for his clothes, he stops and looks down at himself. He feels as if he's looking at his body for the first time. His dick. He thought he knew his dick but it's clear he doesn't, doesn't know this thing and what it's capable of, so maybe, therefore, he doesn't know the rest of himself either.

Is this exciting or terrifying? All his life, he's played everything by the book, safe and straight. He's never succumbed to temptation, mainly because he's never felt it. Everything he's ever wanted is what a good man should want anyway – to do well at his studies, to do well at work, to marry well and earn stacks of money. Could it be that it's possible that he might be someone who wants things which aren't right? That he wants to shag the cleaner? In the marital bed? With his wife right outside? If he wants that, what else might he want?

These thoughts, they are making his head spin. He can't think straight.

Could it be that David is not the jerk he always thought himself to be. Could it be that the devoted, docile money-making David is no more?

That David is a liar, a cheat, a cad, a shit?

And that it feels so good?

★

Laura has just been in her bathroom to do her make-up again. Doing her make-up is always a source of comfort for Laura. There's something about making her already very beautiful face even more very beautiful which appeals to her. (In times of stress she has been known to get up and do her make-up at 3 o'clock in the morning, then return to the bed. Sublime to an unseeing world, she reflects on the irony of this and her thoughts rock her gently back to sleep.) Now she is in the drawing room sorting out her priorities. She must be practical. If she's going to do this leaving David project properly, the first thing she needs to do is to sort out the sale of the house. Laura is not totally clear how marriage break-ups work but she's pretty sure they always involve selling the property. Quite apart from anything else, given all the work she's had done, she wouldn't mind getting a valuation on it. It is an eighteenth century detached six bedroomed house in Cheyne Walk — and in the past year Laura has spent many tens, who know, maybe even hundreds of thousands on doing it up. It's been a massive, exhausting project, the whole place had to be ripped out and redone, not so much because there was anything at all wrong with it but because Laura has always said that if it weren't for the fact she was an artist, she would have been a wonderful interior designer.

Then, of course, once she knows how much the house is worth, she can work out how much her lawyer is going to be asking for from David. She's pretty sure about all the rest of it — her monthly running costs for clothes, hair, manicure, pedicure, facial, massage, etc, etc, etc because a friend who was in the process of divorcing her husband told her once how useful it is to have a note of these things just in case and Laura has always kept an updated tally in a little notebook hidden in a drawer in her bedside table.

Laura dials Louella's number — Louella will be able to recommend a good estate agent, Louella has a name and a number for everything. But when Laura explains what she's

after, Louella is less than obliging. She tells her she cannot believe that Laura is really thinking of pursuing this stupid idea. She flatly refuses to help her and calls her a silly bitch.

All friendships have their ups and downs.

So Laura has to resort to the Yellow Pages, like normal people do, and picks the first estate agency whose name she recognises. A very pleasant young man called David (perhaps unfortunately, given the circumstances), says he'll come straight round when she gives him the address. As David (i.e. Laura's husband, for the time being anyway) will be leaving any minute to go to his silly gym, this is most convenient. Laura goes upstairs to her dressing-room, gets changed, then goes back down and settles on the sofa with a coffee to wait for the estate agent. As she flicks through the latest editions of all the interior decorating magazines she tries to think of a good reason, a really good one, why she should leave her husband. Hard as she tries, the only thought that comes to her is this: David never really asks Laura the sort of questions that Laura wants to be asked. He never probes deep enough to discover what really makes her tick. He'll say, 'How was your day?' Laura doesn't want to be asked, 'How was your day', for Christ's sake. She wants to be asked what sort of feelings she has had that day. Or he'll say, 'did you do any painting?' What if she did? What if she didn't? What Laura wants to talk about is her relationship with her art, her inspirations, her associations with her work. David is just not asking things the right way. Because David doesn't really understand the sheer intricacy of the woman he has married – her complexities, her doubts, her dreams, her dilemmas.

But Laura doesn't blame David for being David. She blames herself for marrying someone just not as sophisticated as herself. It's her fault and she's prepared to admit it. And anyway, she criticises herself brutally, just not asking the right questions is not enough of a reason to end a marriage.

She's going to have to come up with something better than that.

Eventually David appears to say goodbye. He's all togged up in his frankly rather ludicrous lycra gym gear and appears to have done something to his hair, flicked it up at the front and put gel in it or something. He looks absurd.

He asks her why she has changed into leather trousers and put on lipstick. Laura, obviously, cannot tell him it's because the same friend who recommended the ongoing tally of personal costs also said when you get the estate agent round, looking your best adds a good few tens of thousands onto the valuation they give the house. She says she just felt like it. Fair enough. David kisses her goodbye, on the hair, like he's been trained, so his lips won't mark her foundation. She hopes he won't have left a mark on her hair.

She forces a smile. David looks at her. How he loves me, Laura thinks. This is going to be so hard.

Why don't I feel any guilt? David thinks.

She looks again at his hair. Should she say something to him, anything, to save him from the embarrassment of going out looking like that? Not to mention her embarrassment – people do know she's married to him, after all.

'Have you put gel in your hair?' she asks affably.

David goes pink. 'Um, just a bit,' he says touching his quiff nervously.

Laura nods.

'You don't approve?' he asks.

'No.'

'Right,' he says.

He raises his hand to flatten it down. Then he remembers. Liar. Cheat. Cad. Shit. He drops his hand.

'Good,' he says, and goes.

*

Everything's going to plan, David's out of the way and the estate agent should be here any minute. Laura can do this, she

really can. All it takes is some determination and a steady head. Then she glances across at the clock on the table next to her. Half past twelve – already. Where has the morning gone? Suddenly she remembers she was supposed to have rung her agent, Isabelle, this morning to confirm lunch for today. Be sure to ring before midday Isabelle had said. How could she have forgotten this? Her work is so important to her, yet this lunch has completely slipped her mind. Then she thinks of all the emotional trauma she's been though this morning, with the decision to end her marriage and everything, and she decides not to be too hard on herself about it.

Laura wonders what to do. She can't go out now – she's got the estate agent coming round. And this thing with Isabelle was only ever going to be a casual lunch, to discuss the finer detail of the exhibition at the gallery. There's no point in getting in a state about it. Isabelle is her agent after all. She's earning her living from Laura's skills. She depends on Laura, not the other way round. Laura can relax. It might even do the relationship some good. Isabelle has been acting a bit stand-offish of late, not always returning calls as promptly as she might, that kind of thing. Laura could simply ring her and apologise. Or, and Laura likes the sound of this, she could just do nothing. Just ignore the problem. And when Isabelle rings to ask her where she is, why she's not in the restaurant, she'll just pretend she thought Isabelle meant next Saturday. Simple. She practises saying the lie to the mirror. 'Oh Issy darling, I thought we said next Saturday. Yes, I'm sure we said next Saturday. Really? I could swear it was ne-e-ext Saturday.' The words slip out easily.

I can do this, Laura thinks. I can do whatever I want.

<p style="text-align:center">★</p>

This is getting out of hand, Louella decides. Laura is going to wreck a perfectly good marriage on a total whim. Louella is not afraid to drop everything and rescue a marriage when

necessary. Plus it has started raining, there isn't a soul about, no one has set foot in the shop for the past hour, and it's lunchtime. Laura always has loads of food in the fridge.

★

David the estate agent bounds up the steps of the Cheyne Walk house three at a time. Bloody hell, he's thinking. The commission on this place alone would take his agency to the top of their sales target. He'd be South-Eastern Estate Agent of the Year. After only three weeks in the job, at 23 he'd be youngest South-Eastern Estate Agent of the Year ever. His face would be on the cover of the national newsletter.

His mother would see it . . .

The sale of this house would take him to his personal sales target for the whole year and it was only May. The pound signs start swimming in front of his eyes. He'd be able to buy Lucy a ring and propose, all in time for her twenty-first birthday!

He was so excited he could feel his asthma coming on. Take it easy, Dave, take deep breaths, remember all your training – first impressions count. Don't look too eager. Don't say anything silly. Deep breaths, deep breaths. But the picture of Lucy's excited face keeps popping up in front of him, crowned with the pound signs and everything feels like it's starting to spin round.

After what is probably only twenty seconds but feels like days the front door opens and a tall, skinny lady is standing there, beaming at him. David automatically remembers the body of his Lucy back in Devon, with all those solid curves which always send him crazy with desire. How lucky he was. Without being able to stop himself, David feels spontaneously sorry for the poor bloke who only has this bony rake to cuddle up with every night.

'Ah!' cries the woman. 'You must be David Brackenbury!'

Her voice is so accented with class and money and other things David can hardly begin to imagine that he is almost

too nervous to reply. What's she going to think about his voice? And what if he gets his grammar wrong? He can tell she's looking him up and down. He knows she's thinking how young he is. David shudders. He knows he should have passed this one on to one of the older, more experienced guys in the office but he decided he was going to have a crack at it because his dad, the day he died, made David promise he would always take the bravest course. Show her you're up to it, David whispers to himself in his head.

'Mrs Denver-Barrette,' he says, loudly and firmly, with good emphasis on the final 't' to reassure her he remembers what she said to him on the phone about spelling Barrette with an 'e' after the second 't'. 'What a remarkable house!'

'But you haven't even seen it yet!' she objects.

'Ah yes,' says David, his chest forward, his mouth smiling, his eyes sparkling, brimming with the full confidence of his 23 years and his six GCSEs, propelled forth by the spirit of his dead father, the hopes and dreams of his mum, and his constant love of his Lucy. 'But first impressions count for so much, don't you think, Mrs Denver-Barrette?'

I'll say they do, thinks Laura. What a handsome young man. So clean. So fresh. She catches him looking longingly at her. Of course. Poor boy. She is so totally more than anything he could ever hope to have.

Suddenly she feels so aware of her loveliness that she wants to cry again. So lovely yet so unfulfilled.

Even this young man would want to sleep with her. She could take him now, into the house, pull him down slowly onto the sofa. She could teach him how to make love. She could imagine, almost hear him, groaning with desire for her, his young body shaking with longing. 'This is ecstasy!' he would cry, as he cleaved himself to her. Yes! she would think but only to herself. Yes, I am!

'Why don't you come in?' she beckons.

★

David goes down to the garage to rev up the Mercedes then he changes his mind and decides to do the manly thing and walk to the gym. Just as he's coming out of the garage doors onto the street, he sees Louella walking down the street towards the house.

Louella.

He's always had rather a soft spot for Louella. Nothing serious. Just, well, sometimes, in the car, driving back after a long day at the Royal Courts of Justice, he'd have the roof of his car down, his tie loosened, country and western on the CD and he'd think of Louella.

He'd think of Louella and then he'd think of the woman Louella reminded him of – Barbara. David was going out with Barbara when he met Laura. He had been in love with Barbara. In fact, he would say (but only to himself, and even then only when he was alone at home or in the car for fear that Laura might hear his very thoughts) that Barbara had been the love of his life. Barbara had liked country and western music as much as he did but that wasn't the only thing they'd had in common. Marshmallows and dominoes and cycle rides on a Sunday morning – the list went on and on.

David and Barbara had been together for two years; not living together, because Barbara was still divorcing her husband and there were her kids to think of. She didn't want him living in the house until the divorce was all settled and the children had had a chance to adjust. Nice kids. Boy and a girl. Tom and Rebecca. Sweet little things. He would have liked a couple of kids like that . . .

Barbara was special and even now when he thought of her, this was the word which came into his head. Special. He used to laugh a lot with her. They always had so much to talk about and then sometimes they didn't talk at all. She'd just sit and look at him, sit and stare and smile and he could see how much she loved him but that was OK because he loved her

that much too. Only he could never quite find the words to say it. He hoped, when they had sex, she could feel it, feel what he thought, what he felt, because with her it wasn't sex, that is, it *was* sex, great, great sex, but it was also love, making love. Had she understood that? Afterwards, he'd hold her, already sad it was over, already wishing he could be inside her again, already longing for the next time, and he'd wonder, did she understand? He'd hold her very close and she'd laugh and tell him he was crushing her and he'd say sorry and stop and she'd say that's OK, I want to be crushed, I want to be crushed by you.

Then, all at once, Barbara had dumped him. Someone had told him years later that it was because she had thought he was having an affair with another woman while he was seeing her. Which of course he wasn't. Why would Barbara have thought that? David would never have gone with anyone else when he could have her. But then, once she had left him, he felt so miserable, so lonely, and Laura was so keen . . .

Sometimes Louella reminds David of Barbara. Same kind of face somehow. Something similar about the voice. So sometimes now, when David's alone in the car, he thinks about Barbara and then he thinks about Louella and his palms go all sweaty on the leather steering wheel and his trousers stick to his skin at the crotch.

Now he can see Louella walking up the street towards him. She swings her hips when she walks. He likes that in a woman. He checks his hair in the wing mirror of the car and stands and waits for her in a spontaneously casual position.

As she walks past the open garage door he calls out, nonchalantly, 'Hi Louella! Popped round to see Laura?'

Louella feels her backbone stiffen. David. For some reason she didn't expect him to be there – he was usually out at his gym on Saturdays which as far as she can tell he likes to go to just so he can tell people that's where he goes. Other friends of Louella's who go to the same gym say that all David does

when he's there is sit at the bar and read The Telegraph or swim endless straight line lengths up and down the pool in an unstylish interpretation of the crawl. Louella has never taken David seriously. She invites him to her dinner parties, of course, but that's only because he's Laura's husband. Laura's the interesting one. David just stocks up the bank account (not that this doesn't have its uses). The trouble with David is that making money is all he does. There are plenty of men out there who make money – even more money than David, in fact – and who tell great dinner party stories, or who are fantastically good-looking, or who come in the kitchen between courses and give Louella an invigorating tongue-job while their wives are wittering on to the poor unfortunate sitting next to them about the price of lampshades in Peter Jones. David offered none of these services. Sometimes she wasn't sure what value he added at all. He would sit quietly at her dining table, chewing slowly on his food as if it were stewed scrag-end she had given him, not *crêpe farcie au jambon et aux asperges*, boring people with his interminable prognoses of legal technicalities which no one had the least interest in. And he was always the first to say in a louder than necessary voice to his wife that it-was-getting-late-and-they-really-should-be-going.

Anyway, whatever; looking at him now, Louella feels obliged to stop and exchange pleasantries with him. It's probably not his fault he's so dull, just something genetic which in 50 years time they'll be able to identify precisely in the DNA and extract at birth. In the meantime, people like David were just going to have to be suffered with good grace.

'Hello, David. Is that another new car?'

David looks lovingly across at the shiny navy blue Mercedes. 'I'm afraid so, Louella. You know how it is – boys and their toys.'

She smiles patiently. So much money, so little charisma.

'Well, I can see you're busy, I won't keep you, I'm just here for a chat with Laura.'

'Oh no! I mean . . . no, I'm not busy. Just polishing the wing mirrors!'

'Right.' But even Louella, a woman with a steamroller for a mouth, just can't think of a single other thing to say to him, so she nods, politely, and disappears.

★

David (the estate agent) is not handling this brief very well and, while he's sure whatever he's doing isn't right, he's not so sure why it's wrong. For a start, he's doesn't really know what to make of this house. From the outside it looks like a palace but inside it has been done up in such a strange way that he's not sure any buyer will see anything past the decor. The hall is a dark purple, the drawing room a blood red and the kitchen a candy pink. David's nephew George aged six could do better than this with his box of paints. There's too much lighting, too many cupboards, period features have been ripped out and not-quite-right architectural bits and pieces have been stuck in. Even David could see the whole thing was a mess.

Then there's Mrs Denver-Barrette. Mrs Denver-Barrette is what his Lucy would call a bit of a weirdy. She keeps running her hands over her neck and that bit which makes a V just above her bosoms. Once she actually did touch one of her bosoms, sort of cupped it and lifted it and rubbed it while she was showing him how they'd had the original fireplace knocked out to create an indoor water feature. She keeps laughing at what he says, as if he's made some sort of joke, which he hasn't. (David knows, from his estate agency training courses, that humour is best reserved for later meetings with clients when a firmer relationship has been established.) At one point she disappeared into the bathroom and came back five minutes later with lots of extra lipstick on, a bit too much in fact, so it had sort of gone over the edges of her lips at

one point and too far into one corner of her mouth. One of her front teeth was also bright red. That was another thing he loved, loved about his Lucy: no make-up. She didn't believe in it. And he always teased her and said she could only afford not to believe in it because she was so pretty that she didn't need it. Even her spots – Lucy did nothing to cover them up. She said they were a part of who she was and she was not ashamed of them. David loved that about her – her strong personality. His mother called Lucy feisty. David always forgets to look feisty up in the dictionary to find out exactly what it means. (He knew roughly.)

Mrs Denver-Barrette keeps referring to her husband – so far David has learnt that Mr Denver-Barrette is a busy man, a very important man, and a very successful man. When David suggests that Mr Denver-Barrette might like to attend a second meeting (David knows, from his training, that you need to get the decision-maker, i.e. the man, involved as soon as poss), Mrs Denver-Barrette flinches as if David has tried to punch her and says no, no, no, Mr Denver-Barrette didn't need to be bothered with all of this. Mr Denver-Barrette is far too busy, important and successful to be bothered with all of this.

Although it is inappropriate, David can't help feeling sorry for this Mr Denver-Barrette whom he has never met and, from the sound of things, is unlikely to. Although this sort of thing was not covered on the training, David cannot help wondering what it must be like to have to go to bed with and be expected to make love to a middle-aged woman like this every night, whose skin is getting a bit scraggy round the edges, with those funny grey bags under the eyes that make-up can't quite cover up. One day will his beloved Lucy look a bit like that? He just can't imagine it.

David is beginning to wonder how serious this Mrs Denver-Barrette really is about actually wanting to sell. He remembers the 'MMM' technique he had been taught at his 'How To

Win At Estate Agency' course. MMM stands for: • Motive • Moment • Money (all starting with the same letter helps you to remember it more easily). This means: • why does the vendor want to sell? • when do they want to move? • how much do they want for the house? Some bright spark on the course had suggested it should be the 'WWW' – Why, When and Wonga, but of course that was just being silly and not taking things seriously, and anyway, as David had pointed out at the time, people would get it confused with the WWW which means World Wide Web.

Anyway, applying the 'MMM' criteria, which any estate agent should do when attempting to take on a new property, Mrs Denver-Barrette appears to fail on all counts. She is vague about when she wants to put the house on the market, ('Not exactly now but not never'), says that money is the least of her worries, ('I'm at a stage in my life where feelings count for more than pounds, shillings and pence'), and positively comes to a full stop when asked why she wants to sell, ('Who knows why anyone really does anything in this life?').

David is starting to panic. He'd taken a bit of a flier and asked her • Moment • Money • Motive whereas perhaps the trick was to ask in the order he'd been taught – i.e. • Motive • Moment • Money. Perhaps the key to it all psychologically, (Lucy says everything in life boils down ultimately to psychology), was the order in which the questions were asked. Oh God. He's done the wrong thing. He's done everything wrong. He should've told Tony, his manager, about Mrs Denver-Barrette's call. When she rang he should've waited for Tony to come back from lunch and given the brief to him, not lied and told the others he was off to get yet another tuna sandwich and then crept down the King's Road looking all the while nervously over his shoulder to check no one from the office was following him. Now everyone would know, everyone would find out and David would lose his job there and then because if there's one thing Tony can't stand it's

underhand behaviour. And estate agents who go to give a valuation but don't get the brief. That's another thing Tony can't stand. Now David had single-handedly and in one after-noon accomplished both things that Tony can't stand. David would get the sack and it would go straight on his CV and his name would be mud in the industry. He would never get a job again, unless it was in some two-man bog hole on the coast where only old people go to find somewhere to die.

David tries desperately to focus on the matter in hand. He needs this business, needs to get this one right, needs to be able to go back to Tony, his manager, and say in the la-di-da kind of voice all the other men in the office use, 'Got a call today – you were out – thought I'd save you the hassle – six bedroomed house in Cheyne Walk – won the exclusive – all sewn up – drinks on me at The Cock and Feathers'. He knows Tony is not impressed with him – underwhelmed is the word he's actually used. No room on board for those who can't pay their way. That's what Tony likes to say. And Lucy – if David didn't bag her soon, that Paul Wybrow would have her. It was only when Lucy heard about David's new job in Chelsea that things between them had got back on track. David is sure that if he produces a big enough ring at her birthday party Lucy will say yes. The timing is perfect. This house is God-given. This is David's destiny.

Come on, come on, you can do this, he promises himself.

'Shall we write up some notes?' he offers with a wide smile.

*

Laura needs to make up her mind. Is she going to have him or not have him? He's obviously keen. Desperate. It's totally up to her. Half of her head is thinking – for God's sake, Laura, are you really going to stoop so low as to shag an estate agent? The other half is thinking of all the pain and humiliation David has put her through – why shouldn't she have some fun in her life? And yet another half, (Laura has a complicated head), is worrying what it will be like to do it with a total

stranger who may have infections or genital warts or may expect her to respond or perform in some way which David never does. Also, on closer inspection, this David is not even particularly attractive. He looks clean enough but parts of the skin on his face are shiny. His suit is shiny. And his tie. He has black shoes and brown socks. He has clammy hands.

But so what? So bloody what? Her confidence, her self-esteem are so low. Why shouldn't she feel the longing of a younger man's hands, (albeit somewhat damp), caressing her body? That will begin to pay David back for all those times he has started to try to make love to her, kissing her and cuddling her, just assuming that it was what she wanted too. He was so controlling. Even the cornflakes, that was all about control: showing her what he could and couldn't do, or rather, what he would or wouldn't do. Well now she, Laura, was the one in control. She was going to show him.

All halves of her mind are made up.

*

'Shall we start in the bedroom? I mean, my bedroom?' Laura asks David the estate agent.

'Well, sure!' he cries, happy suddenly to detect some, any, enthusiasm on her part. 'Lead the way!' he challenges her, his smile ever broader. Her skinny bum turns and goes up the stairs before him – he doesn't want to be thinking these kinds of thoughts but David can't help reflecting that to make love to a woman as stringy as this must be like eating roast pork without any crackling.

Laura can feel his eyes behind her burning into her buttocks. Ah, she thinks. This is what control, what power over someone must feel like: it felt wonderful, even if that someone was only an estate agent.

They arrive at the master bedroom. Laura is careful to close and lock the door behind her. Anouschka has made up the room perfectly: in the pocket of her apron she keeps a little sketch Laura has prepared for her to show her the precise

94

arrangement required for the silk cushions (all seventeen of them) on the bed. This room is baroque in theme – Laura's very personal interpretation of baroque. Last year her bedroom was Chinese. Lots of T'ang. Now countless cherubs squint down from paintings, chandeliers and bedheads. No surface is left ungilded. The furniture is all repro because Laura can never think of antique as anything other than essentially second-hand, much to Louella's eternal contempt.

'Do you mind if we don't disturb the bed?' Laura asks, removing her jacket and drawing the velvet curtains. 'Only we have people coming for drinks tonight and the chances are that they'll want a tour of the house – people always do when they come here, I'm afraid my reputation usually precedes me – and my housekeeper has only just finished arranging it.'

David is prompt with his reassurance. 'Oh goodness me, of course, I won't go near it. That won't be necessary for what I need to do.'

'Super,' she smiles.

She takes off all her clothes and lies down on the Aubusson carpet.

Then she has second thoughts. She gets up, rolls back the carpet, pulls out a blanket from an extremely gold chest of drawers and arranges that on the floor. This is not the most romantic of gestures, Laura is prepared to concede, but the Aubusson cost her £85,000 and she's not sure she'd ever be able to get the semen stains out of it.

She lies down again.

David gasps and gapes.

Yes, yes, she thinks, I'm beautiful. Tell me something I don't already know.

'Mrs Denver-Barrette,' he stutters. His face is sweating. The shiny bits shine harder than ever under the cherubic light. She laughs. How entertaining this all is! No emotional encumbrances to unnerve her, no concern as to whether this foolish boy will consider her availability a sign of weakness or

not: all that stuff she worries about in bed with David her husband is simply absent on the floor with David the estate agent.

She lifts one knee coyly and leers at him. 'Come now,' she suggests. 'This must be the sort of thing young men like you dream about.'

Frankly, no.

To her silent horror Laura realises, as the seconds tick slowly and inactively by, that what she has assumed was shyness on his part may even possibly be – reluctance.

'You need to undress,' she commands. She gestures irritably at the shimmering suit. 'We can hardly get up to much while you're wearing all that.'

'Mrs Denver-Barrette,' David attempts to stammer, 'it would not be the professional thing for me to –'

'Fuck the professional thing,' Laura declares. 'I've got half of London after me and you're standing there dithering. Do you want this house or not?' she adds in exasperation.

Yes, he does want this house. He wants it badly. Slowly but not seductively David begins to undress, folding his suit jacket carefully on the bed so the label won't show. He unties his laces (double knot on the bow) and removes his shoes. The aroma of his feet pervades the room. He's conscious that his feet do smell – it's a problem he's had since childhood – and Lucy knows about it and has learnt to accept it. When he goes to her house he takes off his shoes as soon as he goes into the house, (everyone has to do that at Lucy's house anyway, her mum has a problem with the outside world), and puts them in a cardboard box left behind the front door especially for the purpose of his visits. Now, here, at Laura's, there is no box: David tucks his shoes underneath the elaborate silk quilt on the bed and hopes for the best. He takes off his socks and folds the tops of each one into the other so they won't get separated in the wash then remembers that he's not taking them off to go into the wash, he's taking them off so he can have sex with

Mrs Denver-Barrette on her bedroom floor and then get the exclusive on her six bedroom house in Chelsea, so he unfolds them again, then thinks what the hell he might as well fold them one into the other anyway, then he hears Mrs Denver-Barrette sighing with impatience and his hands start shaking and he just tosses them onto the bed. He fumbles with his tie and shirt buttons. He peels off his shirt to reveal a bald washing powder white chest with dips where the muscles should be. He unzips his trousers and shakes them to the ground.

He is in his underpants.

With a sharp movement Laura juts her chin forward to indicate that the Bart Simpson boxer shorts must also go.

They go.

David is not erect. That much is clear. Laura gasps. It is years since she has seen a penis in repose. David her husband's is always solid whenever he is naked in front of her; postcoitally she always dashes straight to the bathroom to douche herself down so she never sees it then. She had forgotten how unattractive an organ it is in its supine state. Or perhaps it is just David the estate agent's which looks as slack and saggy as a used stocking, an object without coherence, without form, without meaning.

Without erection.

'I'm sorry about this,' David squeaks. 'Perhaps I should put my clothes back on,' he suggests hopefully. 'Don't be silly. You're shy, that's all. Overwhelmed,' Laura tells him. 'Come and lie on top of me,' she beckons. David considers this. He is not a particularly large man but Mrs Denver-Barrette is so bony he is frightened she may crack and splinter underneath him. So he goes and lies next to her, on the blanket.

'You may kiss me,' she says.

David shuffles his bottom a little closer to hers then, hitching himself up awkwardly on an elbow, holds his closed mouth over hers. Laura detects the heady whiff of tuna on his breath and this does little to enhance the mood of the moment.

He presses his lips hard, harder against hers but they are coated in so much lipstick he keeps sliding off. Think of the property, he urges himself. Think of the glory! Think of the commission! He forces his mouth open and pushes his tongue heavily, laboriously towards hers. The tongue is intense with tuna. It might as well be a tuna complete with the soggy, scaly texture and the fetid saline aroma. The tongue hangs there, inert, indecisive in her mouth. It saturates her mouth with its weight and smell.

They both think they hear a noise at the door and look up, but no one is there.

It occurs to Laura at this point in time that maybe this was not such a good idea after all. There is no sensation of revenge, of redemption, even of lust. Just the simple desire to escape from the moist, pungent mass of this man. She looks up at the ceiling in despair. As if things couldn't get any worse, she catches sight of a patch of paint that has been missed, which has not been rag-rolled properly by the decorators. Thank God David is on top of her looking down – perhaps he hasn't yet spotted it. Carefully, almost tenderly, she extracts his tongue from her mouth. This is not going to work. She'll have to find another reason for leaving David her husband. Sex with David the estate agent is more than she can bear. 'We'd best get on,' she says. 'I'm sure your time is very precious, and there's so much of this house to see, so many features, the wallpaper in this room, for example, which I commissioned specially to fit with the rest of the décor.'

David is not sure what it is he has done wrong – or right – but whatever it is he is very grateful for it and jumps up quickly to get dressed.

'The wallpaper!' Laura trills as his head goes up. 'I really want you to make special note of the wallpaper in the house particulars when you come to write them up. It's details like that which make or break a sale,' Laura informs him.

But all David can think is that if she's talking to him about

writing up the house particulars then he must have got the deal even though he didn't quite give her what he thought she was expecting. Maybe his kiss was enough. His Lucy told him that the taste of his kisses would always linger for hours in her mouth. Maybe he was more of a romantic than he gave himself credit for.

Time to get your brain in gear, he chides himself.

'The wallpaper – the wallpaper is spectacular,' he proclaims, surveying the red and gold swirls. 'We will have a special photo in the brochure, a photo for the wallpaper alone,' he beams.

Mrs Denver-Barrette seems happy.

David is ecstatic. This estate agency thing, he tells himself, it's a piece of bloody cake.

<p style="text-align:center">★</p>

The doorbell rings and Laura gets the fright of her life. What if it's David (her husband)? How could she explain the presence of an estate agent in the house? Who has only just this moment put his trousers back on? But of course David (the husband) would have his keys wouldn't he? Even so, she checks on the video entry system in the hall before she opens the door. It's Louella. Damn it. Poor timing. Dreadful timing! Yes, yes: Louella is Laura's best friend but not right now, for God's sake. And she'll only be there because the shop's quiet and because she wants a free lunch. Perhaps if Laura makes no noise Louella will think there's no one at home and she'll just go away. She goes to hide behind the drawing room door.

Suddenly there is an almighty yell. 'Mrs Denver-Barrette! Do you mind if I look inside the wardrobes?' the estate agent cries uncouthly down the stairs. She could tell the chap had no breeding the minute she laid eyes on him. So then of course she is compelled to cry back, 'By all means', and of course Louella, standing the other side of the front door, can hear her and Laura is obliged to let her in.

(Laura wonders whether this kind of conspiracy in life,

where so much can go so wrong so quickly, is something which happens only to her for some reason.)

Louella squeezes in through the crack of open door offered to her. 'Who's that you're talking to?' she demands.

'Oh, it's David,' Laura retorts huffily. (Can she have no privacy, not even in her own house?)

'No, it's not! I've just seen David. He's down in the garage.'

'Well, no, sorry, I wasn't thinking, what I meant was, it was Anouschka.'

'It sounded more like a man.'

Laura shrugs her shoulders. 'These Eastern European women you know . . .'

Louella doesn't believe her. They both stand and stare at the magnificent central staircase as if this will somehow provide all the answers to the universe. And then it does. David the estate agent appears at its head and comes tripping down the stairs. 'Right. Well I've measured upstairs and now I'll just do the lounge and kitchen and everything. OK?'

Laura shudders. The lounge? 'Do you mean – the drawing room?' she declares. He stares at her, mouth open. She looks back at him with a look which is clearly willing him dead, or ill, or incapacitated in any way.

David, terrified, disappears, clutching onto his tape measure for courage.

'What the hell is going on?' Louella demands. 'Is he an estate agent? He is, isn't he? You've got an estate agent round to measure up the house! And I bet you haven't even told David, have you? Have you? You haven't! My God, you've lost your mind! You're taking this all too far too quickly! You only made the decision to leave him this morning!'

'The wonderful thing about having an argument with you, Louella dear, is that one doesn't even have to open one's mouth.'

'Laura – I've come round here to talk you out of this silly, silly mess you're getting yourself into. It really is too . . . silly!

Let's go and sit down and have a nice chat and sort everything out before you do something you're really going to regret.'

Laura is not impressed. 'Look, I haven't time for this. Why don't you go and get a bottle of wine from the fridge and some of my best smoked trout and buzz off. After all, that was what you came for wasn't it?'

'How dare you? What I came for was to help you save your marriage!'

'Of course. You – being the expert in relationships.'

'Why! You know there have been very good reasons why all of my relationships have ended!'

'Yes! One very good reason in fact – none of them can stand you any more!'

'You bitch! You cow! You don't deserve David! He'll be better off without you! You think you're so amazing – last week that red dress you were wearing when you came into the shop, the one with the fringing and the studs – it was vile, simply vile! After you left, two other women in the shop couldn't stop laughing about it! And the trousers you wore to my dinner party last week made your arse look enormous! And your highlights at the back have gone green! I wasn't going to tell you, out of loyalty, out of friendship, but I see that loyalty and friendship mean nothing to you, so now . . . now . . . consider yourself told!' Louella turns violently on her heel and exits. She was a member of the Birmingham rep as a young girl, before she got into the antiques business, and some skills are never forgotten.

The front door slams. David, the estate agent, wonders whether Mrs Denver-Barrette has simply decided to go and just leave him there. He wouldn't put it past her. 'Mrs Denver-Barrette! Mrs Denver-Barrette!' he calls out, never forgetting the loving emphasis on the final 't'. There is no reply. He wanders round looking for her. Finally he finds her in the downstairs cloakroom. He waits a moment then asks politely: 'Will you be leaving the appliances?'

But Mrs Denver-Barrette doesn't answer. She's standing looking at herself in the mirror, peering intently at a lock of hair from the back of her head she is holding high into the air.

'Mr Brackenbury,' she says firmly, 'may I ask you something?'

David goes pale. 'Er . . . of course. I mean, if it's within my professional capacity to answer, I'd be glad to . . .'

She says: 'Do you think my hair looks green, here, at the back?'

<p align="center">★</p>

David, the estate agent, retreats into the kitchen. He just doesn't know what to do next. The house is revolting. All the work done on it would have to be ripped out and redone by anyone brave enough to buy the place. There is a madwoman eating chocolates, drinking sherry, watching TV and plucking out the hairs on her toes with a pair of tweezers in one of the bedrooms. There is a strange girl in the kitchen scrubbing the edges of the cupboards with a toothbrush. And Mrs Denver-Barrette appears to have totally lost interest in the fact he's there: she's on a call now to her hairdressers. He wants to ask her if he can go down and look at the garage – because Tony, his boss, says that on their patch the garages are worth more than the houses – but he can't keep going to talk to her if she doesn't answer him, can he? He feels a nervous throbbing round his temples. He is getting one of his headaches. He wants to get a glass of water but doesn't dare. He breaks out in a cold sweat at the back of his neck. He's doing this wrong, wrong, wrong. He wants to cry. He turns round. The girl with the toothbrush is standing staring at him.

'Sorry I not say this you before. There is something I must say you,' she entreats him.

They look at each other in mutual dread.

'Er . . . yes?' David whispers.

'Welcome to DenverBarrettehouse!' the girl cries.

<p align="center">★</p>

David the estate agent is out in the garden. It is not a large garden but this does not matter: people with enough money to pay for a house like this don't care for too much outdoor stuff anyway.

Laura has let him wander round here on his own. She has told him, personally, she never goes out there, but she happens to catch sight of it sometimes when she opens the curtains in the mornings.

She has explained to David that she had the two hundred year old wisteria removed (it was looking its age) along with the banks of rose bushes (too asymmetrical) to give the garden a more contemporary look. David is not sure how well this works with the Georgian house. Actually, he is sure: not well at all; what he is not sure of is how he's going to make it sound like it works when he starts the viewings. The space has been entirely paved in black slate. Three vertical fish tanks have been inserted into the back wall and are full of rather troubled looking black fish. Three enormous black conical pots line one side of the paved area and three the other. The pots have large black plastic flowers erupting from them. There is a black wrought iron table and chairs.

The look is black.

Laura says the garden is deliberately and self-consciously monochrome. Laura says it is an ironic statement on the finite quality of nature.

David decides he needs a little sit down. He dislodges one of the chairs from its perfect position and flops down on it. It is cold, very cold outside but better than the stifling atmosphere in that house. A fish stares mournfully at him for a very long time until it occurs to David that the fish is on its side on the top of the water and therefore dead.

'She never feeds them, you know,' someone says over his shoulder.

'Oh my god!' David yelps in terror, impaling himself on the

sharp spike of the contemporary arm rest as he turns to see who is there.

It is the toe-hair tweezerer, an elderly red-headed woman, thinner even than Mrs Denver-Barrette, in a purple silk dressing gown flapping over her turtle-skin breasts, a bottle of sherry tucked under her arm.

'I have explained to her that if you don't feed fish the chances are they will die but she knows better of course. Who are you?' the woman demands, lighting up.

'I am David Brackenbury. I am an estate agent,' he proclaims proudly, holding out his hand. Lydia looks at the proffered hand with something akin to revulsion.

'An estate agent? What the fuck are you doing here, in my daughter's garden?'

'Ah. So you must be Mrs Denver-Barrette's mother,' David concludes enthusiastically.

Lydia simply looks at him as if he confirms many thoughts.

'Are you the man who was attempting to have sex with her on her bedroom floor just a little while ago?'

'Oh my God! You saw . . . It wasn't . . . I didn't . . .'

'No. I could see that. Now listen to me. I am a sex psychotherapist. I could help you.' Lydia pulls up a chair very close to him and the dressing gown dangles open a little further. He can see her nipples, brown and wizened and crusty.

'Help? I'm not sure I need . . . help.'

Lydia raises one eyebrow.

'Really? When I happened to pass the bedroom earlier you looked very much like a man in need of assistance to me.'

'That was only because . . .'

'Yes?'

'Well, because I was taken by surprise.'

'Come now, erectile dysfunction happens to the best of us. It's nothing to be ashamed of. There are techniques available,' she assures him, placing a hand on his thigh, 'which can cure even the most extreme cases.'

David is terrified. Terrified. And there's worse. This strange, well, horrible really, woman whose gnarled hand covered in brown spots and funny blue wrinkles is caressing his upper thigh with some vigour is having an effect on him which lying on top of Mrs Denver-Barrette naked did not. He hates himself for it, he wants it to stop, but it doesn't, it gets stronger, bigger, harder, and any minute now, as her kneading hand moves its way slowly but purposefully up his leg, she will get there and know this for herself.

'Um, Mrs Denver-Barrette's mother,' he begins, not having been formally introduced, 'I really don't think –,' he stutters.

Suddenly, however, she stops. She takes back her hand. She looks at him. In disgust. In horror.

'Did you say – estate agent?'

'Er, yes.'

At this, Lydia seems to engage in some form of minor fit. She writhes and exclaims and holds up the hand only just extracted from his thigh as if contaminated.

'Did you know that I am dying?' she asks.

'Well, no.'

'Well no? Well no? Well yes I am! And you come to this house with your cheap suit, your vulgar shirt, your nasty notebook and plastic pen to sell this house from under my feet even before I am in my grave? Search the farthest corners of your soul! Have you no pity? No honour? You vile, horrid little man!' She wheezes heavily, takes a last long drag on her cigarette, then, stubbing it out on the designer table, staggers to her feet and exits.

David is left. Quaking. He still has his erection. He wants to hit it to quieten the wretched thing down. How can he be sexually attracted to such an old woman? Such an old dying woman. How can he sell the house now? His conscience would never let him. He stands up and re-arranges the contents of his boxer shorts. He looks enviously at the

dead fish. Then he takes a deep breath and goes back into the house.

<div align="center">★</div>

It is unfair to pursue the matter with this schoolboy. He is sitting cowering on the sofa next to her, a quivering mass of nerves. The teacup on his lap – for Anouschka had for some reason taken it into her head to offer him tea – is clattering on its saucer. Anyway Laura is no longer sure she really wants to sell: perhaps David would offer to move out and she could stay in the house and live on the proceeds of her paintings. Either way, there was no point in fast-forwarding the tape too much. She had made the decision she was going to leave him – surely that was enough.

Laura glances at her watch: 1.37 p.m. She has less than eleven hours to find a reason why she's leaving David before she tells him at the end of the day. Because Laura has promised herself she will do it today on the understanding that she just can't stand another day of this marriage, and Laura doesn't break promises, not to anyone, much less to herself. (It does occur to Laura at this point in time, vis-à-vis the quest for a reason to leave, that all she would have to do is get the estate agent back up to the bedroom and stay there long enough for her husband to come home and find them at it and there would be her reason, vacuum-packed. But Laura wants to leave David, not have him leave her. She wants the moral high ground. That's what Laura wants. So this trembling boy really is no use to her at all. In fact, she's bored with him. He has dandruff and dreadful taste in shirts. His shoes squeak and his tie is giving her a migraine. She keeps catching a whiff of his feet. She wants rid of him now.

As for David, the estate agent, he does not know what to say, or what not to say. He wants this house. He wants Lucy. But he does not want to be responsible for the death of an old lady. She reminds him too much of his grandmother. He squeaks something neither of them can quite understand. Mrs

Denver-Barrette sighs and looks at her watch again, this time only for effect. She tells him she needs to consider her options. David gets the message. He goes.

Laura hardly notices the front door as it clips shut behind him. She's back in front of the mirror. She's already arranged the first appointment with Rupert on Monday morning, but how's she going to cope till then? Surely if her highlights really had turned green, Rupert would have told her when she was in there yesterday. How's she going to cope until Monday, for God's sake? Bloody Rupert – damn him for being away, today of all days.

Laura decides to take drastic action. She goes to the kitchen, fetches some scissors and cuts off a hank of hair from the back. It's blonde, a perfect buttercup blonde. She might have guessed. Poor Louella. Silly, jealous Louella. She was getting bored with her friendship anyway. Or maybe they would make it up. They usually did. She'd leave it half an hour or so and then give her a call.

<div align="center">★</div>

David the estate agent walks slowly down the Embankment. He has failed at what was surely going to be his finest opportunity – a six bedroomed house in Cheyne Walk. He could estate agent a lifetime – they don't come any grander than that. He has let down his father; he is not worthy of Lucy. His eczema is boiling furiously under his shirt; he scratches at it until blood starts to sweat through the stripes of his 'I'm-an-estate-agent' stripy shirt. There's no point in waiting for the inevitable. He taps out a text to Lucy. '2nd thoughts. Wedding off. Us off. No point. Sorry'. SMS has been sent. He stands and stares at the river. The grey, greasy liquid slaps against the wall beneath. He climbs up and sits on the parapet. The water is so high it almost reaches his feet. He imagines that cold water against his burning skin. He imagines it sliding against him and up, down, inside of him, filling his mouth, his throat and his lungs. The dark, forgiving water. He reaches his

bloodstained arms out towards it and welcomes, welcomes it to him.

*

Lydia, up in the bedroom, is getting restless. She's had a couple of naps; the sherry bottle is empty; she's had one too many chocolate rum truffles and is feeling she may be sick. Lydia throws up quite often after she has eaten. Best of both worlds: eat what you like and no weight gain. But she used to be able to decide when to do it. Now her stomach tends to do it whether she wants it to or not.

She's dealt with the estate agent. Now she's trying to think of a plan to stop her daughter pursuing her ridiculous idea of leaving David. She needs to focus. As long as Lydia can focus she will find a solution. She believes firmly that there is nothing in life so impossible that it cannot be solved by the application of will. But with so many shopping channels on Laura's lovely TV it's hard to focus on anything.

Then, all at once, Lydia is crying, and as she hasn't cried genuine tears for quite a while now, fifty odd years or so, they feel strange on her skin; although it's true that everything feels strange on her reconstituted skin, these feel stranger than strange. She is rather taken aback by her own spontaneity. The novelty of it. The pain of it. She tries to convince herself that she's only upset because she ate all those chocolates and because she has that painful scraping feeling in her belly again. But she is not crying about that. No. She is crying because she is old and tired and lonely and wishes that instead of having red cropped hair and wearing a red leather microskirt she was sitting in a white cotton dress in a garden looking at red roses with a man holding her hand, a man with whom she had spent her life calmly and loyally and who would bring those red roses to her grave when she was gone.

She is crying because she has rejected any man who had shown her true love because, if he already loved her, what was the point? She had pursued instead the fickle, the disoriented,

the inconsistent, and often simply the cruel. In her heyday, she had been so magnificent. This was a sport she could endure because her own beauty was her constant safety net. At any time she chose, she could pick up the phone and *tout de suite* some faithful hound could be relied upon to come trotting round, obediently wagging his tail with gratitude at her recollection of his very existence, proffering dinner, diamonds, devotion. Now the dogs were all dead. Or had bad backs, shaky hands and ears full of wax and hair. They had long since lost the ability to react to her charms, even if they were still able to make out her handsome features through myopic rheumy eyes. Those few who retained charisma, sanity and teeth had long since been snapped up by good women who had given them children and grandchildren and happy wholesome homes.

Now her own daughter, just as she had always done, was throttling her own happiness with the same contempt for contentment.

The fool. The fool.

Lydia has to stop her. Not because she feels a need to protect her daughter − Laura can make her own mistakes any time she likes − but because Lydia knows she has to look after her own interests. The doctor has heartlessly sent her home to die but what if she doesn't? Most of these doctors base their prognoses on research they've carried out on hamsters − Lydia might not react in quite the same way. Perhaps instead of killing her the alcohol is the only thing that's keeping her going. David's money makes her world go round and it might not be ready to stop spinning just yet.

Meanwhile the acrid whiff of urine comes up at her from under the bedclothes and her heart sinks. This mild but irrefutable incontinence every time she slept, it was hideous. So cruel. Her body is disintegrating around her. Everyday the eyes can see less, the ears hear less. The bones ache, the veins swell, the bladder has a mind of its own. The bowels don't

perform, the gums recede. Every day brings some new horror. Today, today it is worse than ever. Her vision is uncoordinated, her head aches. The whole right side of her body no longer feels right.

What her idiot of a daughter needs to realise, before it's too late, is that Laura needs David. She thinks that because she has some bloody silly show lined up at a gallery somewhere she is going to survive financially without him. She is totally dependent on him. Laura thinks she can cope but she cannot. Laura must be grateful for what she has and not throttle the golden-egg-laying goose with quite such abandon.

The show. Lydia had forgotten about the show. All those people. And she, Lydia, the mother. The star. How exciting. She lies back and thinks it through – God knows someone has to and Laura's certainly not up to it – and soon realises she simply is going to have to take action. She can no longer depend on David's money – fine. She will simply have to resuscitate her own career. And what better place to do it than at a West End art gallery?

She gets up and creeps downstairs. She pours herself a nice glass of gin which always helps her focus and even before she can raise the glass to her lips, providence determines that she sees exactly what she was about to look for: a copy of the Yellow Pages lying open on the hall table. She scrabbles through the pages. Under 'A' for 'Artificial Grass', 'Artificial Eyes' and 'Art Galleries & Dealers', Lydia soon finds what she is looking for.

She tiptoes back up to the guest bedroom so she cannot be heard and carefully dials the number on her mobile phone. At first she is told that the manager is busy and cannot come to the phone but will read messages later.

'I don't think you quite understand. I am Lydia Banbury, mother of the artist Laura Denver-Barrette.' A bemused receptionist finally puts her through.

'Ah,' begins Lydia. 'Splendid. Mr Derby – or rather, Patrick

– I just wanted to let you know how very much I'm looking forward to my daughter's exhibition later this year. I assume the dress code is fairly formal?'

Patrick explains that he is in the middle of a budget meeting with his staff and that she can wear what she likes. Lydia is so excited. She wants him to know that. She, of course, dabbles herself but professional commitments have never quite allowed her the luxury of time in which to explore fully her real ability. And she has lots of questions. She wants to know if the PR has been sorted out – has it? Will Patrick be sending a car round for her – will he? As well as the canapés at the opening night party, might there be a nice dinner somewhere for a small gathering of close intimates afterwards – might there?

Patrick says he would imagine that the simple answer to each of her questions is no and that he really must go now. Lydia expresses concern. And dismay. Surely a show by a new artist of her daughter's talent warrants all of the above?

Patrick sighs. He doesn't know, and, at this moment, he doesn't care.

Oh. Anyway, would Patrick mind very much if Lydia, mother of the artist, distributed some of her business cards at the gallery? Lydia is a sex psychotherapist and counsellor of many years experience and she was sure that Patrick's clients would –

Patrick's clients would not. And no way did Patrick want her touting her sex stuff at his gallery.

Oh dear! This tone, this rudeness is hardly necessary. If Patrick is not more sensitive in his manner Lydia might well advise her daughter, the artist, to place her show elsewhere!

Patrick does not want to be more sensitive. And if Laura wants to cancel that's fine by him, there's plenty more where she came from. In fact it might be a good idea if she did. And he's hanging up now. Goodbye.

Oh.

That was not how it was meant to go. Lydia was only trying to be helpful, show interest, involvement. She drinks the gin and pours another. It's no good. She's started shaking. Hands, legs. She is shaking so much that she must sit down, then lie down, on the bed and curl the covers way, way over her head. What's happening today? Life is falling apart. Safe, nice life is falling apart.

<div align="center">★</div>

Anouschka is still busy turning out Meesees David's kitchen cupboards. Meesees David likes to have her cupboards turned out once a week. Personally Anouschka thinks this is not so necessary, because Meesees David never does any proper cooking so the pans are never used so the cupboards never get dirty. Until now, this has always annoyed Anouschka but today she would be happy to turn out the cupboards and then turn them out and then turn them out again because the longer she stays in the house the more chance she has of seeing David. She wonders when he is going to tell Laura he is leaving her for his Anouschka – he has gone off to the gym for now, so maybe when he comes back from that.

Anouschka closes her eyes as she wipes the already pristine interiors. She imagines returning to her homeland with her handsome new husband. She imagines the envy of all her friends who stayed behind, who at best could hope to marry the butcher's son or the factory worker's lad. The gentle breeze will cause her hair to flow back behind her head. She will have no acne that day. (She's not sure how this will happen but somehow, who cares, just somehow, it will have disappeared.) She and Meester David will arrive on a carriage drawn by a pair of white horses. Anouschka will wear a silk dress and a pair of Gucci sunglasses, not bought from a suitcase but from a real Gucci shop somewhere. Meester David will have booked the town hall for their wedding lunch. The ceremony first will be long and intense. People will faint with the heat in the church and the potency of the incense.

Afterwards the feast: pigs on a spit and cheese and onion crisps (Anouschka's mad about them). The waiters, some of them will be her old classmates who will look at her with jealousy and admiration in their eyes. They will wish they grabbed her while they still had the chance. The feast will go on until 5 o'clock in the morning at which point Meester David will take her back to the hotel, the only one in her town, where he will have reserved the biggest bedroom. There he will cover her body, which that day will have no scars, with a million kisses and make big love to her – perhaps a little more gently than he had done that morning.

Meesees David comes into the kitchen. She is in not so good a mood. She is shouting to Anouschka about finishing in kitchen and going off to have lunch break quick, quick because so much to do in afternoon, so much.

Anouschka, as part of her promotion-to-housekeeper deal, gets a paid fifteen minute period for a break for something to eat when she works at the house over lunchtime. She has to provide her own lunch of course. And she is requested to eat her lunch and take her cup of coffee when she has made it (the instant stuff, not the good filter coffee) down in the garage. Why she has to go to the garage has never quite been explained to her but Anouschka doesn't mind. She's happy down there. It's quiet, she can't hear Meesees David shouting when she's having one of her rants and she can sit on the little stool provided next to Meester David's shiny car and imagine them driving off in it together one day.

Today, however, as Anouschka tiptoes down the steps which lead from the main part of the house to the garage, clutching her homemade pork and beetroot sandwich, juggling her steaming mug of hot soggy granules, she hears voices. At first she hears only Meester David's and her heart leaps. Then she hears the voice of the terrible friend of Meesees David, Meesees Louella. She stops and listens. They are laughing. No, they are arguing. Now they are laughing

again. Anouschka does not even breathe. Meesees Louella is calling Meester David Mr Big. What does this mean? Then Meester David is saying, 'Mr Big is in lovey-love with his Gooey Girl, Mr Big wants to spend his whole life with his Gooey Girl.'

With. With. Does 'with' actually mean 'with' or could it mean 'at' or 'by'? Anouschka wonders. And 'spend'? Last week, on page 34 of Anouschka's book, Mary went into the shop to spend 30p on a bag of sweets. Meester David wants to spend his life for Meesees Louella? Crazy English people. Crazy, crazy. Nothing they say makes sense. Shaking with trepidation, she takes a step further down towards the garage so she can see what's going on.

Then she hears someone coming up behind her. She quickly turns back and dives into the little cloakroom next to the internal door to the garage. The coffee slops over her hand but as the liquid sears her skin she dare not murmur. She feels guilty. Why? She is the one who is supposed to be in the garage. When the footsteps pass by she flicks open the door just wide enough to see Lydia creeping past. Anouschka silently snaps the door shut and sits back down on the toilet to eat her lunch. She holds the sandwich to her lips but she has no appetite. It's not just that the pork is off. Her hand is throbbing – but that is nothing to the pulsating of her tormented heart.

<p style="text-align:center">*</p>

Louella and David are in a state of some undress on the floor of Laura and David's garage, so it is perhaps just as well that Laura didn't get round to showing it to David the estate agent. Laura has never had any interest in the garage (guests never go down there, so why should she?); she has overseen no renovations or refurbishments in the garage, which is possibly why it is one of the nicest parts of the house. It certainly feels nice to Louella. Even the cold concrete floor, upon which Louella is still sitting in something of a daze, feels nice.

This is because Louella is in love. With David.

And David is in love. With Louella.

After her barney with Laura, Louella had passed David again as she stormed back up the street. She had grunted some form of farewell to him as she flew past but then stopped in her tracks and thought: revenge.

Revenge.

The best way to repay Laura for all her rudeness would be to have her husband. It was an absurd reflex – Louella didn't even fancy the man – but what the hell. Louella had never eschewed the absurd in her life and at 37 was not going to start now. If Laura were to find out she would go berserk: totally – deliciously – berserk. This nonsense about wanting to leave him was just that: nonsense, Louella had concluded. In fact, Louella might even be doing Laura a favour. When Laura found out, it might jolt her back into reality. Either way, Louella had been prepared to make the ultimate sacrifice.

So she had turned back and entered the spacious garage where David was still polishing the wing mirrors on his car, his tongue drooping slightly from one corner of his mouth as he concentrated on his task. And as she watched him, in his smart designer wannabe casual clothes, manfully rubbing the chrome of his beautiful navy blue top of the range Mercedes, it had seemed to her that perhaps there was something different about him. Had he had a new haircut? Or lost weight? Or put on weight? Something was definitely new. She'd never quite noticed it before but David had a great body. He'd left his shirt unbuttoned – Louella had never seen David with an unbuttoned shirt before – and he was unshaven. Louella had felt her loins quiver. How unexpected. How inappropriate. You're doing this for retribution only, she had reminded herself.

Finally David had looked up and seen her. 'Euorgh! Louella! You made me jump! I thought you'd . . . gone.'

'Well, yes, I had, but then I remembered something.'

'Oh?'

'So! David! It's lovely to see you, David. It's been ages!'

'What has?'

'Since we last saw each other.'

'Well, no – we were at dinner at your place on Tuesday.'

'Oh yes. But I mean – well, you know.' David's chest hair was peeking out invitingly from the top of his open shirt. Louella loved a hirsute man. Why had she, in all these years, never considered David before? Because she was a loyal friend. Yes. She would never have betrayed Laura. But now Laura didn't want him any more. Now that loyalty was redundant. Poor David. Poor vulnerable darling David. So industrious, so devoted – imminently to be so cruelly rejected by an unfeeling selfish wife. Laura didn't deserve him. All Louella had to do was tell David what Laura was planning – that she had an estate agent in there right now, at that very minute, going through the bedrooms with a tape measure, plotting the division of cash, scheming treachery, planning betrayal – and David would be hers.

'David, dear, there's something I must tell you,' she had whispered. Instinctively David had backed away but Louella had walked resolutely towards him, shutting the garage doors firmly behind her.

In her head a voice was saying that however much of a spoilt silly bitch Laura might be, it's wrong to tell a man his wife is about leave him (a) before the wife has had a chance to tell him herself and (b) when you're not sure the wife is even all that serious about her intent anyway. But for the first time in a long time Louella was no longer listening to the little voices in her head. All logic had gone to the wind down in the Denver-Barrette's garage as Louella's hormones came surging to a head. She grabbed him and thrust him to her. They had fallen, chaotically, onto the bonnet of his Mercedes. At first all David could worry about was what the metal buttons on Louella's jacket might have been doing to the paintwork, but

the further her tongue found its way to the back of his throat, the deeper these concerns retreated to the back of his mind.

The cleaner, he had decided, was lust. This was the real thing. They didn't actually have sex – Louella did not have matching underwear on so she drew the line – but they had explored each other's bodies with a fervour which had suggested greater things to come. Louella discovered, to her delight, that David's lovemaking was not as boring as his conversation. In fact, it was rather good actually. And he was so careful not to get spittle in her hair, which is something she always readily appreciated in a man.

*

Lydia's fingers tremble as she scrabbles for her pack of cigarettes in her handbag. Really she is feeling quite out of sorts. She needs to get a grip. She just needs to smoke a couple more cigarettes and have another little drinkie and she'll calm down. Of course Laura won't allow smoking in the house, so she has to crawl down to the garage to do it. Oh dear. She shouldn't have made that call. But what else could she do? Maybe everything will work out in the end. After all, David is devoted to Laura. He won't give her up without a struggle. Perhaps, even if the worst comes to the worst, and she tells him she's leaving him, he'll find a way to stop her. He won't give her up without a fight. Lydia's sure of that. And if Laura has lost her show at the gallery, well she's bound to feel differently about leaving him anyway. It's one thing being brave when you believe yourself to be on the cusp of greatness; quite another when you realise that anonymity is still your fate.

She tiptoes slowly down the steps which lead directly from the house to the garage. She fell down these steps once a couple of years back after excessive enjoyment of one of Laura and David's summer drinks parties, and since then she has a horror of them.

Sadly for Lydia, an even greater horror awaits her at the bottom of them.

David, her daughter's husband, is sitting on the floor of the garage next to Louella, her daughter's best friend. Louella's shirt has been unbuttoned to her waist and her bra is up around her chin like a peculiar form of collar. David, it appears, is kissing Louella's neck while rolling one of her nipples between his fingers as if he's trying to open a safe. Louella is lying back against the garage wall, smoking a cigarette, watching him.

Lydia freezes on the staircase. Fortunately she is in shadow and they are right over on the other side of the garage. As long as Lydia does not move or breathe, they might not see her.

For a little while David continues silently and intently on his task. Presently he removes his mouth from her throat.

'Do you like this?' she hears him ask Louella.

'What? The kissing thing?'

'Er, no. The . . .' – he removes his hand from her breast and holds the fingers up in evidence – '. . . other thing.'

'Oh. That. Er, not really,' Louella says.

'Oh. It's what I always do with Laura. She seems to like it.'

Lydia wants to cry.

'I prefer to get down to straight intercourse, you know, no mucking about before or after. It saves on time and mess.'

'Right,' says David, trying to keep up. He's been faithful to Laura all these years. He's trying to remember his sexual etiquette. He didn't much bother with it this morning with Anouschka, but she was only the cleaner. Louella is a somewhat different proposition. 'So shall we do that now?' he suggests politely.

'No. I don't think so,' Louella replies firmly. 'My hair . . . this garage floor . . . you understand. Tell me more about how we're going to run away together.'

Lydia clamps a hand over her mouth to contain her involuntary gasp of terror.

'Well, I don't know, I shouldn't think it will be too complicated really. I need to do this drinks and dinner thing this evening which is very important for work, you know . . .'

'– for the money.'

'Yes. For the money.'

'Yes. Well, that is important.'

'Yes. And then I just pack some things and I tell Laura I'm leaving her and then I get in the car and drive off and come and pick you up from your flat.'

'And then what?'

'Then? Oh, then, I don't know, we check into a hotel. Somewhere lovely in the country . . . Wiltshire. Somerset.'

'Wiltshire? Somerset? Don't be silly, we wouldn't be there until the early hours! No, we'll stay in London. Claridges. I like Claridges. There's one suite in particular of which I have very fond memories.' Louella takes an especially long drag on her Silk Cut and sighs.

David isn't sure whether the polite thing to do at this stage is to ask what those memories might be; some instinct warns him against this.

'OK,' he mumbles, 'Claridges it is.'

'And then what? Then we go and set up the catering business somewhere?'

'Yes. I suppose so.'

With the long-term planning over, Louella seems to perk up and look much happier. She stubs out her cigarette and turns to engage David in a violent embrace the force of which seems borne out of a sense of duty and gratitude rather than any feeling. Certainly for David who abhors cigarettes, kissing her now tastes like sucking out an ashtray. It was never like this when he was dreaming about Louella in his car. In his car she tasted like milk and honey, not tar.

For Lydia, however, perched up on her staircase hidey-hole, this is all too much. Her whole world is disintegrating in this house. She feels giddy. She feels sick. She stuffs her packs of cigarettes and pills and miniature bottles back into her handbag. She creeps silently back upstairs to bed to lie and wonder, when Laura leaves David or David leaves Laura – it seems

academic now to worry which will happen first – and she, Lydia, is bereft, what the point of life will be, even if she is dead by then.

<div align="center">*</div>

So now David and Louella sit on the chilly garage floor and talk about their childhood memories, their relationships with their parents, their hopes, fears and disappointments in life. They decide on nicknames for each other (Mr Big and Gooey), they have their first argument and their first making-up. They decide they have been looking for each other all their lives. For Louella, who has had more boyfriends than she has sold dodgy antiques, this is a new experience. To love someone.

Louella is still debating whether to tell David about Laura's plans. It seems there's no need; it appears, miraculously, that he's hers for the taking anyway. At first there's some doubt as to quite how they're going to be spending the rest of their lives together. Eventually they decide that they are going to sell up everything they have, which for Louella won't be too much of an undertaking, and buy a cottage in Dorset where they will run a catering business. Louella did a cookery course back in the seventies, after finishing school, and feels confident she can cope. David will run the financial and legal side of things.

Finally they part, embracing each other, tired, exhausted in fact, but so happy and so in love. No point, Louella decides definitively, in telling him about Laura's plan to leave him. It will only upset and confuse him. They have agreed that David will tell Laura it's over after the business meeting tonight and then they will check into a hotel. No point in rushing things beyond that; anyway Louella is going to have to sort out what to do with her cat, Titbit, because David is allergic to fur.

As an afterthought, as she adjusts her clothing and fixes her hair, Louella asks David what Laura will think about the pair of them running off together.

All at once his head sinks onto his chest. In a troubled voice, deep and low, he replies, 'I'm not sure how to answer you because I'm just not sure what our marriage is any more. I mean, what the purpose of it is. What the point of it is. I thought marriage was final, immutable. But at some stage today, I'm not quite sure when or how, it dawned on me that I'm not happy, and I don't think that Laura is either. Should one expect happiness after fifteen years together? I love her, but I think I love her simply out of habit. Simply because she is my wife. Would I love her now if she were not already my wife? I don't know. I just don't know.'

Jesus, thinks Louella. She didn't mean him to take the question that seriously!

'Fine, right, whatever,' Louella concludes as she takes her exit.

'Hang on, Louella, you're her friend, what do you think?'

But Louella has things to do. Louella is gone.

CHAPTER 4

Lunchtime.

David said today he would be back from the gym in time for his usual late Saturday lunch. Today Laura is going to spare no effort to make her last meal as David's wife a special one. That's the kind of woman she is. She will take extra care to pierce the cellophane on the pack of chicken lasagne nicely before she puts it in the microwave. Laura has no scruples about not cooking. This is because (a) she cannot, (b) anything a supermarket makes tastes better than anything she ever could and, crucially, (c) she is an artist and she's got her paintings to think about. She has learnt that as long as you finish off a ready-cooked meal attractively on the plate, with a small side garnish of lettuce and quartered cherry tomato and a few delicate strips of yellow pepper, no one can tell the difference anyway. It is true however, that on the rare occasions when they aren't out at dinner, or have caterers in to do a dinner or Anouschka hasn't been instructed to toss together a quick chicken casserole before she goes, Laura has not always been so hot on the small side garnish and has been known to serve up the meal still bubbling in it plastic pot.

Not today.

She pierces the film so that the fork marks form a series of neat lines all equally spaced and perfectly lined up. It occurs to her that this gesture is symbolic of everything she has done for David and everything he has never appreciated in her. Her desire to create order, harmony, beauty in his life. The way she has decorated a room, hung a picture, applied her eye shadow − nine times out of ten it has all gone completely unnoticed, and even when he has made some comment it has been desultory, uninspired. 'Oh, that's nice,' he'll say.

No wonder that, over time, she gave up with the side garnishes.

No one could blame her really.

While she is waiting for the microwave to ping Laura takes a couple of paracetamol – she has drunk a half-glass of white wine to steady her nerves and it has gone straight to her head – then starts to prepare her own lunch. Laura has been on a diet since 1987 and by now has almost totally conditioned the food as pleasure equation out of her system. She tips a tin of pineapple chunks over a tub of cottage cheese and grates a carrot over it. It doesn't matter that it tastes like sick, it keeps her going and it keeps her thin. She's trying not to think about the calories in that white wine because her head is throbbing so violently anyway, she can only take so much.

The ping comes; she hears David shutting the internal door from the house to the garage behind him; she calls out to him to say that lunch is almost ready. David does not reply but moments later appears in the kitchen, pale and terrified.

Anouschka, irritatingly, comes into the kitchen at this point to do the glassware which Laura has just asked her to do. Anouschka starts asking stupid questions about whether Laura wants all of the glasses prepared or only the ones they're going to be using for drinks that evening. It seems to Laura that she has to think of everything for everyone all of the time.

Anouschka wonders, not for the first time, at what point of the day David is going to find the time to take her to one side and let her know when he is going to leave his wife for her. Right now, in the kitchen, he is being rather distant, it has to be said. In fact he is ignoring her completely again, almost tripping over her kneeling legs as she ferrets around down in the bowels of the glasses cupboard as he walks past. But of course Anouschka understands that. He is being discreet in front of Meesees David. For now. All too soon Meesees David is going to find out that Meester David is leaving her. For now

he is still respecting her dignity. Perhaps he needs time first, to plan what he is going to say.

Laura demands: 'Are you ready for lunch?'

'Lunch?' he whispers.

'Yes,' says Laura firmly, not whispering. 'You know. That lunch thing we always do at 2 o'clock when you get back from the gym. You know, that late lunch which I'm always expected to do, even though I would rather eat at midday which suits my metabolism much better and which my nutritionist says would be far preferable but somehow I am prohibited from enjoying. That lunch. Remember now?'

'Yes. Of course.'

Anouschka has stopped working and is watching this scene open-mouthed. This, Laura cannot help but note, does nothing for her already imperfect physiognomy.

'Anouschka, do you think you could go and dust the drawing room?'

'I do it already, Meesees David.'

'Well, I want you to do it again now. Just the surfaces. Please.'

Anouschka is not sure what a surface is but she smiles and says, 'Yes, Meesees David' anyway, because she's learnt to recognise that slightly demented glint which Meesees David sometimes gets in her eye, especially when Meester David's around, and when Meesees David gets that glint, it's best not to argue with her. She gets up and leaves. She offers David a glance of compassion, of desire, of confusion, of hope. It's a complicated glance, but as David has his back turned to her at that moment, it's kind of lost on him anyway.

As Laura extracts the lasagne from the microwave she looks at it in dismay. It appears to be burnt on the outside and still frozen in the middle. Laura never could quite get the hang of this defrosting thing – so tedious for a creative mind. She gauges the meaty mess out onto a plate, prodding at the hard bits to try and soften them down. She looks back up at David. He has gone an unpleasant shade of green.

'Are you not feeling well?'

Actually, now she mentions it, it occurs to David that he is not. Perhaps it is just the smell of the meat as it is disinterred from its plastic coffin before him which is making him feel so nauseous. Perhaps it is his own bacon and egg breakfast coming back to haunt him. Or perhaps it is the fact that, down on the floor of their garage, he has just promised to leave his wife for her best friend which he's having trouble digesting.

'Perhaps I shall go and lie down.'

'I see,' says Laura through pursed lips. 'And your lunch? The lunch I have been waiting two hours to have with you – what am I supposed to do with that?'

David thinks quickly. 'What about your mother? Has she had lunch?'

David and Laura look at each other. The truth is that Laura had forgotten that her mother is still upstairs, unwell, in one of the guest bedrooms. She is not going to admit this to David as disclosure of personal failings is something Laura doesn't do.

'Of course,' she says. 'Of course. Well, half of this was going to be for her anyway.' They both gaze down at the compact, solitary rectangle of processed food on the plate.

'Fine. Well, I'll be off upstairs then. It's the rugby quarter-final on TV this afternoon. If we win this then England goes . . .' David falters. He knows there is no point. Laura explained to him at an early stage in their relationship that if he wished to pursue this obsession with rugby she would not stand in his way but that he should expect neither interest nor comprehension on her part.

'So – is that what all this is about then?' Laura remarks curtly. 'That's why you don't want the lunch I've gone to all this trouble to prepare for you. That's why you're "not feeling well". You want to see the rugby. You might have had the courtesy to let me know.'

David, who is almost out of the door, stops and turns.

'I did tell you. On Wednesday. I did tell you it was going to

be the rugby today and that I'd like to watch it on TV this afternoon.'

'No, you didn't.' In silent, majestic superiority, Laura takes her plate of cottage cheese, pineapple and carrot complete with stylistic sprig of parsley on top – because she appreciates the finer detail in this life, even if no one else does – and tips it ceremoniously into the waste disposal unit.

'Why are you doing that?' he asks.

'Doing what?' she replies.

'Throwing away your lunch.'

'I can't eat. I'm too upset.' (Actually the cottage cheese has curdled but he doesn't need to know that.)

'What – because I'm going to watch the rugby?'

'It doesn't matter,' Laura cries, only just suppressing a loud sob.

As the final slush of layered white and yellow mush slips symbolically away from the plate, David, because there's a first time for everything, decides that he's had enough of Laura's antics. He did tell her about the rugby, he definitely did. He remembers telling her one evening while she was reading in bed; he had said Laura darling, I hope you don't mind but I'll be watching the rugby this Saturday afternoon. He always has to book appointments for games like that. He'd assured her it would be over well in time for the drinks thing in the evening. She had grunted and he had said Laura darling, did you hear that? She had reiterated her grunt and he had said well don't get pissed off with me if you don't remember because you weren't listening when I was telling you about it. She had looked up from the book and said, 'David, please don't use that kind of language with me and please don't talk to me as if I were a child. I'm your wife, not your daughter', which had made them both blush, because he had wanted children so much and they had never come along.

All at once David realises something he's known in his heart for a long time: he's bored with Laura. He really is. He

doesn't love her any more. He thinks she's attractive, he likes having sex with her when he's allowed to but he's not sure his relationship with her amounts to anything much more than that. She's not the love of his life. She never has been. Louella might be, and even though she probably isn't, he wanted out, he wanted to be free to go and find her, whoever she was. Yes. Maybe the right woman was still out there somewhere, standing in a garden right now, or laughing or reading a paper or doing any other mundane trivial thing while not realising that her man, the man who would love her with all his heart was stuck, only temporarily now, in Chelsea, thinking about his escape, thinking about how one fine day he would find her and take her deep in his loving arms and never let her go. His true love. He would cover her face in wet kisses and she wouldn't mind, wouldn't even think about her make-up, her hair; he would make love to her on the sofa in the middle of the day and she wouldn't stop to think about the stains on the cushions or the marks on the velvet pile. He would fill her up with himself and it would never be enough for her. All the while he was inside her she'd tell him she loved him, loved him, loved him, over and over, like she couldn't stop, because she couldn't stop, because she really did love him with all her body and heart, with no intent or motive or guile. And he would come inside her and she wouldn't push him away, she'd want him to stay, stay, be in her, inside her forever, and as soon as they were up and dressed and sorted she'd look at him, with such desire in her eyes she'd look at him, and kiss him and tell him she wanted him again.

This was the sort of love David wanted. Unstructured, uncontrolled, unfathomable love. Adoration. Lust. Laughter. Sex, sex, sex. Love where the fuck was so good it never stopped, whether he was in her or not, he was part of her and she part of him, always, all ways.

Laura picks up the empty white plastic microwave container. Its edges are charred brown with burnt lasagne. Slops of the

dayglo orange sauce still cling to its base. Laura inspects it and sighs. She reaches for an empty plastic bag to wrap it in and then puts it in the bin. She looks up. He's staring at her. 'What are you staring at me for? If I put it straight in the bin all the left-over bits of it will slop down the sides of the bin and make a mess!'

Mess. That's what David wants. Lots of mess. When he finds his woman, they will make so much mess together. They will slop down sides together. They will lick and dribble and slurp and slop all over each other. The sheets will be thick with all the mess they will make. Because they will want each other so much that even though they have talked and talked, at the end of it that's the only way they will be able to say what they mean, the words will slip away and their tongues will meet and talk straight to each other and say more that way than anything else ever could.

Now David's glad he's had sex with the cleaner, he's glad that he's almost had sex with her best friend down on the garage floor, he's glad that he's betrayed her so horribly, he's glad that he's going to leave her, and that she's going to find out and be terribly hurt by it all.

He's glad. He turns and goes. He'd rather put his faith in the hallucination of his true love than live with the reality of Laura.

He turns and goes! He really does. She says nothing. He can feel her eyes burning into his back as he walks out of the room. She makes no attempt to threaten or warn him of the consequences if he goes. He cannot believe it. Hey, his walk almost becomes a skip. This is great, this is easy, he thinks, why have I never done this before? he asks himself.

Laura cannot believe it either. When she realises he really is going to do it, he really is going to just go, walk out through the door and leave her, she picks up, deliberately, wantonly, the plate of congealing lasagne and drops it firmly onto the limestone kitchen floor.

To shock him into coming back.

Except he doesn't.

He doesn't come back.

Laura is surrounded by clumps of lasagne, by chunks of broken fine china.

David hasn't come back. But he must have heard her breaking the plate. What's got into him?

The bastard.

He'll pay horribly for this, in ways he will never expect, at some future date he will never imagine.

She's going to sulk for all eternity now.

Although her heart is beating, Laura will not be cowed. With a spoon she starts scooping up the bits of lasagne and dunks them onto another plate. Anouschka will have to tidy up the broken china later. Laura simply can't risk damaging her hands – or her nails – before the dinner tonight. Notwithstanding everything, she will wait for the dinner before she leaves, before she takes her revenge. Otherwise it wouldn't be fair to David. And it wouldn't be fair to her.

She puts the plate onto a tray with a glass of designer water and a crystal vase containing a single pale pink orchid (the food may be inedible but the style, the style is sublime) for her mother. She wonders if she isn't running a hospital ward or old people's home, rather than simply trying to live in her own house. Never mind, she encourages herself. Not for much longer. After this evening she'd be a free woman, not a glorified waitress. After this evening, she'd no longer be married to someone who ignores her when an expensive plate goes crashing to the floor.

If she ever doubted her decision before, now there can be no more doubt. OK, she may not have her reason yet but she doesn't care. She is leaving David today. Absolutely she is.

*

Lydia lurches back up to the bedroom from the garage, mercifully without encountering Laura en route, and collapses

onto the bed. What is happening to her? She is really seriously not feeling well. Her head is spinning and breathing is somehow no longer instantaneous. It only happens when she makes a concerted effort to remind her lungs to do it.

Perhaps she really is about to die. All alone in the second-best guest bedroom. She calls out feebly, frantically, 'Laura! Laura!'. The cleaner who is dusting down the skirting boards on her hands and knees outside in the corridor hears her and runs off to get Laura who is anyway halfway up the stairs with a tray. Laura appears to find her mother making serious dents in the white Siberian goose-down pillows, gasping and wheezing. She looks terrible. Jesus, Laura thinks. For a brief moment she is taken aback, shocked at what she sees. She even contemplates, speculatively, sympathy or compassion of some kind. Then she swerves back into the real world and remembers that this is Lydia and therefore it's all an act anyway, an act which Laura has endured since early childhood. The, 'I am dying because no one is taking any notice of me!' act. Over the years it has in turns exasperated, infuriated and exhausted her. Now she is just bored with it.

'Take an aspirin, mother,' Laura tells her impatiently. 'God knows, I just have. I'm under so much stress today I can hardly see straight.'

Lydia looks up at her daughter. Ill as she feels she cannot help but notice that Laura has at some stage put an extra layer of eye pencil above and below each eye. Laura thinks it gives her eyes better definition. Lydia thinks it makes her look like a panda on heat.

'Laura – I feel so weak . . .'

Anyone would after the quantities of gin Lydia drinks for breakfast, Laura reflects wryly. 'Well, just eat your lunch and get some sleep then. Then you can go home.'

Lydia looks down at the plate of food before her and winces.

'I was thinking,' Lydia croaks, 'I might stay the night here. I

won't be any trouble. I'll just stay in my room and watch the TV.'

'Stay here? This evening? That's impossible. We have guests!' She looks at her mother in disbelief. Lydia really does look a strange colour. And she's never asked to stay before, ever. She's always told Laura in the heat of an argument, of which there have been more than a few, that she'd rather sleep on the streets than put up with Laura as a hostess. Which is, of course, unlikely to be necessary, as David is so graciously paying for the rent on Lydia's well-proportioned flat in Evelyn Gardens, but Laura understands that it's the thought that counts. 'Look, just eat your lunch, you'll feel better after that.'

Lydia looks down again at the plate of mush. What is it? she wonders. It looks as if it's fallen on the floor and been scooped up again. It looks as if it's been burnt on the outside, undercooked on the inside and mashed up to make the frozen bits softer.

'I don't think so,' she says. She pushes the plate away on the bedside table. 'I just don't think I can.' Feebly she calls out to her daughter, 'Laura darling, can we talk?'

'Oh dear,' Laura groans.

Lydia studies her daughter's face. 'What exactly are your feelings for David? I mean, I ask, because I want to talk about what you told me this morning . . . About leaving David.'

Laura sighs. But her mother is right. Leaving your husband is a pretty serious thing. She sits down on a rather lovely chaise-longue positioned in the bay window of the bedroom, overlooking the garden. The chaise-longue is covered in a very pale dove-grey velvet, almost silver, which sets off the serious violet of Laura's cashmere dress quite perfectly.

'Yes. I know. But – well, I've been searching my conscience all day and I just know it's right, it's the right thing to do. We only live once and I can't waste this one precious life letting him hold me back from being the kind of person I really am. The kind of person I could really be without him.'

'I see,' says Lydia. She lies. 'And . . . how do you think David will feel when you tell him?'

'David? Ha!' Laura tosses back her mane of hair. Then tosses it back again as it didn't fall quite right the first time. 'I know, I know, he'll be shattered. I know this. He's besotted with me. Oh God, you're right, it's going to be so hard for him.'

'Well, perhaps you should know . . .' her mother begins.

'Yes, Yes. You're right. He'll be devastated. Can I really do this to him? Look, I don't know. I just don't know!'

The phone rings.

Lydia, for some reason, because this gift of prescience thing is all a bit of an act really, knows that this call is going to have something to do with Laura's exhibition at the gallery.

'Wait!' she cries feebly, in an impulsive aberrant moment of remorse. 'Don't answer it!'

'Don't answer it? Don't answer it? First you start lecturing me about my husband, then you tell me when I can or cannot answer my own phone! I mean, really, who do you think you are! I will decide what I do or do not do in my own house! Thank you!'

'Oh well, go on then and answer it, you stupid bitch,' Lydia mutters under her breath.

When Laura does it's Isabelle. Her agent. What was that speech she had prepared? 'Issy darling!' Laura hyperventilates into the phone, 'I thought we said next Saturday . . .'

'For what?'

'Lunch!'

'Did we? No, I can't do next Saturday, darling, I'm with friends in Oxford next Saturday.'

'Oh. How about this Saturday then?'

'This Saturday? That's today. That's now! I'm already at another lunch . . .'

'Right. OK. Sure. So . . .'

'Anyway I was just ringing . . .'

'Of course. Lovely to hear from you. Really lovely. Sorry so

long getting to the phone but I'm right in the middle of painting actually, working on the new piece, you know, the one we want finished for the gallery window? I can tell you I've been struggling with it. Getting the mood of the composition exactly right has been hard, very hard. Then at 4 am this morning I cracked it. I found the shade of brown I knew I needed and everything else just fell into place –'

'Laura,' Isabelle interrupts coldly, 'I'm afraid there is bad news.'

'Oh?' Laura says politely. Bad news is always so boring.

'Yes. And I'm afraid I have to fess up' – (Isabelle at 54 has a new 22 year old boyfriend so she needs to talk the way she thinks they do) – 'that what I'm about to tell you is my fault. I was having drinks with Patrick, the gallery owner, last night and I had with me a friend who happened to have brought his portfolio along. He's a young guy, a plumber, that is, training to be a plumber, these things take a while, don't they? He's from Shoreditch, which everyone says is the next Hoxton so that's marvellous, of course. No art experience as such, but bags of talent. Well, Patrick took one look at his portfolio and he was smitten. He told me he only had room for one new show this autumn. It was either you or Shane. He said he'd sleep on it. Makes a change, I thought to myself. Patrick usually sleeps on something quite different! Anyway, I digress. Just now he rang me. And I'm sorry to say he's given Shane your slot.'

'I beg your pardon? Shane? My slot?'

'I'm sorry, Laura. I know this must come as a shock. But I think Patrick wants someone with a bit more edge for the gallery. You know – 35 year old housewife from Chelsea versus 22 year old plumber from Shoreditch. . . . It was no contest really. The PR machine is already going bananas – some woman is interviewing him as we speak for a big piece in one of the Sundays, I can't remember which, but they're all the same really, aren't they? I only slipped away because I

knew it was the least I could do, sort things out with you soon as poss.'

'I am not a bloody housewife!'

'I know that, darling. But it's all about perceptions, isn't it? And that is how you are perceived – as the rich wife of a successful solicitor. Who's interested in that? David's a nice man, but he doesn't play in the Premier Division, he doesn't run an ad agency and he doesn't work for the Labour Party. It doesn't make good copy. Anyway, I really must go. I –'

'Wait!' Laura cries. 'Let me just understand this. You think that it's basically David who's holding me back? Holding back my career?'

'Well, no, not exactly, what I –'

'Yes. Yes. What you were saying was that if only I were married to someone more interesting, more exciting, my PR profile would improve.'

Isabelle is rapidly losing interest in this conversation. She's bored with Laura. She wishes she could tell the stupid woman a few home truths but David, Laura's husband, made her swear that she would never reveal to her that the only reason Laura got the show in the first place was because he was going to pay the gallery to put it on. Now Isabelle has found someone the gallery actually wants to show – someone who also happens to be six foot two, hung like a stallion and ready to sleep with her. She trembles involuntarily at the memory of Shane's calloused hands rubbing her body the night before. An even warmer ripple of pleasure surges through her body at the thought of the sort of commission that his studies in u-bends would soon be clocking up.

'You see, I know it's all bloody David's fault!' Laura rants on bitterly. 'David and his *work*.' She spits the word out as if it were a curse.

'Well, thank God for that, eh? Keeps the wolf from the door,' says Isabelle. She is standing by the entrance to the restaurant where she has had to move to get a better signal on

the mobile. She is looking across the tables at Shane. From this perspective she can see his long lean body draped over the chair like the woman in The Kiss. His beauty is so total it is almost feminine. Isabelle shivers with longing. She has never felt like this about anyone. She has learnt even to love the odour of stale curry on his clothes and the way that he keeps his vest on while he makes love to her. She wonders if he will be wanting sex again tonight in the same position as last night – she was not sure her back could take it if he did. She was not sure she could bear it if he did not.

Laura's veins harden. 'I beg your pardon? Thank God for that? What do you mean? What are you suggesting?' she demands.

'Nothing! Nothing at all,' Isabelle cries. 'Except that, well, you know, a regular income . . . all those nice big court cases. And if your career as an artist is not quite . . .' She can't be bothered to find the words. Laura is starting to get on her nerves. Laura is the sort of woman who manages to have nothing while having it all. Beauty, more money than could be spent, an adoring husband and yet never happy.

She has said what she wanted to say; she can see Shane knocking back the Merlot. Here comes Amber, the hackette who's interviewing him, back from her trip to the ladies. Even at this distance Isabelle can see the tart has an extra coat of lipstick and an extra couple of buttons undone on her blouse. Amber sits down, Shane says something, Amber giggles. She moves her chair closer to Shane's. He reaches out and pulls it closer still. He's talking to her now, his mouth close to her ear, with that earnest expression of his. Which story is Amber getting? Isabelle wonders. The insane childhood, the years spent in care, the abuse, the solvents, the crime. All great for the media copy, but Amber has stopped jotting down notes in her dinky tiger-print notepad. That's because her hands are being grasped by Shane's as he talks.

This charming vignette is interrupted by Laura's insistent

barking in Isabelle's ear. 'Not quite? Not quite what? You're going to have to explain yourself, Isabelle. What do you mean? Exactly. What exactly do you mean?'

'Listen, Laura, I must go. Really. I'll ring you later or something, but I must go. Now.'

'OK,' Laura whimpers, shocked by the sharpness in Isabelle's tone. 'But first, quickly, you must tell me. Tell me the truth. Is David the reason why I've lost my show?'

'Possibly. Yes. He's one reason, anyway.' Anything to shut the woman up.

'But listen, Isabelle, what if David was not – permanent?'

'Not permanent?'

'Yes.'

What is she on about? Whatever it is, Isabelle isn't interested in it. 'The signal's going on the mobile,' she says. 'I can't hear you any more. Laura? Laura? Sorry. Can't hear you at all. So I'll say goodbye. Goodbye.'

Laura slumps back on the chaise-longue. The hair definitely isn't falling the right way now. She may be saddened by the loss of her show, but more than anything she is angry, angry with herself for allowing David to come into her life and impose his dull, dreary persona on her. She, who could have been anything, has ended up with a lousy PR profile and it's all because of him.

Could this be her reason? Can you leave a husband because he's getting in the way of your career as a conceptual artist?

Whatever, if there were any last shards of doubt lingering over her decision, this has dispelled them. She has to leave David, for the sake of her emotional and her professional future.

She looks across at her mother. Lydia has fallen asleep and is snoring gently. With her mouth open and her face in repose, Lydia looks her age and then some. Laura casts about in her shallow reserve of sentiment to find feelings for this person who is old and even possibly quite genuinely under the

weather. But she finds none. She wonders again about this nonsense of being adopted. On reflection she decides it is just that: nonsense. Lydia makes up things all the time; when she gets bored with the quotidian tedium of life she invents her way out of it. Lydia has always done this. It was hard to understand when Laura was five, but at thirty-five she can handle it.

Laura stands to go. As she backs noiselessly out of the room, Lydia suddenly opens her eyes. 'Uuurgh,' she moans. 'Uuu-urgh. Help me, Laura. Help me.' Her eyes roll around in their sockets and her jaw hangs loose. 'I'm dying, I'm dying,' she wails.

Laura leaves.

She's never taken her mother seriously and has no plans to start now.

<div align="center">★</div>

Louella gets back to the shop. It has taken her eleven minutes to walk there. In that time, she has decided that maybe this her and David thing isn't such a great idea after all. There is something about David which, on reflection, does not make him The One. He is dull, actually. Yes, if the truth be told, he is. His idea of conversation is not hers. He wants to talk about ideas. Louella wants to talk about people: about people she knows and what they're doing or not doing and what other people might or might not be doing with them. That kind of thing. And as for all that stuff about nicknames – really. The trouble with David is he seems so desperate to love and be loved: Louella doesn't like that in a man. A bit of space, some reserve, is always so much more appealing. Financially, too, the arrangement holds no water. Laura will demand millions and how much can a catering business realistically be expected to make? Yes, it's true that Louella's antiques shop is losing money hand over fist. But she opened it with a specific strategy in mind: that one day, some handsome moneyed type with an angled jaw and no emotional baggage would saunter in, buy a piece of Limoges and then propose. Who cares if in

<div align="center">140</div>

two and a half years her only customers have been the wives of the moneyed angled types? David will have enough baggage in the form of Laura to fill the hold of a Jumbo. And much less than an angled jaw, he has no chin at all.

She should be determined, stick to her original plan.

She would have to ring David and let him know it was all off.

First, however, there was the more important call to make: to Laura. One thing about Louella – she has the guts to say sorry when sorry is the word that's needed. Having spent half the afternoon snogging Laura's husband on the floor of their garage was not going to put her off doing the proper thing with her best friend now.

Unlocking the door to the shop she heads straight for the phone, to ring and apologise for having made that dreadful remark about the dress Laura had worn to the dinner party.

It hadn't been that bad really.

<p style="text-align:center">★</p>

Laura goes downstairs to ring up Louella. Louella will have calmed down by now and they can make up. Of course they will. They always do. Just as she's reaching for the phone, it rings and it's Louella calling to apologise for what she has said. This is the kind of thing that proves to Laura that whatever happens, she and Louella will be best friends forever really.

'No, no,' insists Laura, 'it's me who must apologise, it was something from last season's wardrobe which I should've chucked out months ago.'

'And what I said about the estate agent,' adds Louella, 'that was out of order – of course you must be allowed to do whatever you want in your own house, I shouldn't have pried as I did.'

'So you won't tell David about the estate agent and my plan to leave him and everything?'

'But of course not, it's none of my business.'

'Do you, as my best friend, think I should tell him, tell him sooner rather than later?'

'No! No! You know what I think. That all this will pass, that it's just a whim. Leave it for now. Give it more time. See how you feel when you've had a chance to give things some proper thought.'

Although Laura doesn't much care for Louella's slightly condescending tone as she delivers this edict, she can hardly start up another row about that so soon after the last one. Laura says she'll reflect on Louella's point of view, hangs up and immediately regrets it. She doesn't want the silence, the space in her head and all around it. She would rather have talked to Louella about anything, about the price of handbags, the cover of that week's Country Life, the feasibility of combining a Gustavian chair with an Arts and Crafts dressing-table in the same bedroom, than just stand there, in an empty kitchen with only her own future to contemplate. Immediately Laura rings Louella back but the line is engaged. That feels wrong somehow. It feels like rejection. Laura wants to shake off this strange contemplative mood she seems to have got herself into but she cannot. So she decides to work in the direction of her spiritual energies rather than fight them. She sits cross-legged on the floor and lets the forces work through her.

Suddenly she feels so lovely, lovelier than ever in fact. She reflects how hard it is to live life sometimes. To live it fully, with a clear conscience and to adapt to change, to develop. To evolve.

Of course, Laura tells herself, she has to accept the fact that, after she has left him, David will have a new life. New women. And Laura will have new men. She tries to picture the scene. They are in a restaurant. Laura is with her boyfriend – probably this time she'll go for someone in the media. One of Louella's friends has just hitched up with someone in 'strategic media consultancy' which sounds divine. She's noticed that people are much more interested in men from the media

than they are in lawyers. At dinner parties, whenever David is asked 'what do you do?' and he merely replies 'law' in that off-the-cuff, blunt-to-the-point-of-rude way of his people always go slightly pale at the prospect of having to look intrigued by the workings of the judiciary for fifty per cent of an entire dinner party (hopefully they'll have someone more fun the other side of them).

So she's there, eating oysters with her strategic media consultant when David walks in. David will be with someone he's met at a conference, a nondescript type, in a grey suit which could well be chain store, at least the way she wears it. They will sit at a table in a corner and talk work, even though they are meant to be lovers. The woman will order too much, wave her cutlery in the air to make a point and finish everything on her plate. At one point David, bored, will glance across the restaurant and see a table basked in sunlight. He will see Laura. She will be laughing as she raises the champagne glass to her lips at something amusing and intimate that her consultant has just said. Then her consultant will lean across the table and press a package into Laura's immaculately manicured hand. It is a gold necklace. Why? Why not? Because it's Tuesday. Who needs a reason? Laura puts on the necklace. The gold of the gold glimmers in the sun.

David will see all this and David will sigh and turn back to his girlfriend and sigh again. He will have lost Laura and he will have no chance of getting her back.

He should have tried harder when he had the chance.

She finds herself thinking of the time when she and David met. Perhaps this is appropriate: now that she is about to leave him. She does not resist the recollections as they tumble towards her: she lets them come.

★

When Laura and David first got to know each other, she was there as a temporary secretary in his office covering someone on maternity leave. Laura always seemed to get bored with

143

permanent positions, or they got bored with her, so temping had for a long time by then seemed like the best idea.

Everyone, everyone in the office was in love with the handsome Mr Denver-Barrette, with his power, his money, his cars. Everyone dreamed of being with him; only Laura decided that she would. She had never been so sure about anyone: he fitted her identikit for a husband perfectly. On the way home from work she bought herself a little notebook and wrote in it a ten point plan to get him. It was mid-October, ten weeks before Christmas. She would do one thing a week and she promised herself that by Christmas, she and David would be engaged.

In terms of basic groundwork there was little for her to do: Laura was already easily the slimmest, tallest, blondest and generally most gorgeous woman in the office. It was merely a question of getting David to stop working long enough to notice it. There was also one other small problem: he already had a girlfriend, some divorced older woman called Barbara. Laura reckoned that if this Barbara had already been through the end of a marriage then breaking up with David, someone she didn't even live with, would be no big deal. So Laura saw to it that Barbara was dispatched. Quietly but efficiently, with just a few careful words in her ear. Laura was determined. Laura was ruthless. Laura was going to get her man.

WEEK 1

Laura sends herself fifty long-stemmed red roses. This costs her quite a bit but the other secretaries at work are always getting lavish bunches of flowers from enthusiastic young lawyers so it has to be something dramatic to make any sort of an impression. Laura tells herself to think of it as an investment rather than a cost. She has instructed the florist to write I ADORE YOU on the card – no name – and not put the card

in an envelope. The flowers arrive and the office comes to a standstill. Laura engages herself on a long phone conversation with directory enquiries to give the flowers plenty of time to sit at reception and generate maximum impact. Finally, David goes over to reception to greet a client. Laura hears Tricia, the receptionist, say in her inane sing-song voice, 'Seen Laura's flowers, Mr Denver-Barrette? Aren't they bee-oo-tiful?' 'Who's Laura?' he says. 'She's Laura,' trills Tricia, pointing.

Laura, at that moment, just happens to look up and smile. A warm, radiant, captivating, alluring, guileless, sincere, fresh, honest smile.

Her lips are moist, her teeth are white.

Their eyes make contact.

£120 well spent.

WEEK 2

The whole office goes out for drinks after work to celebrate David's birthday. Beverley, one of the accountants, has just been dumped by her boyfriend and is drinking too much. Laura buys her an orange juice to cheer her up and gets the barman to stick three shots of vodka in it. Beverley drinks her drink; suddenly she can't cope any more. She starts weeping and cannot stop. She puts her arms round Laura's neck and weeps and weeps. Laura comforts her. Beverley cries so much she gets one of her nose bleeds and then passes out. Laura asks everyone to clear a space and then gives Beverley mouth-to-mouth and puts her in the resuscitation position. (Laura took her First Aid badge as a Girl Guide and watches a lot of hospital drama on TV). Beverley comes to; blood from her nose is all over Laura's suit. Beverley's father turns up to take her home. He thanks Laura; she laughs it off. No, really – she's just happy that Beverley is OK. It was nothing, nothing, really.

Oh, the suit – never mind the suit. The blood will all come out in the dry cleaners. And what's more important – a designer suit or Beverley? David comes over to ask if Laura's all right. Oh, it was nothing, nothing, really. Oh, the suit – never mind the suit. It'll all come out in the dry cleaners. And what's more important – a designer suit or Beverley? David asks if there's anything he can do – he's feeling guilty because it's his drinks party. He feels responsible. Don't, really, Laura urges. She puts her fingers lightly on his arm. Not forward, just friendly. She smiles at him – again. Her front may be splattered with the contents of Beverley's nose but her make-up is immaculate. Her face is perfectly symmetrical. Her skin is flawless. Her eyes are the deepest shade of green. All this David notices.

'You're very sweet,' he says. 'At least let me pay to have your suit cleaned,' he protests. 'No – really!' she says. 'Well, at least, let me take you out for lunch,' he begs.

'All right then,' says Laura. Just to be kind really.

WEEK 3

David sends Laura a memo to ask her if she's still OK for lunch. She waits a whole day then sends him a memo back. It consists of one word: 'Sure!' Light. Happy. He suggests a restaurant for the following week. She memos him back. One word: 'Fine!' Light. Happy.

Gotcha.

WEEK 4

On the appointed day of the lunch, Laura has placed an ad in The Times under 'Deaths':

'BANBURY Priscilla Nancy – adored "nan-nan" of Laura

Banbury, passed away in her sleep in her beloved granddaughter's arms after a short but traumatic illness'.

Laura waits until David emerges from the men's lavatory whereupon he finds her standing sobbing against a wall, newspaper in hand. When he enquires gently as to the cause of her distress, all she can do is flap the paper wordlessly under his nose. 'Your grandmother – I'm so sorry,' he chokes. Laura nods as tears fall. Slowly, the words come . . . Her grandmother meant the world to her. She was always left with her when she was a child and her parents were away, pursuing their own careers. She, Laura, will never do that to any child of hers. She'll stay at home and love and nurture her babies. She has to go to the funeral – does David understand? – of course he does. Lunch – she was so looking forward to it but now . . . Controlling the tears no longer, Laura runs elegantly from the office leaving a stunned David helplessly watching her go.

For the rest of the week, Laura wears black.

WEEK 5

Lunch.

WEEK 6

On the Monday, Laura goes out at midday and window-shops for two hours. Then she pops into a café opposite their office with a large amount of bandage. She binds one ankle to the hilt and waits for David to come back from his afternoon meeting. As he runs up the steps to the entrance to their building, she is limping up them slowly. He expresses concern; she's says it's nothing, really, just a small sprain sustained while

running in a marathon for a charity at the weekend. She tried to cope with the pain all morning but in the end it became too much and she just went to the out-patients of the local A&E to get it bandaged.

David insists that he drive her home at the end of the day – she can't possibly take the tube in her condition. Reluctantly, Laura accepts. During the afternoon her small sprain gets worse and she has to be practically carried (by David) out of the building. He takes her home in his Aston Martin. By happy chance her flat is beautifully clean, full of fresh flowers with a couple of bottles of 'Farniente' chilled in the fridge. David accepts her offer to stay for a glass of white wine. She regales him with stories of her fellow runners. He leaves at 1 a.m., smitten.

WEEK 7

David and Laura have not technically made love – when he tried to, the previous Monday, she refrained because of her ankle. David, full as he was of good white wine, could not quite make out the anatomical configuration required to understand how having sex would (necessarily) affect her ankle. Every other part of Laura's physique, certainly appeared to be in full working order. Especially her tongue. His ears had never felt so clean. He could shut his eyes in the middle of a meeting and still feel her small pink tongue rasping in his ear, her hand manipulating his flies. He could still smell the smell of her, of her perfume, her breath, her thighs. David spends a lot of this week with his eyes shut. David gets little work done. Laura ignores him completely

WEEK 8

David comes into work on the Monday in a daze: he has spent the weekend in a frenzy of desire for Laura. If he doesn't get her tongue in his ear again soon he will surely die. First thing Monday morning he sends her one hundred long-stemmed red roses with a note that says, 'Please have dinner with me – David'. No envelope. The office comes to a standstill. Laura sends him a formal memo thanking him for the lovely bouquet. What about the dinner? he begs back. Next Tuesday, she replies. She definitely might be free next Tuesday for dinner.

WEEK 9

Tuesday.
Dinner. Full sex. Love.

WEEK 10

Proposal.
Result.
(David has never felt her tongue in his ear since.)

CHAPTER 5

David is in his bedroom, flinging clothes into a suitcase. Actually he is not flinging because David is not the flingy type. He is carefully choosing, folding and packing coordinated items of clothing which will suit a range of weather conditions suitable for wherever it is that he and Louella are eloping to. This includes a dinner jacket and tie for Claridges; much beyond that he's not quite sure.

He's going to leave Laura, leave her straight after the dinner this evening. He wants it all to happen quickly. He wants it to happen right now before he has time to think it through and change his mind. He wants to feel emancipated. And liberated. He wants to be leaving his wife with whoops of joy. But the whoops don't come. He was so sure about Louella. He was so sure that he was in love with her. Now he's wondering whether he wasn't happier with the Louella he was wanting to be in love with rather than the one he's actually got. There was something about the way she reapplied her lipstick after their last kiss and then wouldn't give him one final kiss before they parted which reminded him of ˙. . . well, Laura. Surely passion at this stage of a relationship should be more unbridled. It always was before this, when he was dreaming of her in the car. Then that comment she'd made just after they'd decided to run away together when she told him not to bother packing his navy leather bomber jacket because she'd never liked it. That didn't feel good. David is holding the navy leather bomber jacket in his hands. Laura didn't like it either. But he does. He does.

Suddenly David is sitting on the edge of the bed, holding his face in his hands. He is no longer sure of anything. This is a place he's never been to before. He's been sure of everything all his life. He was sure of life even when he got up this

morning – sure of this business deal, sure he wanted sex with his wife, sure he wanted to go to the gym, come back, have lunch, watch the rugby and maybe have a little snooze. How can he go from being so sure of all that to being sure of nothing?

Something has changed today. And it's almost as if instead of him making the changes, the changes are in control of him.

Doesn't he love his wife any more? He has done, unconditionally, for fifteen years. Yes, he's had fantasies but all men do that. He's had moments where he has wondered what things would have been like with Barbara and, yes, Louella, but they were only random daydreams which meant nothing, nothing at all. Laura was his wife. Sometimes she irritated him but basically, once he had married her, he stopped analysing the relationship. What was the point of wondering whether things were going well, badly or indifferently? They were married so nothing was going to change anyway.

Until today. Today, it seems, everything has gone, fragmented, shattered in a matter of hours. All those years and years of affection, arguments resolved with effort, compromise, consideration and goodwill, just tumbled out and gone. Is that really possible? Won't they go to bed together tonight after the dinner and wake up tomorrow morning and everything will be back the way it was?

If David really is going to be waking up next to Louella in a suite in Claridges it seems not.

And is Louella his dream woman?

Er, he doesn't think so. Not really.

So why's he embarking on this with her now?

Does he feel excited or terrified by the fact that life can change so quickly, so radically? He checks consciously and deliberately what his feelings actually are – he's not used to doing this.

He checks and checks but nothing comes. He feels nothing. He feels numb. Then, erratically, uncomfortably, strange

feeling things start to come up from his stomach. David hasn't had sensations like these for years and years. There's been no need for them. He doesn't need them for work – the fewer feelings the better there – and he hasn't needed them for his relationship with Laura. He's married to her.

Now here they are, popping up in front of him, willy-nilly, uncontrolled and, worse, uncontrollable. It's like what he used to have with Barbara, masses of big unruly strong feelings. The past fifteen years have suppressed them, anaesthetised them so successfully but it turns out they have been there inside of him all the time. Now he feels a bit confused. Almost scared. A little elated. And none of it is coming from his head. Amazing. Everything always comes from his head. This isn't from his head. It's from his stomach. Yes. He is feeling though his stomach and then it's going to his brain and it's totally different, a totally different way of processing his life.

What is he doing? Why is he doing this? Where has his easy, ordered existence gone?

There is fear but there is more elation than fear. There is more excitement at the rediscovery of his self than there is terror at what it's going to tell him.

But then he hears someone outside the door. God, it's Laura. He shoves his suitcase swiftly to the back of the wardrobe and slams the door shut.

It's not Laura. It's the cleaner.

'Oh! Hello!' he cries, swooning with relief. 'Hello, er –' he wants to say her name but then remembers he isn't quite sure what it is. Laura did tell him once. Something sch-y. Was it Sacha? Masha? Babouschka? He makes a supreme cranial effort. 'Anouschka!' he announces eventually, triumphantly.

'Meester David,' Anouschka announces solemnly. 'I come to talk you about us.'

David freezes. 'Us?' he asks.

'Yes. Please do not make questions about my English. I know exactly what I say. Us. Our future.'

'Future?'

'Meester David – is very boring every time I make a question you make me another. This morning we have copulation. Very large copulation. I no now can be just chucked in dustbin.' Anouschka's nostrils flare. She feels the blood of her ancestors pumping through her veins. She will fight for what is right.

Is she mad? What does she want, this girl? Money? David wonders (but dare not ask because that would be another question). He reaches for his wallet and gestures to her with it. Anouschka recoils as if wounded.

'I no want money!' she yells, then immediately forces herself to calm down. To breathe deeply. She must stay calm for the sake of the baby. She must remember that this kind of confrontational approach will never work. In her time as a cleaner she has had ample opportunity to study a full range of human behaviour and is in possession of a valuable set of conclusions from her observations. She needs to keep reminding herself that it's hard for a man to leave his marriage. She must support her darling Meester David, make life sweet for him, not bitter like the unripe turnip.

Maybe, also, Meester David is worried whether she really loves him. Really, really loves him. Perhaps he needs some reassurance. If only Meester David understood Anouschka's language – what loving things she could say to him! Zzybrzy blechzy naya plz dzry! ('I will pluck you, my tender nut bush!')

'Meester David,' she returns more calmly. 'I see through slit in door you are packing case. Is for us to go?'

'Er – no. No. I was just . . . sorting out some clothes, that's all.'

'So! You no want me after all? You want your wife!'

'No.'

'No! Don't tell me no! You want your wife!'

'No. I don't want my wife. I swear.'

'I don't understand. Who you want?'

David starts to feel like he's got lost on the set of some low-budget European film. What's he doing, packing clothes he doesn't want to pack, not packing the ones he does want, confessing to his cleaner that he's about to leave his wife for his wife's best friend even when he's not completely sure that he is?

'Look, Meester David, I tell you again, this morning we have copulation –'

'– I know and I've offered you money but –'

Anouschka holds up an imperious hand, still festooned in its yellow rubber, to silence him. 'I am saying, this morning we have copulation and now, now I having baby. Your baby, Meester David.'

There is a long silence.

David's stomach triple salcos. 'Baby? But that's ridiculous. We only did it this morning.'

'I know. But tests you can get now is very quick. At lunch I go Boots, I get test. Is bombs away.'

This is not true, of course, but Anouschka first of all is only standing on one foot which means her lie will not come back to haunt her, and second of all she must be pregnant because her mother told her once if you sleep with a married man you get pregnant straight away. Life always takes the cruellest path. Anyway, she is certainly beginning to feel very pregnant, very tired and a bit dizzy, although the ammonia Meesees David makes her use to clean out the lavatories often has that effect on her.

David, whose mother never really talked to him about this kind of thing, asks himself whether it might be possible for a woman to be, well, screwed at 10 a.m. and know she is pregnant at – he touches base with his watch – 3.35 pm. When he thinks about all the advances made in car technology in recent years it seems to him that actually perhaps it would be possible. In fact, the more he thinks

157

about it, the less possible it seems and the more probable it becomes.

Suddenly it hits him. She is telling the truth. The woman is carrying his baby. His baby. This is the one thing he has wanted most in life – to hold his baby son, his boy, in his arms and know himself to be a father. He thought it would never happen. He had accepted it, never forgotten it but accepted . . .

'This test . . .' he begins, his eyes watering, his words faltering, 'does it tell you what sex the baby is?'

Anouschka nods gravely. Men always want sons. What girl earns a decent living? She doesn't, Meesees David doesn't. It's the same everywhere.

'Is boy,' she intones.

David gasps.

Boy.

He gazes at Anouschka. How could he have been so stupid? This fresh-faced girl, who has been cleaning his home for God knows how long (so many cleaners have come and gone and they all look the same to David) – *she* is the dream woman. A simple, fertile, honest, natural woman. Now that he thinks about it – because to be honest he hadn't given it much thought up till now – she had been pretty good in bed that morning as well. Plus she can clean (obviously). She looks like the sort who can cook. And now she's having his baby. What was he even thinking of, planning to run off with Louella? Louella is just Laura with a slightly different hairstyle. And suddenly he knows, he does know what he feels. He knows he is sick of Laura, sick of Louella and of the whole neurotic set-up that comes with women like them. The dinner parties, the designer clothes, the furnishings, the holidays, he'd had enough of it all. He's so tired of all these so-called sophisti-cated women who want to tell him what to do all the time. He holds Anouschka's face gently. 'Let's run away together, you and I.' Her tears fall onto his hands. Personally she would

rather take the car but she likes the sound of the 'together' bit anyway. 'We'll start a new life somewhere – in the country – a lovely house with a tennis court and a heated swimming pool – a haven of happiness for our baby son.'

A shadow passes over Anouschka's pale face.

'What is it, darling?' David asks tenderly.

'In country but still near shops, yes? I like shops.'

'Shops? Sure. Shops, of course.'

'We go now?'

'Now? No.'

'No now?'

'No, no now. I must wait – till this evening. To sort things out with my business – you understand.'

Anouschka nods. She doesn't but it doesn't matter, she's worried she might try his patience if he realises that she only understands such a small fraction of everything he says.

The tears were sweet but now a long thread of snot hangs from the tip of her nose which is less endearing. David passes her his monogrammed handkerchief, the one she ironed for him only yesterday. Ah sighs Anouschka, by-passing her nose, pressing the handkerchief to her bosom. The first of many presents. Of course.

'I keep this?' she asks eagerly.

'Um – sure.'

'I treasure it forever, Meester David!'

'OK. And – perhaps you should call me David. Just David.'

'OK! OK!' she enthuses. Then her guard goes up again. 'How I can be sure you no change your mind? You no let me down?'

David stares at her. 'Well, I don't know. If I give you my word?'

'Your word? What word?'

'My word. That I just say I will, and you know that I will!'

'Oh. OK.'

She is disappointed. He sees the dejected look on her face,

her pale round face which is shiny with excitement. She really has quite a pleasant face underneath those solid walls of hair. Nice eyes. Long lashes. Almost pretty. Almost, at a certain angle, beautiful. 'Look I tell you what, take this,' he says. He reaches into his wallet and stuffs a bunch of £50 notes into her hand.

'Why you do this! Why! I tell you already! I no want your money!'

'I know. I know. I'm not paying you. I'm just saying – take this, and go and buy yourself some clothes, get your hair done, pack your stuff and come back at midnight. Wait by the garage. I'll come out, in the car, and we'll go, just go. We'll leave together and start our new life. All right?'

Anouschka starts crying.

'I know,' says David sympathetically, patting her moist hand. All this must be overwhelming for a simple cleaner like her. 'This is a lot for you.'

'What lot? What make me sad is you say I do my hair. What wrong with my hair?'

'Nothing,' says David, fondly stroking the greasy blankets either side of her face. 'I just thought it would be fun for you. Something to do while you're waiting for me to finish this business meeting. I'm sorry, I have to go ahead with this meeting. It's so important. Otherwise, I'd leave now. I'd go with you now.'

Anouschka looks down miserably at the notes in her hand.

'OK,' she says. 'Thank you.'

She's sweet. She's honest. He likes this, he really does. He says, 'You still look so confused.'

'You think all I want from you is money. Like Meesees David. I want you know I not want you for money. I love you, Meester David, because you are Meester David!'

David does not know why but suddenly he feels terribly happy. He tugs at the signet ring on his little finger, his father's

160

ring. He pulls the rubber glove off Anouschka's hand and puts it on her finger.

'This was my father's ring. I haven't taken it off since the day he gave it to me. I want you to have it. Now you know that I will not change my mind. I will not let you down.'

'OK,' she says. She would have preferred something with a diamond but this is quite nice. 'I keep it. But only till baby is born. When baby is born, I put it on his finger.'

'But it'll be too big!' David protests. (He is a solicitor after all – detail is important.)

'No, he must have. What belong to father must go to son.'

Son. Son. The word leaps and pirouettes round his head. The son. His son. David is to have a son. A new life with a son.

Suddenly everything is wonderful.

David kisses her lightly on the lips.

'So, is see you midnight!' she whispers.

'Yes – midnight!' he cries. And when he says it, for that moment, he actually means it.

<div align="center">★</div>

Laura is in the drawing room re-arranging the flowers which she'd re-arranged this morning but which still didn't look quite right when you came into the room from the left.

David comes into the room and goes out again.

God, everything about him irritates her so much.

<div align="center">★</div>

Laura is wondering: is this what she really wants? Really, really wants? Because, let's face it, to break up a marriage is a very serious thing to do.

Perhaps she should make a go of it. Perhaps she has been hasty. Perhaps she should give the marriage one last chance.

Yes. She will. She will do that, hard as it will be. She sighs the sigh of the long-suffering. Perhaps her expectations, her hopes of happiness are unrealistic. The relationship is not perfect but Laura is not stupid – she knows that nothing is perfect in this life. David is attentive, affectionate, considerate (up to a

point), thoughtful – often – and kind. So what does she want? Perhaps she wants too much. She has a good life, after all. Her only commitments are to organise the house, manage the social diary, keep herself looking slim and better looking than anyone else David is likely to meet, and then, on average, once or twice a week, to open her legs. This was surely not so hard for her.

So what is it then? Why doesn't she love him more than she does?

Then the word arrives, unannounced, in her head.

Desire.

Desire! This is it. This is why. She does not desire David.

She fumbles feverishly for the phone.

'Louella,' she begins, even before Louella has picked up and remembered to cough. 'Desire. That's it. I have no desire for David. I don't yearn for him, crave him, long for him. If I did, why, then nothing else would matter – would it?'

'Laura – I have a customer.'

'No, you must listen. Desire: lack of: do you think that could be a reason to leave David?'

'I'm sorry but I'm not quite sure what you're on about. Desire? Hm. Desire for what exactly?'

'For him! To feel excitement at the sound of his voice on the phone; a lurching in my stomach whenever he enters the room.'

'Eurgh.'

'What?'

'You make it sound like gastroenteritis.'

'Please Louella – work with me. Desire: should I expect it? In a marriage, I mean? And, if I should, and if it isn't there, is that a good enough reason to go?'

'So when you say desire, what you really mean is passion.'

Of course! Passion. This is an even better description for it. Strike desire. Passion. Passion. That's the word Laura is after.

'Yes! Yes! Passion. Louella, I knew you'd understand.'

162

'The thing is, really Laura, I can't discuss this now,' insists Louella breaking into a loud stage whisper. 'There's a woman here who's interested in that ebony chest of drawers and she looks like the type of amateur who's not going to notice the repair work. I have to go back to her now.'

'But Louella – this is important!'

'Nothing is more important than a customer,' Louella hisses gently, replacing the receiver as she does.

Almost immediately the phone rings again but it's not Louella ringing to say she's just realised that friendship is more important than a few pounds profit on a battered chest of drawers, it's Karen, David's dreadful sister.

'Is David there?' she demands, Karen and Laura having mutually renounced small talk some years back. Karen had been at one of Laura and David's parties where Louella had made some criticism of Karen's green velvet alice band. Karen was, historically, sensitive about her alice bands. She had told Louella that she considered her remark to have been below the belt; Louella had replied, loudly, that she would have thought Karen would be grateful to have anything below her belt nowadays. Karen, outraged, had demanded that Laura ask Louella to leave. Laura explained, rather patiently she thought, that Louella had been drinking so anything was to be expected from her. Karen had said that if Louella didn't leave, she would. Laura had, rather politely she thought, gone to get Karen her coat.

'No,' Laura replies coolly.

'I see,' exclaims Karen, taking David's absence and Laura's communication of it personally. 'When will he be there?

'I don't know,' says Laura. And all at once it occurs to Laura that if she's giving up David, she'll also be giving up Karen and she will never have to hold, bite or watch her tongue with her again. This sends a frisson of elation down Laura's spine. No more Karen. Oh the joy.

'You don't know?' Karen repeats, appalled.

'No, I don't. I'm his wife not his secretary.'

'No. Not any more,' she offers quietly.

Bitch.

'In fact,' Laura continues, furious, 'I won't be his wife for much longer either.'

'Really?' Karen comments with as much irony as she can muster, but Laura can tell she has got her attention.

'Yes, really.'

'And why's that, exactly?'

Ha. Who's in control now!

'Because, Karen, I am leaving your brother.'

'And I said – why's that?'

'Why?' says Laura. Here we go again. The receiver starts to sweat in Laura's hand. Why? Why? Why must it always be bloody why?

'I'm waiting for an answer, Laura,' Karen's thin voice persists.

There is nothing for Laura to do but hang up. She hopes this gesture is sufficiently dramatic in its own right to obviate a more articulate response, given that it is the only response, for the time being, which she has.

Anyway, no point in debating the pros and cons. Laura is leaving David. She has told the revolting Karen she is leaving David and she can't lose face with her now.

*

David is many things but he is not a coward. He knows he must face the music with Louella. Part of being the new David (or rather, the new, new David, because he was new at lunchtime when he was making a formal commitment to Louella, while on top of her on his garage floor; now, at tea-time, that he's in love with Anouschka and determined to spend the rest of his life with her, he's even newer) is that he must confront all his demons with courage and integrity.

And the mental picture he has of Louella right now is certainly pretty demonic. Louella does not like people who

cross her. He knows that from her dinner parties. People at her dinner parties who don't make enough fuss of her *crêpes farcies* end up feeling like one. He heard once about an ex-boyfriend of hers, a judge, who found his name in a personal ad in The Daily Telegraph with information about the stuffed toys he kept in his wardrobe. Louella, once crossed, took no prisoners.

How did he even get into this mess? His day had started so normally, so predictably, just like any other Saturday – wake up, Laura in bad mood, breakfast, sexual rejection by Laura. How did it disintegrate into this? His feet start to drag as he approaches her shop. What, exactly, is he going to say to Louella? A couple of hours ago I was promising you everything, now I've found out the cleaner is pregnant with my son and I'm leaving with her instead?

Then he has a wonderful idea – he will buy Louella a present. Women like Louella always want presents, he's learnt that much about them, and it will soften the blow. Whatever damage he's caused at home, he can usually get Laura to reduce the obligatory sulking by at least half if he gets her an expensive gift. The shop next door to Louella's is also an antique shop. He nips in and spends £360 + VAT on a rather pretty cherub pot on a stand type thing with only slight damage at the base. Laura loves cherubs, he's sure Louella will too. He asks the woman in the shop (who's rather good-looking actually, but enough already) if she'll gift-wrap it for him which she seems only too happy to do.

'Is this for anyone special?' she asks affably.

'Well, sort of yes . . . It's for Louella, the woman who owns the shop next door. I assume you know her?'

At this the woman starts to laugh – a low on-going gurgle of pleasure.

'My goodness,' she chortles, hardly able to find the words through her chimes of laughter, 'if it's for Louella then I'll throw in the gift-wrap for free. It's normally ten pounds, you know,' she explains with delight.

'Why thank you!' David exclaims. People can be so nice when you least expect it.

Triumphantly he appears at Louella's shop window. If she's busy he'll wait outside. Obviously theirs is a conversation which needs to be held in private, he's worked that one out already.

But the shop is empty, and Louella is sitting there, squeezing something out of the side of her face as she peers into an ornate dressing-table mirror.

'Oh!' she cries, as David presents himself. 'Oh! I was just checking the quality of this mirror. It's French you know. Eglomisé, a special technique involving silver on the glass. Or in it. Or under it. Something like that.'

Oh dear, thinks David. She's so flustered. This is going to be harder than he thought.

'Look, Louella,' he says, summoning up courage and integrity et al, 'I'll come straight to the point. This morning, I mean, I know it wasn't exactly morning, more early afternoon –'

'– you mean, when we were in your garage?'

'– er, yes.' (He wonders whether this clarification was quite necessary.) 'Well, it was a mistake.'

'I know,' sighs Louella.

'Do you?'

'Oh yes. I do. I was going to ring you myself and tell you. I've thought about it and it's obvious. Laura. Her heart would be broken. I mean, it would be bad enough to lose you, such a reliable source of . . . affection. But to lose you to me, her very best friend, her confidante – well, I think that would simply break her heart, yes I do.'

David wonders what would happen if he just doesn't say anything at this stage? He is still planning on leaving Laura, it's just that he's no longer leaving her for Louella, he's leaving her for the cleaner instead. Will this unspoken fact constitute a lie which will discredit his integrity?

Conveniently, he decides not.

At this point there is a long pause. There is really nothing more to be said but of course after the reciprocal dumping of a relationship etiquette demands some verbal niceties before closure can be effected.

'Are you busy? In the shop I mean,' David qualifies quickly in case, perversely, she might interpret this as a prelude to asking her out on a date.

'Oh, well, yes. Yes, I am. Quiet at the moment. But you often get that, then all hell breaks loose. Lull before the storm, I shouldn't wonder.'

David smiles agreeably. More silence. Then Louella looks at him and has a thought.

'Er . . . that is why you think it's a mistake, isn't it, David? Because of what it would do to Laura? I mean, not through any insufficient feeling on your part for me?'

'Oh – oh no! I mean, oh yes! Your feelings are uppermost in my mind!' Then he remembers the present. Thank God for the present! 'In fact, I wanted to show you those feelings by giving you this!'

With something of a flourish he produces the package. Louella looks so excited he's worried she might pass out.

'Oh Daaayvid,' she intones. Perhaps she's acted rather too rashly dumping him, if this is the kind of man he is. How long is it since a man's given her a present? She clasps the package to her bosom. Visions of jewellery float like cartoons in front of her closed eyes.

'Oh Daaayvid,' she repeats, not seeming capable of much else. She examines the lavish wrapping, the navy paper and turquoise bows. She doesn't immediately recognise it as either Tiffany or Bulgari. She looks at her watch. Would David have had time to get to Bond Street and back since she left him? 'You shouldn't have, but I am so glad you did. May I open it now?'

'But of course,' David replies courteously. He's rather enjoying all this. Perhaps he should give other women large gifts more often. Laura never responds like this.

With ungracious speed Louella rips open the wrapping.

'Careful!' warns David. 'It's very fragile!'

'Is it? Oh dear,' Louella complains. Since when was a Cartier necklace fragile?

A few seconds later she holds in her hands the very same repro cupid she sold to a dealer the week before for £50. That was not a great deal more than she'd paid for it herself but she was sick of the sight of the thing gathering dust in the shop.

'Where did you get this? she gasps.

David preens, 'Well, as matter of fact I bought it in the shop just next door. Laura says I've no eye for antiques but I rather think –'

'Next door? Not next door as in that next door?' Louella points a blood red talon accusingly to her left.

'Why yes. The antiques shop just next door. I suppose you know her . . .'

Know her? She was only Babs, Louella's arch-enemy and greatest rival, a jumped-up ex-showgirl who existed solely to make Louella's life a misery.

'How much did you pay for it?' Louella asks miserably, turning over the wretched piece of painted paste in her hands, noticing the large chip in the base which wasn't there before.

'Well, it's a present, I hardly think . . .' David stutters.

'How much did you pay for it!' Louella shrieks.

'Three hundred and sixty pounds,' David squeaks.

Louella wheezes and slumps onto her desk.

(Should he tell her about the VAT, David wonders?)

'Please, please don't tell me you told her it was for me . . .'

'Well, as a matter of fact . . . I . . .'

'Eurgh. You did. You diiiid.'

David knows he has done something badly wrong. He is not sure exactly what. He thinks the best thing, perhaps, is if he leaves. Straight away. Saying nothing else. As he backs away towards the shop door Louella suddenly rushes at him. He cries out, afraid that she is about to attack him. He prepares to

defend himself as best he can. Sure enough Louella flings herself at him, thrusting her arms around his neck. 'Oh David, I beg of you, if you care anything for me, if even one shred of affection remains for me, please, please, take something from the shop and walk out with it!'

Oh dear. Poor Louella. It's all been too much for her. 'Take something? I'm not sure I . . .'

'Yes! Something too large to wrap but small enough for you to carry. This table – yes this mahogany table. It's a lovely piece. Inlaid with mother of pearl or something damn near it anyway. It's worth quite a bit. Nothing like the £2,000 on the price tag, of course but a fair bit anyway. You can carry that, can't you? Please, please take it, free, with my compliments, just take it and carry it out, back in the direction you came from, and when you are in front of Babs' shop, will you, stop, please, say you'll stop and turn and wave at me, and cry out, yes, something, cry out: "I'll be back for the rest of the stuff later!" or: "I'll look forward to the delivery of the rest of the stuff later!" Please, David, pleeease!'

David is now really scared. At this point he would do anything to get out of this shop. He grabs the table. He makes for the door. He hesitates. 'So which is it: "I'll be back for the rest later!"? or "I'll look forward to the delivery of the rest later!"?'

They both pause to think.

'Either, David, either one will do,' Louella cries with what little energy is left to her.

'Fine.'

David leaves. He passes the shop next door. He stops. He waves the ugly table high in the air. He calls out loudly, 'I'll be back for the rest later!', because he's always preferred a succinct script whenever possible. Louella waves happily from her shop, her charm bracelet jangling with relief.

Babs' shop, he can't help noticing as he walks on, has 'Just Nipped Out For Five Mins', pinned to the door.

As he continues up the King's Road it occurs to David to worry about the fact that Louella had changed her mind about him so quickly. Even though that's what he did, it was different for him because he had his reasons – what reason did Louella have? Did she really care so much about Laura? Or did she just change her mind because she didn't fancy him enough? Then he looks down at the table he is carrying and realises he shouldn't be wasting his time worrying about that – he's got something far more serious to think about.

Laura is going to hate the table.

Just as he turns into Cheyne Walk he stops and looks around him. The street is momentarily quiet. There's a woman fussing over a baby in its pushchair on the other side: she won't notice anything. There's a traffic warden a few feet away scribbling down a ticket, and a couple next to him embracing. Slickly and silently David lowers the table onto the pavement and walks away. When he turns a minute later the mother has walked on, the couple are still kissing and the warden has moved to the next car. The table remains, alone in the middle of the pavement. It looks a little forlorn yet somehow – and David knows this is ridiculous but even he, with his fine legal mind, can't help thinking it – somehow so heart-rendingly romantic.

★

Three miles further west of the table, there is another table in a restaurant where Isabelle is sitting, silent, miserable, watching Shane and Amber get through their third bottle of Merlot. Amber's blouse is unbuttoned to her navel and her lipstick is all over the place. Isabelle looks at her mobile when it rings and sees Laura's number. She diverts the call.

★

Laura is perched on a polished steel bar stool sitting at the walnut breakfast bar in her kitchen, trying to ring Isabelle to explore David's inadequacies in greater depth. But Isabelle's mobile appears not to be working.

At this point, some might say foolishly, David comes in.

'Laura, I want to ask you something,' he begins. He sits down on the stool next to her. He is invading her space and she doesn't care for it. She looks at him. He's looking eager, earnest. Jesus, Laura thinks, alarmed. Surely he doesn't want sex again!

Time to pre-empt. She groans. She puts a hand to her head. 'God, this headache,' she announces. 'I just can't shake it off.' David takes a deep breath. She studies his expression more closely. She looks anxiously at him. No, this isn't his, 'I want sex' face. It's more like his stupid, 'I want to be nice' face, usually produced when he has to tell her he's going on a business trip, or he wants time off with friends to go to the rugby, or some other piece of information which he knows is going to annoy or upset her.

'Have you seen Anouschka?' Laura asks wearily. 'She's supposed to be preparing the nibbles by now. Why that girl can't keep to a simple schedule I don't know.'

David sits there, looking inadequate. Looking miserable.

'Well?'

'Well?'

'Well – have you seen Anouschka or not?' Laura demands.

'No, I bloody haven't. All right? I bloody haven't!' David croaks. And the tip of his nose goes pink and his forehead puckers and he looks down at the ground and his lower lip droops.

Laura is not happy with this, no, she is not. 'Jesus, I'm only asking!' she cries. 'You'd think I was accusing you of . . . I don't know, having an affair with the girl, the way you're carrying on!'

'And? So? What if I were?' David retaliates courageously, imprudently, because perhaps, who knows, maybe if Laura did think that she might be suddenly jealous and suddenly want him and make him feel loved for once in their marital life.

Laura snorts. A brief and patronising snort. A snort which says – if only you had the gumption, my friend.

Then the thought comes to her.

'Hang on,' she says urgently to David. 'There's something I must do. Hang on.' She rushes into the utility room, closes the door and tries Isabelle again.

Isabelle is standing on a pavement in Oxford Circus weeping. Shane and the journalist have gone off to look at Shane's visual pipework: there was only room for two in Amber's vintage MG. Isabelle turns off the divert calls on her phone in case Shane changes his mind. She'd have him back, even now, however bad her back gets, she'd break her back if necessary. The phone rings at once. GodGodGod, it might be him. She smacks the green button.

'Yes!' she cries.

'It's Laura. What if David were having an affair? With our cleaner. Who's Polish or Albanian or something like that. Would that be any good?'

'Fuck off, Laura,' Isabelle says.

<div align="center">★</div>

Laura goes back into the kitchen.

Even she has to admit that things don't look good with her show at the gallery. Fine. Time to think positively about her life. God knows she's read enough just-published books about doing that. She has a plan B anyway: the interior design route. Because, as Laura reminds herself, not for the first time, she has been told by every single interior designer she has ever employed – and there have been a few of them – that she has an exceptional eye for detail and a natural instinct for colour. If push comes to shove she'll just set up as an interior designer in her own right – how difficult can it be, for Christ's sake, to pick up the phone and order a few pots of paint and a few swag curtains?

'Have you really got a headache?' David asks gently.

'What?'

<div align="center">172</div>

'Headache. You were saying, just now, before you, you know, went out because you had something you had to do, that you had a headache. Have you really got one?'

Actually, Laura's headache had gone but she can certainly feel it coming on again now.

'So now what? Now I'm a liar?'

'No; I'm not suggesting you're lying – as such,' he ventures forth bravely. 'But you might just be saying that you have a headache because there's something else going on, something you feel uncomfortable talking to me about.'

She looks at the floor and sighs. What's the point? She's already decided she's going to leave him. She could accuse him now of an affair with Anouschka – he'd deny it – they'd have a huge argument – they'd stop talking – he'd cancel the dinner and bang would go his business deal and her big pay-off.

'Look, Laura –' he begins, because that idiotic table sitting empty on the pavement has put crazy, dreamy notions into his head, God only knows why, about going home and finding a way of making things work with his wife.

'Don't, "look, Laura" me, please. I've had enough of your, "look, Lauras" to last me a lifetime. I think if I hear one more, "look, Laura" I'll explode.'

'I'm just not sure what I'm supposed to have done,' he whimpers.

'Look, David,' she says, wantonly stealing his copyright, 'I can't really explain it to you. You wouldn't understand even if I did.'

'Was it something Isabelle said? You've been strange with me' – what he means is even stranger but strange will do for now – 'ever since she rang this morning.'

'Oh. Ha! Yes. Ha! How convenient. Blame it on Isabelle. Yes. Ha! That's convenient.'

'Was it?' he persists.

'All right! All right! If you must now, it was. She rang me to

let me know that you, you are the reason why I've lost my show at the gallery in Cork Street. And now, just now, when I rang her, she actually told me to fuck off! Yes! That's what she said. So do you see what you're doing to me? You're holding me back! As a woman! An artist! As a human being!'

David goes pale. 'I'm not saying you're wrong, but I'm just wondering how . . .'

He looks so perplexed. She sees his eyebrows contort to understand her. She wishes he wouldn't do this. This expression does not suit him. Makes his eyes squint and his nose look bigger.

She grunts with exasperation and throws her slender arms in the air because words fail her, they really do.

David stares at her. What else is there for him to say?

'I love you,' he whispers and he walks away.

Laura shudders at the cliché. She's leaving him, she's more or less told him, in so many words, she's had enough. And all he can come up with is – he loves her.

Is this the best he can do?

CHAPTER 6

'Is OK I clean here?' asks Anouschka, sliding her white face round the door. She holds her breath and waits for the abuse. Lydia does not like her. She knows that. But she has to offer to clean, so that when Laura asks her whether she has cleaned the second-best guest room she can at least say she offered and that Lydia sent her away.

Lydia says nothing.

She must be asleep. Anouschka creeps over and peers behind the covers. Lydia is not asleep. Her eyes are open. She is not moving. Anouschka cannot see if she is breathing or not. It doesn't look as though she is.

She holds her face very close to Lydia's. 'Excuse me, Mees Lydia,' she whispers, 'is you dead?'

Lydia winces at the sharp tang of stale perfume which jolts her back to consciousness. 'No. No, I'm not dead. I was a little weary, that's all. I can't quite sleep but I can't seem to stay awake either.'

'I go tell Meesees David!' Anouschka cries, making for the door.

'No! No. Don't do that. I . . . I don't really want her to see me like this. I just need to rest. I'll be fine.'

'What you think is wrong with you? You are finedandy when you arrive this morning,' Anouschka says. She wants to add, 'when you shut drawing room doors in my face', but when she looks at this poor old lady's sunken features, her grey skin falling down underneath her eyes she has not the courage.

'My daughter. She is what is wrong.'

'Meesees David? She make you ill?'

'In a way, yes,' Lydia sighs. She wants to tell this girl, tell her everything, how Laura is going to leave David, or how David

will leave Laura, but how either way after that he will cut off her income, how she will be what she has feared all her life, she will be poor, how she would rather die than be poor which is ridiculous as she is dying anyway. But how can she say all this to a cleaner?

'How she make you ill?' Anouschka asks.

'Oh, look it doesn't matter. I really haven't got the strength to explain.'

'You no eat your lunch.' They both look across at the plate of food.

'No,' Lydia agrees.

'Is OK I eat?'

'If . . . you want it.'

Anouschka smiles. Food does not get wasted where she comes from. She shovels down the tepid mess in four large forkfuls. Lydia watches, fascinated and appalled.

'I make you nice hot couple?' Anouschka offers.

'Couple?'

'Couple tea?'

In spite of herself, Lydia smiles. If you disregard the spots, the smell and the stupidity this girl is quite sweet really. She is more caring than Laura, that's for sure. The thought comes to Lydia that she, Laura and this girl, they are all no better one than the other. They all depended on David and his money. Laura might think she is better than Lydia; Lydia might think she is better than this cleaner but really, what was the difference?

Lydia struggles to prop herself up on one elbow. 'I am old,' she begins stoically, ' but you, er –'

'Anouschka. My name is Anouschka.'

'– yes, you, Anouschka, you are young. You should try and make something of your life. Not spend your days here, cleaning, for a pittance. That's no life for anyone.'

Now it is Anouschka's turn to smile. 'Actually I am no stay here. No do this any longer. I leave soon. I leave tonight!' Why

shouldn't she tell Mees Lydia this? Meesees David was going to find out sooner or later, perhaps sooner would be better for everyone's sake.

'Oh? Have you told Laura?'

'No.'

'Why not? You might do her the courtesy of telling her you're going.'

'Curtsy? What curtsy she ever do me? I no do no curtsy anyone anymore! Not now I be – the new Meesees David!'

Oh God. Lydia just can't cope. All this stress, all this confusion, and now the cleaner's mad.

'Don't be ridiculous,' Lydia mumbles, falling back on the cushions.

'I no ridiculous!' cries Anouschka. 'I leave! Midnight tonight! With Meester David!'

'Oh please! Just because he had sex with you this morning – and yes, I caught you at it, but don't worry I haven't told anyone, I'm far too discreet for that – doesn't mean he's going to run away with you! Don't be so absurd!'

'You don't know! What you know!' Anouschka spits.

'I do know, you stupid, silly girl. I do know because I have seen him, down in the garage, with Louella, Laura's best friend, promising to run away with her. Heard it from his own lips, with my own ears.' Lydia points to lips and ears. With this girl and her pained expression you can never be quite sure that anything is going in. 'Look, my dear, you can understand. David will stay with someone of his own class. His own calibre. If he is going to leave Laura –' the very thought causes another short stabbing pain in Lydia's side, 'he's going to do it with someone like Louella. Not someone like . . . you.'

'I no believe you!'

'Don't be so silly. Why would I lie to you? Whatever he has told you, he's leaving with Louella tonight!'

'He give me his word! He give me ring!'

'He'd do anything to shut you up. You know what men are like.'

Anouschka's head is spinning, but not so hard she can't think straight. She knows what she has to do. She rips off the absurd gingham pinny Laura makes her wear and rips off her rubber gloves.

'What are you doing?' exclaims Lydia, afraid of the glint of lunacy she sees in Anouschka's eyes.

'I go kill Mees Louella,' Anouschka announces. Like she means it.

★

This, 'I need a reason' thing is still troubling Laura. Nagging at her like an irksome itch. She's tried thinking laterally. She went and checked some back copies of her women's magazines, a couple of which have letter pages about sex and emotions and relationships and all that kind of stuff which women of Laura's age should've grown out of but haven't quite yet. She wanted to see if she could find anything akin to her own experience, to find an answer that way. Most of the problems are about men who are leaving or deceiving their wives in one way or another. The closest she could find to her own situation was someone with two children and a husband who adores her, but she has just found out that he's a cross-dresser: should she stay or should she go? She should stay, the magazine decrees, because she has children, and because her husband had the courage to admit his hobby to her and because cross-dressing, in this day and age, is no big deal anyway, is it? As Laura and David have no kids and as he does not (as far as she is aware) use her underwear, this is not much help. But the general tone, the general principle seems to be you can only leave a husband and end a marriage if you've got a really good reason to do so. So she's back to square one.

God, she just can't cope with this marriage thing any more. She just can't. She has to calm down, acknowledge that currently, given circumstances, she's in a heightened emotional

state. She takes a couple more paracetamol. She assumes a couple of yoga positions and tells herself to get a grip.

Then the revelation.

David isn't having an affair with Anouschka.

But maybe he should be.

Of course! This is the answer to everything. David must have an affair with her. Simple, obvious. David has an affair, Laura finds out, everyone will feel sorry for her – not pity, she is too beautiful to be pitied – just sorry, and Laura will have her reason to end the marriage gift-wrapped. The other, marvellous thing about this idea is that Anouschka is already there in the house so no time need be wasted. And Anouschka will do anything Laura asks her to. In fact the only downside to this plan is that once Laura finds out about Anouschka and David, she'll have to sack Anouschka and have all the hassle of finding a new cleaner yet again. Laura sighs. Nothing in life is ever quite how one would like it. Never mind.

She goes in search of her cleaner, only to find her half way out of the front door.

'Anouschka?' Laura calls imperiously from the top of the stairs. 'Where do you think you are going?'

'Uh,' Anouschka grunts in terror. 'Is already six. I done.'

'Done? Don't be silly. We agreed: you will stay all evening. You know we have these guests coming, you were going to help me with my hair and take my clothes out of the wardrobe. You know that. What do you think you're doing?'

'I must go, Meesees David. Is something I must do.'

Anouschka looks slightly mad. Her hair is standing on end and her nostrils are bulging. This is not enhancing her appearance in any way, Laura can't help but note.

'What you must do, my dear, is honour the contractual agreement you have with me,' Laura cries. When they start with her Laura makes all her cleaners sign a bit of paper which she has printed out on her word processor full of long words about duty, responsibility, commitment, integrity. When

181

things get sticky, reference is made to this contract. When things get really rough, said contract is extracted from the drawer and waved around under their noses with references to lawyers and the weight of the English legal system.

It usually does the trick.

Anouschka drags her body miserably back inside the house and clips the front door shut behind her. If only she had made a move just a few seconds earlier . . .

Laura begins to walk slowly down the grand staircase.

'Oh,' she exclaims as she approaches Anouschka. 'My. You do look tired. In fact, you look exhausted.'

Anouschka, against her better judgement, feels the beat of her heart quicken again.

'Yes. Is true. I tell you, even this morning, I no well. So is better I go. Yes?'

'No, Anouschka. Is better you have a nice rest. Just an hour or so. You'll find it'll do you a world of good. I'll come and wake you around seven so you've got time to rinse out the glasses before the guests come.'

Anouschka thinks: Meesees David is gone mad.

Laura takes her kindly yet decisively by the elbow and guides her upstairs towards the master bedroom.

'But Meesees David – is your room!'

'I know that, Anouschka. This is the kind of woman I am – prepared to sacrifice my own bed when I can see someone needs it. You can get undressed now.'

'Is what?'

'Undressed. You know, everything. Right down to bra and panties. You can hardly sleep in all those clothes. You'll get far too hot. Come on, come on. We have no time to waste. The sooner we get you asleep, the more rest you'll get.'

Anouschka is scared. This woman is even weirder than she had thought and she had thought quite a lot. She starts to yank at the belt of her beige raincoat and systematically, under Laura's watchful eye, removes all her clothes, until she is

reduced to a grey pair of pants which stretch from above her navel to the tops of her knees (old thermal habits die hard) and a brassiere which hangs like a pair of drooping saddle bags dangling somewhere above her flat breasts. Laura makes a firm gesture towards the bed. For the second time today, although with some greater reluctance now than this morning, Anouschka clambers in.

'That's it, that's the way,' Laura reassures her like a malevolent nanny, tucking the silk bedclothes in around her, chucking the seventeen cushions with abandon on the floor: she's way past caring about any of that now. 'You stay there, nice and cosy and warm. I'll be back in an hour. You'll see how much better you'll feel then.'

Laura draws the curtains and leaves the room, turning off the light and shutting the door behind her.

The sheets still smell of Meester David and Meester David's semen. Anouschka wants to find this comforting but she cannot. Meesees David is mad and Anouschka has had enough. But she is too scared to say no to her. She touches the ring, Meester David's ring, for good luck, then leaves the bed, dresses quickly and goes to stand on the windowsill. The bedroom is only one floor up. The fall surely cannot be so bad. Anouschka thinks of her hands around Mees Louella's neck. Then she thinks of Meester David, of their baby, of their house in the country, of the envy of her friends, the pride of her family, of the clothes she will buy, the diamonds she will wear, the happiness she will have – if only she escapes now.

She swings across to the drainpipe and clings to it for dear life, sliding down it inch by inch until she can cling no longer and she jumps.

*

Sometimes, only sometimes, things work out so perfectly in life that you know they are simply meant to be. The purity, the unspeakable flawlessness of her plan impresses even Laura. She goes quickly to the hall mirror to apply a fresh coat of

lipstick. If you're going to surprise your husband in bed with your cleaner, or even housekeeper, you might as well look good when you do it.

'Omigod. Omigod. I don't believe it! How could you do this to me!' she hisses at her reflection. Or better: 'Omigod. Omigod. I don't believe it! How could you, of all people, do this to me!' she rehearses.

On cue, on absolute cue, David brushes past her. He does not worry that his wife is talking to herself in the hall mirror; she seems to do a lot of that.

'Where are you going?' Laura asks pleasantly.

'Hm?'

'I said: where are you going?'

'Oh. Bed.'

'Bed. At six o'clock?'

'Yes. Yes. I'm not feeling . . . great. Just for a nap. Before our guests arrive.'

'I see.'

'Do you have a problem with that?' he demands aggressively.

'No. Absolutely not, David,' she replies sweetly. This is so easy it's unreal.

As he turns and walks away from her it is as if his steps are counting down the final moments of their marriage. She panics momentarily when she realises that it's all going to happen before the business meeting tonight, but now everything's in place that just can't be helped; she is sure David has sufficient millions to keep her from indigence even without this new deal going ahead.

Now, now the timing is crucial. She must wait, wait just long enough for him to get into the room, be right in there, before she makes her entrance and her terrible discovery. One last check in the mirror. Yes, now is the time. She looks great and she is word perfect. She turns towards the bedroom. Slowly. One, two, three. She throws open the door. David is

alone in the bedroom, doing nothing, sitting dejectedly on the bed.

'Ha!' she cries.

He looks up at her.

'I'm miserable, Laura. So miserable.'

Where's Anouschka? Where's bloody Anouschka? Laura walks to the bed and rips back the covers. She goes into each of the en suites. Nothing. The bedroom is freezing. He's come in and opened the bloody window wide open just to annoy her. With some fury, she slams it shut so hard the sashes rattle in their casings. David is looking warily, wearily in her direction.

'Next time you want to open the window, you might ask me first. This is my bedroom too, you know,' she yells as she storms out.

David sighs. What's he going to do? His wife has lost her mind. He cannot cope with it, her, any more. He lies down and yanks the bedclothes over his face and wishes he was someone else.

<p style="text-align:center">★</p>

6.12pm. Time is running out and Laura is done with procrastination. Now she wants action. So David's not going to have an affair, nor is he likely to start one in the next few hours. Fine; let him keep the moral high ground if it means that much to him.

She will have the affair.

It would have been the easiest thing in the world for Laura at any time during the course of her marriage to have taken a lover, like all her girlfriends did. God knows she could have had her choice. There was that man she'd met at one of Louella's dinner parties who could hardly keep his eyes – and hands – off her. Naturally Louella said he did that to anything in a skirt; Laura had long since learnt to cope with her friend's awful jealousy. There was the man who owned the lighting shop where Laura had spent £11,000 on Venetian light

fittings – his face lit up whenever he saw her coming. And the designer who claimed he was gay but whose eyes followed her everywhere when she was in his shop. She could go on – but what was the point. The point was – the men were out there and she had always been too locked into her fidelity to David to do anything about it.

Not any more.

She is going to have an affair. Yes, maybe she overwhelmed the estate agent this morning, but there must be men out there who were up to her standard and who could cope.

She is going to have an affair. Not a proper, full-blown meeting in a coffee bar holding hands under the table kind of an affair – there's no time for that – but a virtual one. On the internet. That will be good enough.

She is going to have an affair and be found out. When David stumbles in and finds her telling a man how much she desires him, actually no, finds a man telling her how much he desires her, yes, he's hardly going to quibble whether the other party is in her arms or merely on the screen. It's the thought that counts.

On the last day of Laura's, 'Interior Design For The Contemporary Urban Setting' course, they were taught all about the internet and the woman sitting next to her, who was already something of an expert, it appeared, told Laura how she sourced all her men on the net. She showed her which sites allowed you to enter the required income bracket along with all the other obvious essentials like not fat, not short, own teeth and so on. This, she explained, meant you cut out the dross with one easy tick of a box. Then you saw a photo of every man anyway so it really was foolproof. Laura had scoffed at the time but there you go. Never say never in this life, she reflects philosophically as she boots up the computer to let her chosen solvent suitor know (a) she exists and (b) she is available to him as of now.

★

Louella is in her shop, about to close up for the day. A man comes in. A tall good-looking man in a smart suit. About her age, perhaps a little older. Now this is more like it! Louella thinks. Thank God she skipped lunch – none of that post-prandial bloating which can make or break an encounter. Automatically her eyes go to his hands for a quick ring check – not that this tells you everything but it can tell you something, just for starters at least.

No ring.

'Do you mind if I just browse?' he asks with a voice which is at best Eton at worst Marlborough. Gosh, she doesn't mind at all. She doesn't mind what he does.

'But of course,' she replies. Slowly, softly. Cocking her head slightly to the left which is undoubtedly her best angle. 'Are you looking for anything in particular?'

'Wedding present, actually,' he replies with a smile exposing good teeth bolstered by expensive dentistry. 'Not an especially close friend, you know, a chum.'

'Of course!' Louella twitters, maintaining the left-slung position even though her neck is starting to ache somewhat.

'Yes,' he goes on. He sighs. 'Sometimes it seems as if the whole world is married apart from me. Still searching for the right one! Funny isn't it? One can have everything – the London house the country estate, cars, boats, holiday houses in Antigua and Seville, but if you haven't got anyone to share them with, none of it means anything.'

Louella has to remind herself to close her mouth and inconspicuously to wipe away the drool that has collected at one corner.

<center>★</center>

It really is amazing how many wealthy men are out there just waiting to be told that a slim, good-looking woman in her early thirties whose husband doesn't appreciate her is open to offers of a serious, committed relationship from someone who can give her a suitably comfortable lifestyle.

<center>187</center>

Gosh, thinks Laura. If I'd known finding a replacement for David was going to be this easy I could have done it years ago.

With the photo gallery things couldn't be easier. After even a cursory review of what's available, Laura can see three men who will fit the bill, but quite soon rejects two of them. One on account of his unpleasant name, (she can't see herself telling her friends that her new beau is called Desmond; what sort of a name is that?), and the other because he lists parachuting among his hobbies. Reckless men do nothing for Laura.

The third, however, much like the bowls of porridge, is perfect. He lives in central London, (Laura pictures a town house in Mayfair) and works in banking, (money, money, money) and is called Edward. You can't go wrong with an Edward. He has never been married and is looking for 'a woman who will fulfil his highest expectations'. Laura is confident that she can fulfil, indeed exceed, any fantasy any man can ever have. She sends him an email. She describes herself briefly and almost accurately. My name is Laura. I'm a seriously attractive (there seemed no point in beating around the bush – facts are facts) conceptual artist, tall, slim, blonde, rich. Then she sits back and waits for the love affair to start.

<div align="center">★</div>

'What's this?' the affluent, eligible, good-looking stranger says, picking up the cherub dish. 'This is a nice piece. How old is it, exactly, would you say?'

'Well,' Louella begins, ready to make the speech of her life, 'this is rather lovely actually. You obviously have a good eye! This is eighteenth century, yes, I would say the latish end of the eighteenth century, maybe 1876, 77 . . .'

'You mean 1776, 77?'

'Do I?'

'Well, you said eighteenth century . . .'

'Oh! Yes! Sorry! Of course! Yes! Indeed! 1776! That's the one! And there is slight damage to the base, as you can see, just

here, but of course, given the age of the piece, this adds to its integrity, don't you think?'

'It's lovely. I think it's perfect in fact. A cherub – that's a symbol of romance, isn't it? So it's perfect for a wedding. This world could do with more romance, don't you think?'

'Oh I do, absolutely I do.'

'How much is it?'

'Oh . . . I'm afraid this is one of my more expensive pieces . . . er . . . let me see . . . As it's a wedding . . . of a friend . . . I can let you have it for £450, but that's as low as I can go I'm afraid . . .'

'£450? That's fine. Like I say, he's not a particularly close friend so I don't want to spend too much. Let me see, I've got the cash here, nine fifties, that's right, isn't it?' He starts flicking ceremoniously through a large wad of new and shiny notes. 'And, I hope you don't mind me asking, but this evening, or any other evening in fact, would you consider having dinner with me?'

'Oh! Oh!' babbles Louella as her mind starts involuntarily scanning her wardrobe for the right outfit for dinner with this gorgeous man. 'Well, I'd have to check my diary of course but in principle, yes, that would be lovely!'

'Super. Is there any particular restaurant you might like or would you rather I chose?'

Louella opens her heavily painted lips to answer. At that very moment the door to her shop crashes open leaving the chandeliers quaking and the Quimper ornaments bouncing on their shelves.

It is Anouschka.

Anouschka who is full of hate.

She thunders into the shop aiming straight for Louella's throat. One leg appears to drag somewhat behind the other but this merely adds to the swashbuckling effect.

'Tell me is not true he want you more me! Tell me is not!' Anouschka cries.

'For God's sake you foolish girl, watch what you're doing! You're wrecking my shop!'

'I give no toss of shop. I come here kill you!'

Louella turns to her new man and laughs – ha ha ha. 'Please don't worry,' she soothes. 'She's not English.' She turns back to Anouschka. 'Now, my dear, I can see you are confused –'

'No, I no confused,' Anouschka yells. 'I come here tell you that I love Meester David, and tonight I leave with Meester David, we leave together!'

'Fine!'

'What?'

'Fine! Have fun!'

'You no mind?'

'No, I no mind,' Louella seethes, walking up to stand very close to Anouschka, so close that Anouschka can see the feathery cracks round Louella's mouth which the blood-red lipstick is starting to seep into. 'In fact I think that's a very good idea. You do what you like. You go off with David –'

'– even if he be husband your best friend? –'

'– even if he be husband my best friend. Just make sure you do it quietly, and you do it now. You go now. Do you understand?' Louella snarls into the side of Anouschka's dazed face.

'You so strange lady,' Anouschka gasps, backing away. 'You make big love with him, man who is husband of your best friend, on floor of his garage only two, three hour ago and now I say you I go with him and you say is OK. Is love this? I no think so.'

The affluent, eligible, good-looking stranger standing between the two women goes pale. 'I really ought to be getting along,' he mumbles. 'You two obviously have a lot to talk about.' He starts backing away toward the door.

'No!' Louella wails. 'Don't leave! Don't take any notice of her! She's a cleaner, for God's sake. A cleaner! And a foreigner! She doesn't even understand what she's saying. What she says means nothing!'

But she is talking to his back, and then only to the rush of cold air from the open door left flapping in his wake.

<center>★</center>

This is unbelievable. Unbelievable. Six and a half minutes after Laura sends her message to Edward, there's a reply from him. It does occur to her that if he's a man who's got any kind of life at all, what's he doing sitting watching a computer screen on a Saturday afternoon waiting on the off-chance that someone is going to reply to his message? Then she adopts a more fatalistic approach. Sometimes things are just meant to be. He has just come in from an expensive late lunch with friends and is about to change for drinks with more chums at his club. His life is rich and varied yet somehow empty because it does not have someone like Laura in it. He thinks: busy as I am, why don't I just quickly check on the internet to see if anyone might, just might be out there for me? Of course, he has already had a thousand replies but ignored them all: none of them was The Special One he was looking for. He flicks on his pc, and boom. Or should that be bam. There is Laura's message. He reads and re-reads it. My God, he thinks. With trembling fingers he taps out a reply: 'Are you still there?'

With trembling fingers Laura replies: 'Yes, I am.'

'Hi.'

'Hi.'

'Thanks for your message.'

'No problem.'

'What sort of art do you enjoy?'

'Well, it's more then just enjoy, I am a professional artist; I concentrate on studies on hard surfaces – sort of pictures within pictures actually.'

'That sounds amazing. I'd love to see them. Are they on display anywhere?'

'What about you? What sort of banking are you involved in?'

'M&A. Complex stuff, I'm afraid. Big money, high stakes.'

<center>191</center>

'I see.'

'It's difficult, isn't it, getting to know someone on the internet?'

'Yes. But I already feel I have an affinity with you.'

'Yes. I do too – with you, that is. Would you like to meet?'

'I'd love that.'

'Great. Where and when?'

'Tonight?'

'OK. Sure. Why not? Do you like tapas?'

'My husband does. I'm afraid I have more conservative tastes.'

'Your husband?'

'Yes. But don't worry. I'm leaving him. In a way I sort of already have. So I'm free to start a new relationship unencumbered.'

'Why are you leaving him?'

'Yes. That's a good question. I'm working on that. I'm still at the stage of wondering whether the simple idea that there must be more to life than this is no reason at all to want to leave your husband or the best one there is.'

'Sounds a bit vague to me.'

'From that I infer you are not married nor ever have been.'

'That's right.'

'That's why it sounds vague to you.'

'Don't you believe in the sanctity of marriage?'

'The what?'

'The sanctity of marriage? What about that? Do you remember your marriage vows?'

'I do – but only just! They were 15 years ago.'

'Do you think marriage is so disposable? So temporal? What right have you to tamper with something that transcends the human?'

'I don't think I understand . . .'

'No, I mean this. You cannot separate what God has joined together. That includes you. You cannot do this, not for

any reason, much less this . . . filthy whim based on pure self-gratification.'

Oh dear. How unpleasant. Laura is not quite sure what to make of this. Her fingers hover over the keys. Finally she taps:

'Are you an actor?'

'No, I am an honest man. It is people like you who are the performers. People like you who treat marriage as no more than an entertainment. Nowadays we set people up merely to watch them fall. We clap with glee when we see those we once thought so happy together moving apart. But marriage is a sacrament, not a soap opera. It is a consecrated act. It is a vocation.'

'I'm so sorry — I thought this was a dating website. I was looking for a date. I must have been mistaken. Sorry. Goodbye.'

'I have made it my vocation to enter into these pit-holes of depravity where married people barter their oaths to warn them against the folly, no, the iniquity of their ambitions! The self-aggrandisement of their wanton self-gratification and –'

Laura switches off the computer without exiting properly which she knows is going to cause her all sorts of problems for next time but what the hell.

Then David being David chooses this very moment to wander into the study. Having woken from his little grumpy nap he has come down to look for some papers for work. The timing is appalling. Only a few moments earlier and he would have been confronted with the line about tapas and Laura would have allowed her cheeks to colour and stammered excuses, he's only a friend, really . . . and . . . and . . . and everything would have progressed naturally from there with the perfect excuse glowing at him via a thousand million pixels which cannot lie.

<p style="text-align:center">★</p>

Anouschka leaves the shop and wanders out into the unfriendly evening air. She has nothing more she wants to say

to Mees Louella. She can see in her eyes that she is telling the truth about Meester David and that she has no interest in him. She walks back towards the house and stands by the garage door. She feels the money David has given her heavy in her cardigan pocket. She could go to a cafe and wait there but she wants to feel close to him. She knows he is in there. She cannot see or touch him but she knows he is there. It is not yet seven, she has over five hours to wait but she will wait a lifetime if she has to, she will wait forever for the man she loves.

Louella watches her trail away. And when she has gone the door stays open and the winter air comes charging in, invading every corner of the shop. Louella doesn't care. Louella has a bottle of sweet sherry which she keeps in a walnut escritoire for emergencies. After she has drunk it, everything seems clearer. Life seems easier. There are no more problems. She will just lie down now, here, on the cold, cosy floor of her shop. She is crying but not because she is sad. Just because the tears appear from nowhere on her face. She doesn't know why they come. Really there are no more problems to speak of. She can't remember what the love she was so desperate for is anyway. What it was. What it ever might have been. Whatever.

CHAPTER 7

At 6.15 p.m. Laura realises that she's going to have to deal with a reality which she's been trying desperately to avoid. She reflects that, however painful this is going to be for her, just like finding the courage to leave David, her life will be considerably easier once she has confronted it.

Anouschka has gone.

Anouschka is not coming back.

Laura is going to have to get an agency cleaner in.

Over the weeks Laura has kept a collection of cards which have come through the door advertising cleaning agencies pinned up prominently on her kitchen notice board, just to let Anouschka know that there are plenty more where she came from. Now Laura grabs one of the cards and dials the number. As she does so, all the horror stories Laura has heard about agency cleaners start seeping back into her mind. The theft, the damage, the deception. She has always sworn to friends relaying these tales that she would rather get down on her hands and knees and scrub the floor herself than ever use an agency cleaner but of course, now that push has come to shove, this is not really an option. The kitchen bin needs emptying, the glassware needs to be taken out and polished and the nibbles which Anouschka bought yesterday need to be arranged on plates. Laura will have enough on her hands with her hair, clothes and make-up. Plus she is a state of considerable emotional chaos coping with the breakdown of her marriage – she can't do everything, for God's sake.

Laura tries five numbers with no success. On the sixth, the phone rings for about five minutes when, just as Laura is about to give up, it stops ringing and there is silence. Laura is not sure whether the line has been cut off or whether someone has in fact answered.

'Is anybody there?' she calls out.

'I am,' a voice says.

'Oh. Thank goodness for that. Because you're the sixth number I've rung and everyone else is either on answering machine, engaged or just not there,' Laura lists angrily, as if it were somehow the voice's fault.

The voice, annoyingly, provides neither apology nor explanation for her fellow cleaning agencies' shortfalls. After a few more moments of silence Laura barks: 'Are you still there?'

'Yes,' mumbles the voice, diffident, as if it is not really sure whether it is or not.

'Well, I need someone and I need them now,' Laura instructs.

'No chance. It's Saturday. There's no one here.'

'What? You're there!'

'Yes. But I'm just the cleaner.'

'Exactly!'

'No. I'm the cleaner for this office. I'm not one of the agency cleaners. They're shut now till Monday.'

'But the ad says, 'Open Twenty Four Hours For Your Every Emergency!'

'I didn't write the ad,' the woman argues philosophically.

'So why did you answer the phone?'

'I thought it might be my kid. He sometimes rings me when I'm at work. He gets lonely on his own at home. He's only five. They won't let me bring him in, but we need the money so that's that.'

Laura wonders why this woman is foisting the story of her life upon her when all she wants is a cleaner who knows how to open the fiddly plastic bit on the spout of a bottle of anti-bac.

'Whatever,' Laura interrupts. 'Look, I hardly care whether you're an agency cleaner or not. You're a cleaner so will you come round to my place and clean?'

The woman says nothing.

'I'll make it worth your while,' says Laura, catching a whiff of the dustbin.

'How much?'

'Well I pay my regular cleaner four pounds sixty an hour. I'll pay you five.'

'No. Not worth it. Bye.'

'Wait! Let's say six. Let's say seven . . . eight.'

'Twenty.'

'What?'

'You heard.'

Laura feels her cheeks colour. Twenty pounds an hour is absurd. But she knows it's this woman or nothing. Damn Anouschka. Damn her. 'All right. Twenty. But you come now, do you hear me?' She gives the woman the address, slowly, spelling out each word.

'How am I supposed to get there?'

'How do I know?'

'No. I think I'll leave it. Chelsea's miles away from me. I can't be bothered.'

'Look, look, look. Take a cab. OK. Take a cab. I'll pay him when you get here.'

'I'll think about it,' the woman says ominously and puts down the phone.

When Laura rings back to demand a formal verbal commitment the phone is off the hook.

What is she to do?

There's only one thing for it. She will ring Louella. Louella will know. But the phone at Louella's shop just rings and rings, and no one answers her mobile phone and her phone at home is on answering machine.

Strange.

It seems there is nothing left for her to do but sit and wait.

How melancholy she is. How alone. But then, she reflects, the end of a marriage is always sad. Like the tearful bits in

films. The very concept has a poetry, a poignancy which makes Laura's lower lip tremble. Then she worries this may make her look afflicted in some way so it stops trembling.

What she needs to do is play some music. She goes to David's CD cabinet – David's always been the one with a passion for music, she's never had time for anything like that, what with all her other commitments – and looks through his collection of country and western music. None of it means anything to her of course, she can't stand that kind of stuff, so she just grabs one with a pretty cover and puts it on. David used to play a lot of this kind of music when she first met him. (She always complained it gave her a migraine so eventually he stopped, thank God.) She thinks back now to those early days. She had such high hopes for their relationship then. She feels such bitterness that David has let her down. All she had ever wanted was a man to give her a lovely big home in Chelsea, lovely clothes, lovely holidays and some attention. Well, she had the lovely home, clothes and holidays – but what about the rest? David was always working, always jabbering into that bloody mobile of his. Always leaving at 5.30 a.m. to get into the office, coming back late, exhausted. It was always all about him. What about her needs – as a wife, as a woman for Christ's sake?

Eventually the plaintive wailing of the track she has put on starts vibrating through Laura's body – she is an artist after all. Her body starts swaying to the rhythm. Hardly aware of her own actions, she gets to her feet and begins gyrating, spontaneously but mesmerically, to the beat of the music. Her slender arms reach high up and then fall, like the long graceful branches of a weeping willow over a sun-dappled lake. In awe of her own grace, she throws back her head, to the side, the other side and then low onto her chest. Her hair flows with her movements. Her long legs twirl and spin and leap on the expensive new maple flooring. Her slim ankles turn elegantly to the rhythm. Laura is dancing. Dancing the dance of

freedom, of independence, dancing the dance of courage, will and joy. The dance of freedom.

Then suddenly. Horribly. A voice from behind. Lydia.

'Omigod! You terrified me!' This is a turn of phrase of course – but the fact is her mother really does terrify her. Lydia looks half-dead. Her make-up is falling off her face, the skin is slipping, sliding off the high cheek bones as if in flight. Her mother looks like she is drunk. And trembling.

'What are you doing down here!' Laura admonishes because attack seems like the best defence right now. 'I thought you were resting in bed.'

'Yes,' Lydia slurs. 'Cigarette,' she explains, holding up a crumpled pack as evidence. Laura, who operates a strict no-smoking policy in the house, usually makes her mother go outside for a fag. However, she knows that when it's cold, Lydia has taken to sliding down to the garage instead and Laura has been prepared to turn a blind eye to this.

'Fine,' she acquiesces. 'Go ahead. You know where the key to the garage door is,' she adds magnanimously.

'Cigarette,' Lydia confirms, waving the packet triumphantly in the air, disappearing back into the hall.

Garage door. Garage door. Yes. Must find garage door. But don't like garage. No. Steep steps in garage. No light. Never can find switch. And keys. Can't be bothered to fiddle with keys. Didn't like garage before anyway. Nasty things on floor of garage. Nasty surprises. Not like nasty surprises. Front door. Here. Better. Easier. No steps. No surprises.

Anouschka, only just conscious with cold, watches in wonder as the front door of the house opens and Lydia spills out of it. Having arrived on the pavement, she stands there, her meagre frame swaying slightly in the wind blowing up along the empty street, as if she has forgotten what she has come out for. Then she staggers and clutches onto the railings at the front of the house, her packet of cigarettes spilling out in front of her. Instinctively, Anouschka moves forward to help the

old lady. Lydia clutches onto her. She is as hot as Anouschka is cold.

'You have fever,' she says.

'Cigarette,' wails Lydia looking at the mess at her feet in dismay.

'Come, you must inside,' says Anouschka, guiding her back into the house. Lydia offers no resistance. She is so thin she seems to dissolve in Anouschka's arms. They go back into the house and Anouschka shuts the door so it makes no noise. She more or less carries Lydia upstairs and is about to lift her onto the bed when she sees the sheets are wet with alcohol and urine. Anouschka covers the mess with a blanket and then lies Lydia down on top of it.

All Anouschka can think about is how angry Meesees David is going to be. The sheets are supposed to last two days and Anouschka only changed these yesterday.

Lydia lies there, quiet apart from the sound of the air she is forcing in and out of her lungs. Lydia's face is grey. Her mouth has lost its shape and hangs distended and asymmetrical on her face. Her skin burns to the touch. For an hour or so she sleeps.

Anouschka sits on the side of the bed and watches her. She does not like this woman but she feels sorry for her. She is happy to be in the warm but that is not why she stays. She stays because she can see this woman is sick and she cannot leave her like this.

After some time Lydia opens her eyes.

'This blanket, I hate it, it's itching,' she complains, tugging at the woollen cover beneath her.

'You must have. Bed is wet.'

Lydia moans.

'Why have you turned off the television?'

'Is so noisy, I think maybe is off better for you.'

'Get it back on, on, I want it on, now, louder, louder!'

Anouschka turns the volume up high then sits Lydia up and gives her some water.

'Can I say you something, Mees Lydia? You look no well. So bad well.'

'And why I no look well? Why I no look well? I am not well. And it's because of you, all because of you,' Lydia cries, strangely coherent once more after her short nap.

'I? I no do nothing to you!'

'Not me, you fool! At least, not me directly. But you started all this, everything, this morning, with my son-in-law, with David and your seduction of him. You put the idea in his head. Are you not ashamed to have come into this family and caused so much upset with your . . . your . . .' Lydia gropes for a word – '. . . promiscuity!'

(Sadly Anouschka cannot enjoy the full irony of this accusation. Firstly, because she does not know Lydia sufficiently well to appreciate that Lydia herself has slept with enough men to staff a meat factory. Secondly, because Anouschka does not know what promiscuity means.)

A violent pain rocks through Lydia's temples. She throws her head back on the pillows and breathes heavily until it passes.

'I love Meester David. Is real love.'

'Oh don't start. I've told you. You were just a bit of fun for him.'

'No! Way you speak me make me angry, so angry, like red rag to a beef! I no just fun, I no just toy. Is love he and me, I tell you, is love. You never have been in love? You not understand?'

Lydia glares at her, the stale eyes wide with horror. The shame of hearing, of accepting this formulation of words from this ignorant foreign girl.

You have never been in love.

No. She never has. Only manipulation, games and compromise. Always from the head, never from the heart. So what has been the point of any of it. The pain comes more sharply. The colours in the room fade and dissolve. Breathing is becoming such a chore.

Lydia takes Anouschka's hand. She whispers through dry lips, 'No, I never have.' Anouschka holds her hands. Now Lydia's skin is wet and cold.

'Love – does it feel nice?' Lydia asks.

Anouschka nods.

'I can imagine,' Lydia says, although she can't really and now it's too late.

She shuts her eyes again and breathes. Anouschka holds tightly onto the damp bones of Lydia's fingers and watches her breathe and breathe and breathe and then give up.

<p style="text-align:center">★</p>

When Laura answers the door a young woman is standing on the doorstep. In fact she is not so much a young woman as a girl. A small boy is clutching onto her hand.

Seeing Laura's horrified stare, the woman says defiantly, 'I've brought my little boy with me.'

The boy, Laura remembers, is five. But the girl-woman looks no more than 17 or 18. How can that be? For a long while Laura is silent working out the arithmetic of the equation in her head.

'Do you still want me?'

'What? Yes. Yes, of course. But the boy . . . Did you have to bring him?'

'What else was I supposed to do with him?'

'Well you said you left him on his own before . . .'

'That's because I had to. I don't have to now. In fact, I don't have to be here at all,' she adds wistfully glancing over her shoulder at the cab. 'That's the taxi. He needs paying.'

'Right,' says Laura nervously. 'Um, could the boy stay there possibly?'

'There where? In the taxi? On his own?'

'Well, yes. Only you have to understand, this is not a particularly child-friendly house. Full of antiques and things. We've only just had it decorated. And we've got people coming tonight.'

The girl looks at her. As if she is crazy.

'Sorry. I don't mean to sound . . . unfriendly. But do you see what I mean?'

The girl says nothing. The boy says nothing. They stand on her doorstep and look incredulously at her.

Laura grabs her handbag from the table in the hall. She simply can't cope with this situation. No, she can't. She takes notes from the bag – one, two, three twenty pound notes. She thrusts them under the face of the girl. 'I'm sorry. But really, this isn't a house for children. Thank you so much for coming but I think it won't be necessary after all. Please, take this money and go. I've got your number so maybe another day?'

The girl shows no expression. She takes the notes and turns back towards the waiting cab. Laura stays at the door, as if afraid to move. The girl gets in the cab and doesn't look back. Only the boy, just before he follows her in, turns and sticks a solitary finger high in the air at her, by way of farewell.

<p style="text-align:center">★</p>

David is in a strange mood. Normally he is very excited to have guests in the house and runs round checking lighting and adjusting the position of books on coffee tables. Especially today, as so much hangs on this meeting, Laura expected him to be particularly hyperactive. Instead he sits in the semi-darkness of the drawing room while she does everything: puts nuts in bowls, re-arranges the glasses Anouschka has prepared on a tray, sprays rooms with a lavender and hyacinth aromatherapy fragrance, lights candles, gets dressed, fixes her hair, checks and double checks her make-up: everything. She wants to say something to him like, 'You could help, you know', or, 'Shall I do everything then?', or some other sarcastic jibe to jolt him into action but she's feeling so exhausted by him and so aware that these are their last hours together as husband and wife that she simply can't face making the effort.

Nevertheless, his attitude is getting to her.

And the fact she still hasn't got an excuse is getting to her.

Suddenly she starts to feel very confused. She starts wringing her hands which is doing them no good at all. Should she, shouldn't she? Leaving one's husband is such a big step and that loony on the internet has unnerved her terribly.

She comes to a decision. She needs help. She needs advice. She needs counselling.

The same friend who had advised keeping a tally of expenditure in preparation for divorce had also given her the name of a wonderful counsellor called Christine. At the time, of course, Laura had laughed it off. 'I shall never leave David!' she had cried. 'You never know,' the woman had replied gravely. 'That's what I used to say about Jonathan until he turned to drink, gambling and physical violence and I had to go, just had to go, before I went insane.' Now of course, Laura is in the same position – well, at least about the having to go, just having to go bit. Laura finds the woman's details in her personal organiser. She has typed in two numbers on the friend's instructions: office and home number for emergencies only. And what was this, if not an emergency?

She looks at her watch. Just gone 8. There's only a couple of minutes to go before the guests arrive but people are always late and even a few minutes supportive therapy would be better than nothing. However, just as Laura is about to dial Christine's number David comes ceremoniously into the kitchen to announce in a low and mournful voice that he wants to talk. He starts mumbling something about their marriage and what it has meant to him and how sorry he is if he hasn't been the man she might exactly have wanted him to be. This means that those precious minutes tick by and before Laura knows it, the doorbell is ringing and the guests are there.

David dashes to the hallway to greet them. Laura remains in the drawing room. She finds it vulgar to rush out and embrace

visitors. She is the hostess. They must come to her. She does concede to standing up. So that when they enter the room they will see her: proud, dignified and unbearably beautiful. They will gasp at David's good fortune. Admire his taste. Applaud his success.

Finally they enter. David introduces everyone: Gerard, my wife Laura; Laura, Gerard's wife Margaux.

Laura surveys her guests.

There is only one problem. The wife, the woman, Margaux – she too is proud, dignified and unbearably beautiful.

<div align="center">★</div>

Lydia, it would appear, is no more. There is no breath, no pulse, no movement of any kind. These are the conventional signs of death as Anouschka understands them. She considers going down to tell Meesees David but refrains. For a start she is not meant to be in the house anyway; if Meesees David finds that she is, she will only give her more jobs to do and frankly Anouschka has had enough. She's going to wait the few remaining hours back out in the cold for Meester David after which time she has no plans to set foot in this house, much less clean anything in it, ever again. Then, as Mees Lydia is already dead, there seems little point in making a big fuss alarming everyone. Meesees David has her guests now. Anouschka heard the doorbell and the polite chatter of their voices when they came in. Meesees David would not be pleased to have her evening interrupted in this way. Finally, as if any further reason were necessary given the above, Anouschka would not put it past Meesees David to implicate her in some way in Mees Lydia's demise. Caught off guard in a moment of stress Meesees David can say unpleasant things. She can make accusations. She can even lie. It's not that Meesees David is a bad woman as such. Just highly strung. Anouschka scrapes her things back together and shivers at the thought of the cold outside. But there is nothing to be done. She cannot stay here, next to the body of a woman whose soul

is at this very moment climbing the path of the mountain to the great apple orchard in the sky.

★

'I don't know why we must be introduced as our husbands' wives, David,' Laura titters, inviting their guests to sit, 'and not just as ourselves.'

'Oh, but I am very happy to be introduced as Gerard's wife,' Margaux exclaims, her affection lingering on his name as she offers him a subliminal smile to accompany this gracious remark. Laura, by contrast, pitches a sharp look of spite in Margaux's direction. Women of great beauty unnerve Laura – she prefers the monopoly. Nevertheless she had been prepared to be nice, to treat this Margaux as an equal, or at least a near-runner. However, if this was going to be her attitude, she could forget it and Laura would revert to moving in for the jugular as was her wont in such situations.

'Is that Margaux with an a-u-x or Margot with a g-o-t?' she enquires.

'Oh, a-u-x, like the actress.'

'Thank goodness for that!' Laura exclaims with exaggerated relief. 'I always think Margot with a g-o-t sounds like it should be said with a hard t – like Margotte. Which I always thinks sounds like 'my God'. Our surname, Denver-Barrette, is spelt with two t's and an e, so one does pronounce the t's there, but of course that's an entirely different thing.'

'Right,' says Margaux. Explicitly, she turns her dazzling face away to look at the men. 'Did you get to see that play at the National, David? Gerard mentioned that you were thinking of going. We went last week and I'm still –'

'We had a Margaux at boarding school when I was young,' Laura continues earnestly. 'Lovely girl. Beautiful hands. She got kicked in the head by her pony. She struggled for years after that to keep up, if you know what I mean, but finally gave up and left just before her A-levels. I believe she works in an old people's home now, changing sheets and feeding them,

things like that. Nothing too challenging. Funny how names have particular associations, isn't it? Whenever I hear the name Margaux now, I think of her, surrounded by the elderly and infirm, gathering up soiled bed linen and scooping luke warm soup into their mouths. Poor girl.'

For several moments subsequently no one is quite sure what to say. Laura's eyes mist over as she reflects on the sad fate of her friend and the other three look on.

'I thought,' David eventually announces with valour, 'that instead of going out for dinner, we might order in some food. There's an amazing new Vietnamese restaurant round the corner which does home delivery. The food really is exquisite. So I've asked them to come by in half an hour with a selection of their best dishes. What does everyone think?'

What does everyone think? Laura can hardly know or care what everyone else thinks but she for one is disgusted. Going out for a meal, to be seen in a decent restaurant, was the one thing she had been looking forward to. What on earth is David thinking of?

'It means that instead of venturing out into the cold and sitting formally at table,' David elaborates gaily, 'we can kick our shoes off, relax and be casual.'

Laura looks down in horror at her absurdly expensive velvet party shoes – why would she want to 'kick them off'? Her shoes are part of who she is. They define her.

'Marvellous,' concurs Gerard. He likes this kind of don't-be-limited-by-convention approach in a man. Margaux nods agreeably. Laura asks to be excused and disappears. She goes up to her bedroom to try Christine's number again.

If counselling was an option before, it's a bloody necessity now.

Sadly, when Laura gets through, Christine does not seem to appreciate this. She explains that this is her private line, that she has family guests there to celebrate her son's engagement

and that now is really not a good time. This number is for existing clients only in cases of extreme need. But Laura is feeling extreme. She wonders how this woman can put her son's flirtations before the salvation of her marriage. Christine reminds her it is a Saturday night after all. Laura thanks her but says she is well aware of the day and time of it. Christine is firm. 'This is my private line,' she repeats. 'I'll give you my office number: ring on Monday and my secretary will make an appointment for you.'

'I don't think you understand. This is something I have to resolve now. Today. Don't you see? I'm about to leave my husband and I need to know if it's the right thing to do.'

'Well, I wouldn't worry about that. It's natural to have feelings of doubt.'

'Yes. And?'

'And?'

'And, and come on, you're the counsellor, not me, feelings of doubt and then what?'

'Look, I'm not reading from a script here. I can't give you advice. I don't know the first thing about you.'

'Well, I'm 35, tall, slim . . .'

'Look, I'm sorry, this isn't going to work.'

'Fine. Leave me high and dry. How will you sleep tonight, not knowing what has happened to me?'

'I don't feel that I have any resp –'

'Can't you just pretend you know me? I mean, at the end of the day one bad marriage must be pretty much like another. You must have been through this a thousand times before with other people. What did you say to them?'

The woman sighs with frustration. 'I don't know . . . I say what is appropriate to the case which is different every time.'

'Yes but what? What? What do you say?'

'I don't know! Buy some new clothes, have a change of career, have an affair, any number of things –'

'Have an affair! You make it sound so easy! Do you think I

haven't tried! I've already been on the internet, this afternoon, but there's no one suitable out there.'

'Well, I don't know, sometimes what we seek is right there anyway, right under our nose, only because it's so close to us we've never seen it clearly.'

'I don't understand.'

'Well,' Christine continues, hardly containing her exasperation, 'sometimes we struggle so hard to find the answers to our questions; then we realise that the solutions are there, in front of us, waiting for us. They have been all along. We attempt to second-guess our future, to complicate our lives with convoluted thought which leads us only further up blind alleys. What we are looking for is already there.'

Already there. Of course. Already there. In her house. Right now. The man of her dreams.

Gerard.

★

When Laura finally comes back into the drawing room, it seems as if things are going really rather well. The food has arrived and the three of them are tucking in, chatting and laughing. The Vietnamese menu has been a big success. They have discovered mutual acquaintances and holiday destinations, all good fertiliser for a solid social relationship to complement the wonderful new business partnership which is all set to take off.

David is undeterred by Laura's mild idiosyncrasies thus far. He has taken the opportunity in her protracted absence to explain to Gerard and Margaux that she is a conceptual artist and hopes that this will both impress them and leave them unperturbed by any aberrant behaviour on her part. When Laura made her abrupt exit, David pointed out to those who were left behind that inspiration can come to her at any moment of the day. 'And when it does,' he comments gently, 'she has to go paint. It's her creative drive in action.'

Now, an hour or so later, here is Laura back again and

211

instead of looking embarrassed by her antics, all three of them beam at her, knowing themselves to be in the presence of an artist, ergo a higher being, one who simply cannot be expected to behave according to the usual rules.

In the interim, Laura, also possibly because she is an artist, has changed clothes, jewellery, hairstyle and make-up. Gone is the rather severe grey cashmere polo neck; now she wears an opal blue silk crossover tunic which has been so languidly crossed-over that it reveals more chest than it covers. The pretty strands of pink pearls have been replaced by an extravagant amber concoction which dangles suggestively somewhere in the region of her lower stomach. The immaculate chignon has been deconstructed to a come-shag-me loose style caressing her shoulders. The subdued pastel tones on her lids are now kohl of a deep Turkish delight; her lips, stained a strong you-know-what-this-reminds-you-of crimson, are welded into a sultry pout.

'Hi,' she says, coming back into the room.

'Hi!' all three chorus obediently back.

'Will you have some supper?' David asks, indicating the remains on plates. 'It really is marvellous.'

'Oh yes, it really is,' Margaux agrees.

'Yes. Really. Marvellous,' Gerard adds.

'Shall we have a change of music?' Laura suggests, ignoring the food, pressing the eject button on the CD player before anyone has a chance to answer.

'Er . . . Bach is apparently a particular favourite of Gerard's. We had just put that on.'

'Maybe it's time for Gerard to discover some new . . . particular favourites,' Laura whispers before going to lie on a casual arrangement of cushions which she has cast spontaneously for the purpose onto the floor. Within seconds a disturbing kasbah-style melody starts reverberating a little too loudly round the drawing room and Laura, throwing back her head, begins flexing her hands suggestively.

'Mmm . . .' she declares, throwing back her head and parting her legs, only slightly. 'This rhythm . . . it's so evocative.'

Evocative of exactly what she does not say; the relief is palpable. She rocks her hips to and fro, her shoulders rise and fall to the beat. The whirligig hands move down to start caressing her thighs. David's mouth, unattractively full of bean sprout, falls open in horror.

'La la la mmm,' Laura chants as she writhes about. 'La la-la-la mm mm la la. Aaah.'

'Gerard was just telling us,' David swallows and begins urgently, 'how he would love to see some of your work, darling.'

'Yes,' enthuses Gerard. 'Art is my passion, I'm always very excited to see any new artist's work. And from what your proud husband tells me, you really are very talented, Laura.'

'It would mean going up to my atelier, at the top of the house.'

'Well of course, that's fine,' Gerard says.

'Oh. All right,' Laura murmurs. Gosh. She was all set to seduce Gerard but now it seems he's one step ahead of her. Sometimes life is so hard and then sometimes so . . . easy. 'What sort of things do you paint, Laura?' Margaux asks.

'Let me see,' Laura begins. 'How can I . . .' she mutters as if groping for words to express the ineffable.

'I'm an art historian. I have a PhD in Art History from Stanford,' Margaux informs her with eager modesty, 'so I do have a fair understanding of art terminology – if that's any help.'

Laura smiles. 'Yes. I'm afraid terminology is not really what I'm about. I am art – as life.' She exhales a small snort which could be interpreted as pity or contempt or merely an itchy nostril, no one is quite sure. 'My work,' she continues generously, 'can loosely be described as surfaces. Hard textures. Solid fluids. Concrete, granite, marble, flint. Visual tactile sensations.'

'So – you make paintings from stone? Like mosaics?'

More ambivalent snorting. 'No. I paint them.'

'Right.' Fortunately Gerard is so well brought up that nonsense does not disorientate him. 'And – what inspires you in your work?'

'Sex, Gerard. Sex and sexuality. States of arousal. Desire.'

'I see,' Gerard nods pleasantly. David pours himself a drink and grins idiotically at Margaux hoping against hope that it's all somehow magically going to go away.

'I think that's a wonderful idea,' Margaux rallies gallantly, for she too had been blessed with parents who had taught her to find the good in everyone, 'I often catch myself looking at, say, marble and seeing amazing pictures in the swirls and veins of the stone. Did you know the word marble is from the Greek "marmoris" meaning "shining stone" – I think that's a wonderful –' She stops short. Laura, it appears, has lost interest in this conversation: the music has entered her soul once more and she has got up and begun dancing again, running her hands up and down her sides, shaking her hair this way and that. Not for the first time today (this is obviously going to be a feature of the new her) Laura feels herself penetrated by rhythm. As she sways to the music she can feel her breasts rubbing gently but significantly against her ribcage. She can feel her thighs moving against each other. The fact is that Laura is a sensual woman. Or a sensuous woman. She's definitely one of the two, if not both. All these years she has suppressed, actually David has suppressed, her inner self. This, finally, is the real Laura coming out: the blossom emerging from the bud: the woman from the girl: the . . . well, the real her anyway. She can see David watching her, an iridescent cerise of embarrassment hanging like cheap blusher on his cheeks. Fine; let him suffer. Laura has been suffering for fifteen years! Fifteen long years of repression, humiliation, only now eradicated by this spontaneous dance of joy, of life-affirming victory she is performing in front of her toe-curled audience. She could dance, dance, dance forever.

For Gerard, however, Laura's time is up. He turns to David, spreads his hands and engages eye contact. 'So, my friend,' he begins, 'we need, sooner or later, to talk a little business. Why not crack it now? You know that, in principle, we're all set to go. If there are any reservations on your part, David, speak now or forever hold your peace,' he chuckles because even solicitors can have the occasional sense of fun.

David's heart thuds with excitement. Finally. But how should he answer? Not too keen, even at this late stage; yet detachment might suggest reluctance. And should he be serious? Serious will imply commitment but also perhaps inflexibility. Gerard's tone was light, just light enough. Maybe David should match that, perhaps pick up on that marital play on words, say something smart, snappy like, 'Gerard, I do'.

Would Gerard think he was gay?

Then the perfect sentence comes to him. As sometimes it does. The right words in the right place just at the right time. He takes a deep breath and opens his mouth.

Laura says: 'I think it's time for us to go upstairs now.'

Laura has stopped gyrating to make her announcement. She holds her chin high. She goes up close to Gerard. She licks her upper lip, slowly, with the very tip of her tongue, and then rubs a forefinger, more slowly still, along the wet she has made. 'Yes,' she says, 'I think I'm ready for you now.'

CHAPTER 8

David is regaling Margaux with yet another anecdote about last Christmas's skiing holiday in Meribel. His tale is intermittently interrupted by a distressing caterwauling noise coming from upstairs, a sound not unlike the squealing of a moribund pig. When Margaux ventures her concern David nonchalantly dismisses it as the cries of his ailing mother-in-law who is staying for the night and is prone to calling out in her sleep. Margaux wonders, as the story of David's salopettes unfolds, whether, asleep or not, someone shouldn't go to the poor woman's aid but is too polite to stop him in his flow.

Then Gerard appears. Although Margaux is always happy to see him, at this moment she feels a particularly keen debt of gratitude. 'Hello darling – David was just telling me about his –'

He offers her his hand. 'Shall we go,' he asks with a look which shows this is not a question.

David panics. 'Is there something wrong?' he asks to their departing backs.

'Not with us,' Gerard quips, ushering Margaux out of the front door.

'But what about the deal?' David insists.

'No, we won't be pursuing that now. I think you have other matters to address, David,' Gerard mutters.

'What other matters? I don't understand!' David cries to the slamming door.

Outside Gerard and Margaux make a run for it to their waiting car, almost tripping over some waif-like creature who is standing shivering on the pavement right in front of the Denver-Barrette's house. They have flung themselves onto the back seat and got the car door shut behind them before

their chauffeur has even had a chance to get his peaked cap back facing the right way on his head.

<center>★</center>

Laura saunters casually downstairs.

'What happened just now when you took Gerard upstairs?' David demands desperately when he sees her. 'And why did you disappear for an hour before that?'

'Do you want those answers consecutively or chronologically?' Laura asks whimsically.

'Just bloody tell me,' he cries. 'What has gone wrong here this evening?'

Gosh, she can't remember the last time she saw him like this. Angry. Dominant. And his freshly quiffed hairstyle has started to grow on her. It makes him look much younger. Sexier.

'Gerard's more or less told me the deal is off,' he moans. 'I can't understand why.'

He flings himself onto the sofa opposite her and holds his head in his hands. This makes him look so vulnerable and innocent: Laura finds that rather enchanting too.

Coming downstairs she had been poised on the very brink of confessing to adultery, of saying, bashfully yet purposefully: 'Well, I suppose you must have heard us at it upstairs; I'm sorry, David, really sorry, but I've just had sex with Gerard and – obviously – because of that and for that reason, I'm going to have to leave you.'

Now she has decided that perhaps in fact, after all, she won't. No. She won't tell him of her betrayal and she won't leave him. Because he looks dominant and vulnerable and because she's tired and had a long day and frankly isn't up to a big scene now. So she will give him a second chance. She will cope with all his shortcomings. She'll find a way, whatever personal sacrifice it takes. She will try and close her eyes to all his many failings and re-double her efforts with the house, maybe to redecorate some of the redecorations. Yes. This

is definitely the best route and so much less stressful than separation and divorce and selling the house and having to earn her own money and all that kind of nonsense.

One day she might mention to David he came very close to losing her. She might just hint at how differently things could have been. But not now, not now. Best not to rock the boat for now.

She'll go upstairs and wait for him in bed and everything will be fine and they'll carry on as they always have done for the past fifteen years.

In the meantime she just wants to try on those trousers quickly again. She ate three spring rolls for dinner – will this have an impact? No sense in disturbing David just for the moment; she doesn't want him hanging round the bedroom with the price tags on those trousers and a few other items which are in the bag fluttering round the room like confetti. She creeps off silently upstairs.

On the way up she considers ringing Louella – it was so odd that she wasn't replying to any calls earlier. On second thoughts perhaps it will do Louella good for Laura to leave her for a while – let her know Laura can exist perfectly well without her. Then she considers going in to say goodnight to her mother. She turns towards the second-best guest bedroom but hearing the TV still blaring away in there suddenly can't face the prospect. Surely it's enough she's letting her mother stay the night there at all. She'll go in and see her with a cup of tea in the morning – she's a good daughter at heart.

<div align="center">★</div>

Margaux puts a hand to her husband's cheek.

'You look – strange. Is everything OK? What were her paintings like?'

'Vile.'

'Why the rush to leave?'

'The woman's insane. When I got up there she just stood

there, staring at me, like she was waiting for me to do something. I thought maybe she was shy, you know, about her art. So I gestured to the sheeted canvases lined up against the wall and I said something like – so, are these your paintings? And she said "evidently" and sort of huffed and puffed like I was wasting her time. Do you really want to see them? she demanded. Well, yes, I said. So she went along, ripping the sheets off them, one after the other, like she was furious.'

'And?'

'And they were horrible. I mean – really terrible. Boring. Empty. I looked at them. I took a deep breath. I was wondering what on earth I could say to her. But when I turned round she was taking off her clothes, slowly and, I think she thought, seductively. Then she went over to the mirror, checked her hair, and lay down on the couch. She opened her legs and told me I could take her any way I wanted to. "How about ironically?" I said. She said she didn't understand. I said that made two of us. She said, look, she didn't have time to mess about. She got up and grabbed me and tried to kiss me. What the hell are you doing? I said. She told me she needed to have sex with me so she would have a reason to leave David. She told me infidelity was definitely a reason to leave. I told her I agreed that infidelity definitely didn't help a marriage but that she wouldn't be committing it with me.'

'My God! So then what happened?'

'I asked her if she wanted to talk about the paintings. Fuck the paintings, she said. I told her I thought I would. She asked me if I didn't find her attractive. I said "pass", and that anyway I was in love with my wife, you know, I said, Margaux, the one who was sitting downstairs (for the avoidance of doubt). This seemed to confuse her. She asked me what star sign I was. I said Libra. Ah, she said, that might explain it. Then she asked if it would make any difference if she put on a darker shade of lipstick? I declined. She thought about things for a

moment and then she asked – politely – would I mind, even if we didn't actually do it, if we could at least pretend we had?'

'Pretend?'

'Yes, she said. And at this point I thought maybe she was joking, that this was perhaps some peculiar party game. Or worse: whether this amateur seduction scene wasn't some elaborate and desperate plan of David's to make the deal go through: the gift of the wife as part of the package. Did David tell you to bring me up here and say all this? I said. David? Are you insane? she replied. He would go crazy if he knew what we're about to do. I reminded her we weren't about to do anything. And I was dying for a pee. So to buy myself time I asked where the toilet was and while I was in there I heard her start – crying out, making scary yelping noises – hideous, horrible noises. If that's what sex sounds like with David, I thought to myself, no wonder she wants to leave him. To be honest I was a bit afraid to come out but the longer I stayed in there the louder the yowling got and in the end I made a run for it and came down and grabbed you. You must have heard her.'

'I did. David said it was the gruntings of his mother-in-law who's upstairs ill in one of the guest bedrooms.'

'My God, they're all mad in there.'

'What about the deal?'

'There is no deal; I don't think I can face going into partnership with anyone who can want to be married to someone like her.'

'And you weren't tempted by her, not even just a little?' Margaux grins coyly. 'She is a beautiful woman after all. What was stopping you?'

Gerard looks across at his beloved wife. He takes her hand.

'The shade of lipstick,' he says, caressing her cool, soft fingers. 'That was all.'

★

When David looks up, Laura has disappeared. He feels a bit out of it. Actually a lot, totally out of it. He has not been asleep, but not awake either. He tries to think how long he has been sitting there. He feels so stiff, he must have been there for hours. Minutes pass before it occurs to him that he is wearing a watch and that he can look at it if he wants to work out what time it is.

Five to midnight.

What time did their guests leave? He can't remember. Then he remembers he doesn't want to remember anything about what has happened and tries to stop his memories in their tracks. No good: they come hurtling back to him and he groans and covers his face with his hands again to make them go away. The evening has been a disaster. And now that he comes to think about it, because he hasn't ever done that before, it's not just the evening, but everything. His job, his marriage, everything, what has been the point of it all? He's not really been happy all these years, just going through the motions of happiness, of living out a life which has been successful but also routine and empty and inane.

He feels like he wants to stay on the sofa forever, not get up, not ring Gerard and beg him to reconsider, not go into the bedroom and find out what sort of mood Laura is in and try and cope with it.

There is a tapping at the drawing room window.

He pulls back the curtain. It's the cleaner on the pavement.

Bloody hell. His head starts to spin. This is too much, too absurd. The cleaner at midnight. But what can he do? He must open the door to her, although why doesn't she use her own key and why she is here at this time anyway? Then, only then the awful fact comes to him that she is here because he told her to be here. To leave with him. How could he have said that? The afternoon feels like it happened a million years ago, it feels like pre-history, as if some neanderthal ancestor of his invited her to elope with him, and now he, homo super

sapiens David, is somehow being held responsible for this patently ridiculous idea.

He goes out and opens the door to her. Her face is wrinkled with cold. He looks at her helplessly. At first she says nothing. This is possibly because her mouth is so cold that words are hard to form. Then, when he says nothing either, eventually she whispers: 'You ready we go now?'

Bloody hell, he thinks. Give me a break, he thinks. He goes back into the house and flops back onto the sofa. Anouschka follows him in and sits down next to him. She is too exhausted and cold to do anything else.

'You change mind. You no want me?'

'Well, to be honest, no, not really.'

'And ring? And baby? And word?'

'Word?'

'You give me word remember?'

'Ah yes. Word.' He nods sadly. 'Word,' he repeats and they both ponder silently for a while on the significance of that.

Finally Anouschka says: 'You know is dead your wife mother.'

David didn't know this but nothing would surprise him now. He nods again.

'So – I go?'

He nods.

'I come back Monday, usual time,' she whispers. David is not sure if this is a statement or a question but simply nods again – this wordless nodding seems to be doing the trick in a way that all the day's talk has not.

She stands to go. For one absurd and reckless moment it occurs to David that he could in fact, get up now and leave, go with her, out of the front door of his lovely redecorated Chelsea home, leave Laura and start a whole new life with the cleaner somewhere else. That he might be happier. Or something.

The moment passes.

'Bye then,' he says forcing a half-smile. And off she goes.

<div align="center">*</div>

Laura is happy. The trousers, notwithstanding the spring rolls, are fine. She climbs into bed to wait for David whose amorous advances she is now, for tonight anyway, ready not to repel. Yes. If he wants sex when he comes to bed, she will consent.

Who knows. She may even reciprocate!